RODGER McPHAIL

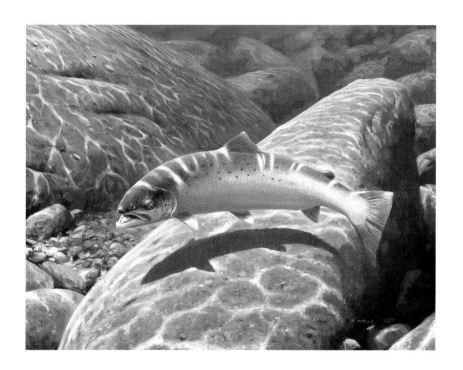

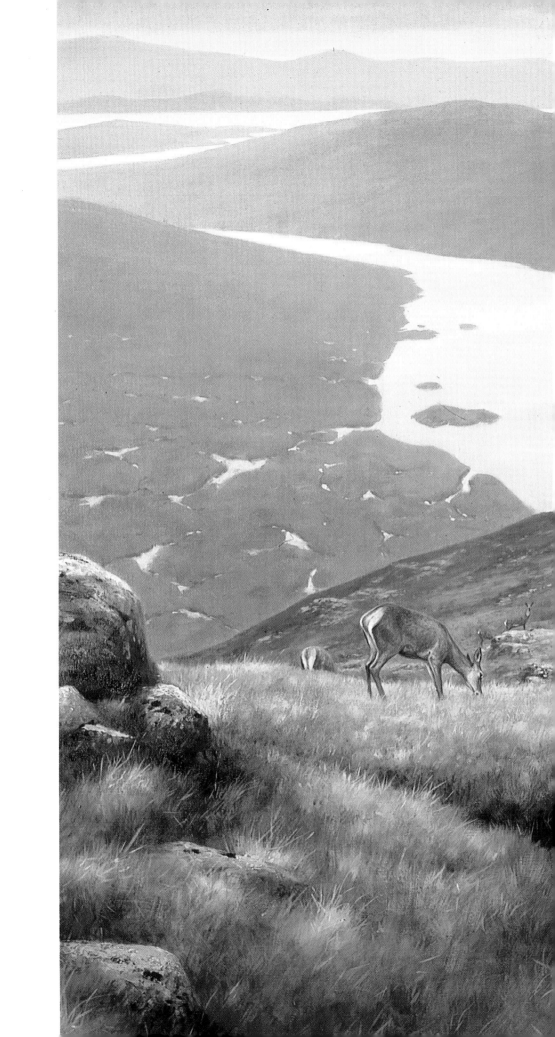

Red Deer 48" x 60" Oil on canvas

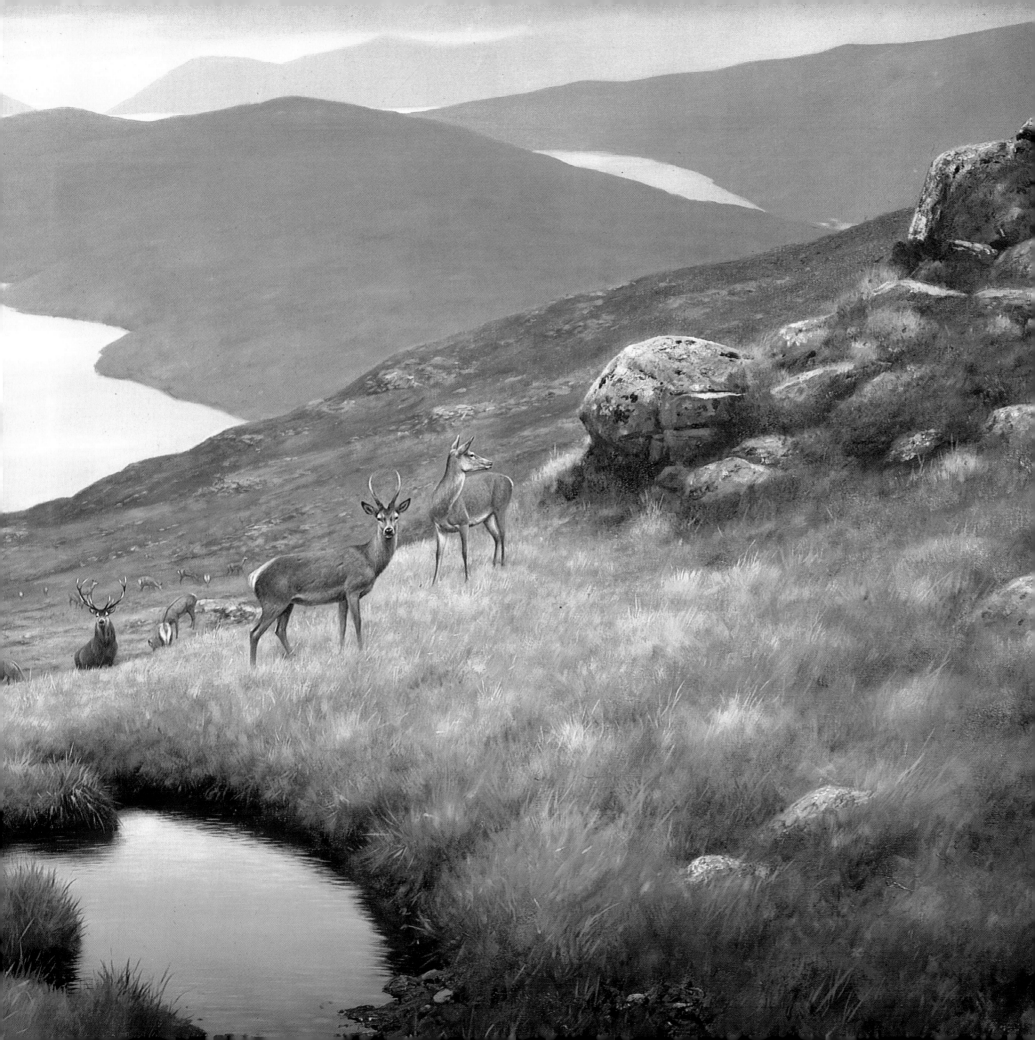

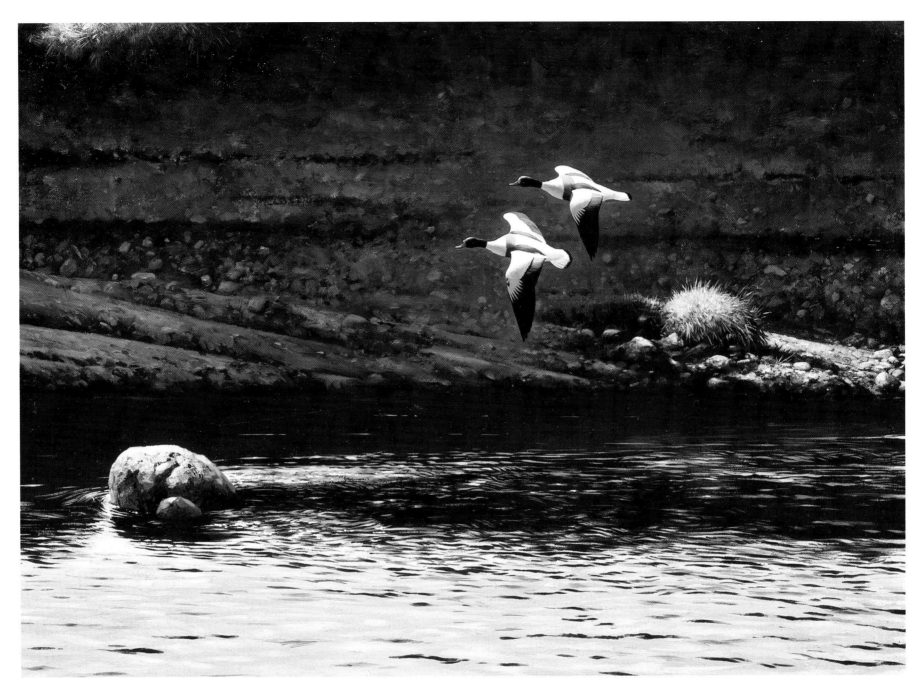

Shelducks 18″ x 24″ Oil on board

RODGER McPHAIL

ARTIST · NATURALIST · SPORTSMAN

TEXT BY

Ian Alcock

SWAN·HILL
PRESS

Text © 1998 Ian Alcock
Illustrations © 1998 Rodger McPhail

First published in the UK in 1998
by Swan Hill Press, an imprint of Airlife Publishing Ltd

British Library Cataloguing-in-Publication Data
 A catalogue record for this book
 is available from the British Library

ISBN 1 85310 954 1

Typeset by Servis Filmsetting Ltd, Manchester, England
Printed in Italy

Swan Hill Press

an imprint of Airlife Publishing Ltd

101 Longden Road, Shrewsbury, SY3 9EB, England

ACKNOWLEDGEMENTS

I would like to thank all the people whose paintings appear in this book. In particular:

Mrs Barbara Hawkins
Mr M. Meredith
Mr and Mrs S. Murphy
Mr C.M. Fleming
Mrs Sally Merison
Mrs S. Ingleby
Mr Claude Berry
Mr and Mrs P. Keyser
Mr and Mrs A. Lukas
Mr and Mrs J. Keyser
Mr and Mrs Mark Birkbeck
Ms Sue Hodgkiss
Mr and Mrs C. O'Donnell
Mr and Mrs D. Hodgkiss
Mr and Mrs R. Lowes
Mr and Mrs E. Verbeek
Mr and Mrs Jake Morley
Mr M. Hannah
Mr A.W. Parker
Mr and Mrs R. Bury
Ms E. Duffin
Mr C. Mowat
Mr L. Ratcliffe
Mr P. Reichwald
Mr and Mrs I.C.N. Alcock
Mr and Mrs T. Kimber
Mr and Mrs J. Cantey
Mr and Mrs R. Webb

Mr and Mrs P. Duckworth
Mr Anthony Duckworth
Mr Colin McKelvie
Mr and Mrs M. Stone
Mr and Mrs Peter Johnson
Mr M. Harding
Mr and Mrs E. Maher
Mrs H. Casey
Mr C. Mckinnes
Mr and Mrs M. Ainscough
Mr S. Hoyle
Mr and Mrs R. Mather
Mr Bill Makins
Mr C. Curtis
Mr and Mrs C.A. Pejrone
Mr Alain Cheneviére
Mr C. Baxter
Mr M. Osborne
Mr P. Stremmel
Mr Matthew Gloag
Mr G. Akins
Mrs E. Herd
Mr G.W. Wallis
Mr D. Kelly
The Hon. Harry Orde-
 Powlett
Commander G. Edzell

FOREWORD

As a collector of paintings and drawings of wildlife, especially of deer, I was impressed by a double-page spread of black and white reproductions of paintings in the magazine *Shooting Times* of 22 July 1972. They were by a nineteen-year-old artist, whose scraper-board and ink drawings I had noticed in issues of the publication in preceding months, since these had superseded the drawings by my wife, who by then submitted work to the magazine infrequently. I was also impressed by his comment in the accompanying article with regard to the wildlife artists whose work he most admired, since these coincided with some of my own views. I wrote to the artist, Rodger McPhail, care of the *Shooting Times* and asked him whether he painted deer. In due course I received a reply saying that he had not painted deer but would like to do so. I replied that if he cared to come and visit us I should be delighted to show him roe deer. So began a friendship of twenty-six years thus far.

After he had made several visits to stay with us I gave Rodger a copy of Dr K. E. Russow's book on Bruno Liljefors, the great Swedish wildlife artist who died in 1939, regarded by many throughout the world as 'The Master' amongst wildlife artists. Recently in Rodger's studio I noticed the book on his shelf and took it down. I was amused to note that I had originally inscribed the book 'One day you will be a well known and successful wildlife artist'. That prophetic sentiment was written in expectation and not merely with hope.

The paintings of Rodger McPhail are now known and sought after internationally; his exhibitions invariably result in the overwhelming majority of the work being sold at the first evening private viewings, and often ballots for the pictures are necessitated, even in times of recession when other paintings have not sold well. His workload of commissions is such that he is continually under great pressure to complete them and reluctantly often has to refuse to take more until his schedule becomes lighter. Notwithstanding, Rodger manages to intersperse respites from long days at his easel and drawing table with trips to many wonderful places, which enable him to add to his already impressive reservoir of wildlife experiences and knowledge of animals and birds.

That Rodger McPhail is an artist of outstanding talent, and a knowledgeable naturalist, is obvious to the many admirers of his paintings and illustrations, but I doubt that many of these people, or even most of his many friends, are aware of the full extent of Rodger's talent. He has made his name known through paintings of wildlife and sporting art, but he could have achieved equal success in many other artistic fields – portrait painter, landscape artist, illustrator, cartoonist, sculptor. Not only has Rodger demonstrated his remarkable skill in all these diverse fields, a versatility shared by few other artists, but his talents extend beyond the field of art. Not least of these is the natural ability to be at ease with, and to put at ease, people of all walks of life. Duke or dustman, Rodger gets on with them equally, and several of both categories are enthusiastic admirers of his talents.

Rodger McPhail has already become widely known as one of the outstanding, if not the best, wildlife and sporting artists in Britain today, but what sets him apart from all the others is his wide range of talents.

Ian Alcock

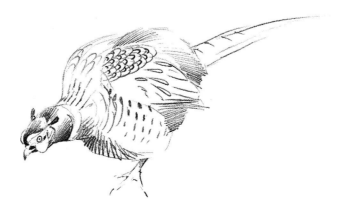

CONTENTS

RODGER McPHAIL

Rodger McPhail was born in Westhoughton, Lancashire, in 1953. His father was a coach-trimmer from Edinburgh, who moved down to Lancashire in the 1940s. His first wife had died in childbirth, leaving him with three daughters and a son. In Lancashire he met and married a local girl, with whom he had a further three daughters and a son, Rodger.

When Rodger was aged five the family moved to Coventry, where he was brought up. Within ten minutes' walk from where they lived was open countryside, and Rodger spent all his free time wandering about in the fields and woods, becoming obsessed with birds and animals. In those days it was quite normal for young children to go out to play or amuse themselves on their own, without fear of the dangers of traffic or molestation, and the children, during holiday times, often seemed to come home only for meals, preferring to be outside in the fresh air.

The youngsters got into all sorts of the scrapes in which country children, or those with access to countryside, find themselves. Climbing and falling out of trees, daring to walk on icy ponds and the inevitable disastrous immersion, fooling with wasp nests and getting badly stung are typical examples. At the same time Rodger was also observing and noting wildlife and from an early age his drawing showed promise. He was encouraged to indulge in and improve upon his skills by his parents and various sympathetic teachers who appreciated the talent shown. Any dead creature that came into Rodger's possession, not necessarily by conventional or respectable means, was sketched or painted. At various times Rodger kept a pet kestrel, which he fed with sparrows that he shot with an airgun or a blow-pipe, a tame magpie and the inevitable ferrets. On his second visit to stay with us in Surrey, Rodger gave us a watercolour of a magpie. When I admired this he told us that he could paint magpies almost blindfolded, since he knew the birds so well having kept a tame one.

In those days the countryside where Rodger wandered was well populated with wildlife. There were wild partridges in the fields, redstarts in the hedges and grass snakes to find in summer. They fished in various ponds and lakes locally, and on winter trips to Lancashire his brother-in-law took him out wildfowling in Morecambe Bay.

He did not enjoy his time at school greatly and shone only at Art and English, but he managed to scrape together sufficient 'O' and 'A' level examination passes to enable him to enter the Coventry Art College at the Lanchester Polytechnic in 1971, where he stayed a year. Despite their awareness of Rodger's ability with pen and brush, and their encouragement, his parents, understandably, had some misgivings when Rodger chose to pursue the idea of a career in art.

By the time that he left school he had become quite proficient with watercolours and had his first scraper-board and black and white drawings published in the *Shooting Times* at the age of sixteen. At nineteen he achieved the accolade of the first of what would subsequently be many paintings published on the front cover of that magazine.

These days Rodger says that of the many artists whose work he admires, the one that has influenced him most is the Dutch artist Rien Poortvliet. However, in those early days he did not know of Rien, and one of those whom he most admired then was the late Eric Ennion. My wife, Diana, knew Eric quite well, and so it was a pleasure for all of us that we were able to take Rodger to see him, and his studio. We were privileged to be shown some of Ennion's early very tight studies of birds which were quite unlike his later freer style. When Rien Poortvliet's first marvellous book *Jacht Tekeningen* was published in 1972 I sent Rodger a copy and subsequently engineered a meeting between them. The two artists shared certain aspects in common, including a remarkable ability to memorise subjects and scenes in detail.

After his pre-diploma year at Coventry Art College, Rodger moved to the Liverpool Art College in 1972. He chose the graphic design course because his time at Coventry had shown him that traditional and figurative work was scorned at that time, and on so-called Fine Art courses skill seemed to be ridiculed. However, at Liverpool, Rodger discovered some very 'painterly' (as he describes them) tutors and that draughtsmanship was encouraged. In the three years to 1975 when Rodger studied in Liverpool he reckons that he learned a great deal, and as he himself says, it was three years of valuable practice without the headache of trying to earn a living. He also had a wonderful time in Liverpool with his fellow students.

Rodger's wife Cecilia also studied at Liverpool Art College, in the year behind Rodger, and they knew each other, being in the same group of friends. They never lost touch after they finished college and later Cecilia came to one of Rodger's exhibition parties. A friend there asked her to design and research and arrange the printing of posters that he had commissioned Rodger to paint of East African

wildlife and people. This fortuitous arrangement led to the relationship that later resulted in their marriage.

As an impecunious student Rodger had sought to augment his grant income by selling a few drawings, including those to the *Shooting Times*, a magazine to which he had been attracted by his involvement with wildfowling. As a result of his drawings being published in the *Shooting Times*, Rodger subsequently secured the commission to provide illustrations for a book, *The ABC of Shooting* , written by a long-standing contributor to the magazine, Colin Willock, who writes under the pseudonym 'Town Gun'.

His submission of illustrations to the *Shooting Times* led to an article on him being published, with a double-page spread showing a selection of his paintings. In those days the magazine was printed in black and white, with only the cover in colour. It was this article, illustrating some of his paintings and his obvious talent, which led to my getting to know Rodger, then still nineteen years old and studying at the Liverpool Art College.

On one of his visits to stay with us at our Surrey cottage later that summer, he mentioned that he had been given an introduction to see Aylmer Tryon of the Tryon Gallery in London, the country's leading gallery for wildlife and sporting art. I suggested to him that he would be wise to take up the introduction without delay, as they handled many internationally known artists. When Rodger wrote to thank us for the weekend's visit he mentioned that he had called to see Aylmer Tryon on his way home through London and the connection had been made. Undoubtedly his work would have been taken by the gallery in due course in any case, but equally undoubtedly the early association between Rodger and the gallery was propitious and Aylmer and he remained good friends until the death of the former in early 1996. This association between artist and gallery was of great benefit to both over the years.

Aylmer recognised Rodger's skill immediately, and sold a number of paintings for him, as well as instigating commissions. In the late summer of 1973 Rodger was commissioned to paint a picture as a birthday present for a wealthy Dutch gentleman who was also vice-chairman of the Olympic Games. The painting was to be of his hunting estate. It was Rodger's first flight in an aeroplane and his first visit abroad, so the trip to Holland was very exciting. A chauffeur awaited him at Amsterdam airport and drove him the hundred miles to the estate, where he was to paint a picture of a scene near the house, a huge wooden hunting lodge.

The following day Rodger was given a tour of the estate by the gamekeeper and then given a bicycle, traditional transport in flat Holland, so that he could explore on his own. He saw new birds there, including a marsh harrier and a crested tit. He also saw a new frog, the edible frog, which he discovered is bright green with a yellow stripe down the back. The pond there was full of them. In the pond were also a few grass snakes, and Rodger, ever the inquisitive naturalist, caught three of them, one of which was the biggest grass snake that he had ever seen. It was about four-and-a-half feet long, and its reaction to being snatched out of the water was to spray Rodger all over with evil-smelling fluid

Later, Rodger brought us two sheets of sketches that he had made there. One sheet showed three different watercolour sketches. Rodger kindly gave this to us and I subsequently had it framed. Later, when we had the great Rien Poortvliet staying with us I showed him these sketches made by Rodger in Holland. 'I wish that I had been able to paint like that at his age' he said.

Since then Rodger must have been one of the most prolific contributors to the Tryon Gallery, having exhibited paintings there in many mixed exhibitions and six one-man shows. He also executed numerous commissions for gallery customers. He exhibited in various places in the world in the ensuing years, including Johannesburg, Brussels, Paris, San Antonio and New York.

In those early days, whilst still studying at Liverpool Art College, he also managed to sell a few paintings locally, as well as some through the Tryon Gallery. However, perhaps the most remarkable achievement was his demonstration of skill as a cartoonist. He had a bet with some of his art college friends who wagered that he would not succeed in having an illustration published in the magazine with the highest circulation. They looked up circulation figures and, to Rodger's disquiet, picked *Men Only* as the target. Rodger submitted to this magazine a sheet showing a series of taxidermy cartoons. Not only did they accept this and publish it as a double-page spread, but requested that he should submit more. Uncertain of the reaction to such an association, especially from his family, Rodger declined further continued requests for more work from the magazine, although he was persuaded by them to provide one more double-page spread, on the subject of suicides.

Rodger started life as an artist, or as a prospective artist, in what is deemed to be the conventional way. In 1973 he wrote to us from college:

'I have at last moved into my bedsit, or 'the rat-hole' as it has come to be known. I am sitting here now, on my only chair . . . The last few weeks have been absolutely hectic. Most of my time has been spent making this place bearable, with gallons of emulsion, and trying to find furniture, cooker and bed etc. Well I'm in now, and it's a bit spartan, but not too bad. I can begin painting again next week . . . A walk round Sefton Park makes me forget the squalor of student life, and the frightening financial situation that I have got myself into.'

Even in the city, birds could be seen and appreciated and Rodger, noted not only the wildlife resident in the parks and the urban areas, but often spotted unlikely birds passing overhead. All of these were prospective subjects for pictures and his ability to recapture the impressions of these birds in the few lines of a quick sketch demonstrates the detail absorbed by him in what might appear to have been casual watching. His letters to us always mentioned birds and other creatures that he had seen and were illustrated with wonderful sketches of these.

Rodger has always been intrigued by investigating and catching creatures, in an atavistic way, driven by curiosity and the wish to learn more about them. He has always been game for a bit of fun too! He relates that during a camping holiday with friends in the Lake District, they called in at Grasmere for something to eat in a little open-air café that overlooks the river. There were eels and trout right under the balcony, so he tackled up his fishing rod and soon had a big eel caught with a piece of pork pie! A little crowd had gathered by this time to watch him land the eel, and when he did so he got a round of applause! Unfortunately the café manager came to see what the fuss was, with the result that the eel and Rodger were duly ejected from the café.

Eels have retained their fascination for Rodger. Years later, when Rodger was staying with us in Aberdeenshire, we decided to set about catching some. Rodger, displaying the skill and craftsmanship that I have seen so often, constructed a most beautiful eel trap from small-mesh wire netting, modelled from traps which he had seen elsewhere previously. We baited the trap with rabbit guts and set it in the burn. Alas, the only catch was a small trout, which I released, despite keeping the bait renewed for some weeks. The skill of his hands is not solely confined to the use of pen and brush. His enquiring mind, eager to discover how things work, and how creatures live and move, is part of the build-up of the store of knowledge that enables him to convey the character of an animal or bird. It is this ability that sets his pictures apart from the work of many run-of-the mill wildlife artists.

Even at the age of twenty Rodger referred to his painting as his work, drawing or painting compulsively and seriously. 'I have neglected my work this last few days to do some shooting and fishing,' he wrote to us, 'A friend of mine who is a keen pigeon shooter was getting married last week, so we had a last day's shooting and got 37 in only about two hours. One pigeon came into the decoys and got hit and then flew off to the far end of the field and landed on the ground, where two crows pounced on it. Later when I went to pick it up, it was walking about with both eyes neatly extracted. A horrible sight.' On his return home he made a water-colour sketch of the beautiful but helpless pigeon cowering from the approach of a hideous black crow. It was not intended as other than a rough sketch record, but he captured the raw cruelty of wild creatures that so many wildlife artists and conservationists choose to ignore, or fail to appreciate. Nature is the realm of the hunter and the hunted, and the raw, violent and destructive side is as real as the beauty and gentleness so often portrayed by artists because it is the facet they imagine most people wish to see.

In the true tradition of an atavistic hunter, Rodger has always regarded fishing and shooting as the acquisition of food, catching his quarry to eat it. From an early age he was ready to pluck and dress game and clean fish for the kitchen; but with the added interest of the opportunity to study in detail the anatomy of the subject being prepared. Moreover, doubtless as a result of having to cater for himself whilst at college, he developed his skills as a cook, although these may have been allowed to lapse now after years of marriage.

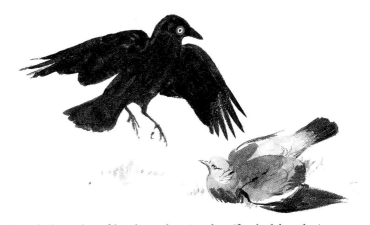

The detailed study of birds and animals afforded by their preparation for the kitchen provides a valuable insight into feathering and texture of fur and hair, as well as skeletal structure and muscle arrangement. Familiarity with these features is important when portraying the correct proportions and attitudes of subjects.

In 1973 Rodger made several wildfowling excursions on the Lancashire coastal mudflats with his brother-in-law. He enjoyed the excitement of the flighting of the wildfowl and the visual experience of the frozen marshes and mudbanks of the shoreline and estuary. It is evident in his wildfowl pictures that these have been painted by someone who has actually been out there on the lonely marshes and watched with excitement the ducks flighting overhead. Even in his earliest work one can see the wonderful light that he achieves in many of his paintings, and the excellent composition, both being features on which so many lesser artists fail.

Always eager to try any new experience, Rodger enrolled to take part in a parachute jump.

'Would there be any chance of meeting Kenneth Whitehead this Christmas holiday? That is if I survive the parachute fall.' 'It's next week. I must admit that it no longer seems as funny as before, and to be quite frank I am getting extremely scared. I don't think they allow you to take any bottled courage up in the plane.'

The terrifying experience proved worthwhile in retrospect however.

'The plane was tiny, hardly enough room for four of us, the instructor and the pilot. I was first out, and was so rigid with terror as to forget everything we had been taught, and just bundled out with a strangled scream! Never been so scared in all my life. It was worth it though, a few seconds later when I found myself suspended in complete silence miles above the countryside. It was so fascinating that I also forgot steering instructions and happily floated four or five miles away from the airfield. I crash-landed in a root field and had to hitch back. It was great, well worth doing, but once was enough for me'.

We had given Rodger an introduction to Kenneth Whitehead, the well-known expert on deer and author of many books on the subject. Rodger was delighted to meet him, and this was reciprocated by Kenneth, who had already seen and admired his work. He gave Rodger a copy of his book on deer-stalking in Scotland and this filled him with enthusiasm for the sport. Subsequently they came to know each other well. Kenneth bought pictures and commissioned illustrations for his books from Rodger, and at times gave him advice on the subject matter of paintings.

Aylmer Tryon, himself a keen and competent naturalist, as well as fisherman and shooter, undoubtedly recognised in Rodger an artist who knew his subjects and was able to portray this in his work. He had promised Rodger the opportunity of an exhibition when he had accumulated a sufficient number of paintings. Rodger planned to have a holiday in South Africa before settling down to the serious business of becoming a professional artist. The South African trip introduced Rodger to many new birds, animals and snakes, and added to his repertoire of wildlife and subject matter for possible future paintings.

Whilst still at the art college there was a steady demand for Rodger's paintings. He was also producing illustrations for the *Shooting Times* and other magazines and had been commissioned by Colin Willock to illustrate the *ABC of Shooting*. About 90 pictures were needed in all, many of these technical – trigger mechanisms etc. Colin Willock was already familiar with Rodger's scraper-board and drawing illustrations and asked Rodger for three watercolour paintings that he could buy. Rodger sent him three large pictures,

asking between £30 and £40 each for them. Willock apparently did not like them, as he sent them back saying that they were too expensive. I was disappointed when I heard this from Rodger, and having confidence in his work, despite never having seen the pictures, I sent him a cheque saying that if he still wanted to sell them, then I would buy them instead.

After his experience of seeing roe in winter, during a trip to stay with us in Surrey, and seeing me shoot a doe, he expressed enthusiasm for roe stalking and I promised him the opportunity during the following summer. It was arranged that he should come and stay with us for a week at the end of July or early in August, when the roe deer rut should be in progress and there was a good chance of his shooting one. I can remember very clearly the first two bucks that he shot, because of his reactions.

On the first evening we sat in a high seat that I had made in a large yew tree, looking across a small valley to a slope opposite that was newly planted with small conifers. There, I had located a roe rutting ring, in a figure of eight shape. Two days earlier my wife, Diana, had watched a buck running a doe accompanied by twin kids. After we had settled into position for a few minutes I began calling, and before long a good buck appeared and walked slowly across the slope. I told Rodger to shoot the buck when it stopped, which he did at about sixty or seventy yards range. At the shot the deer went down and never moved. We waited a moment to check that all was well and then descended the tree. Rodger stood looking down at the fine roe, absorbing detail. Then he moved the beast's legs into different positions and stood looking. I was delighted that somebody should admire these beautiful animals in this way. Only after several minutes of examination was I allowed to gralloch the deer. His reaction was not the triumph of securing a trophy, but the fascination in being able to examine closely and absorb detail of an animal that he had never before seen at close range.

The second buck was shown similar respect, if more briefly. This time we were seated in another ancient yew tree overlooking a very large clearing that had been planted for only a year. I spotted a buck at the far corner of the clearing. It must have been at least four hundred yards away and I decided to try a call. To my satisfaction the buck responded instantly and came towards us at speed. As he neared our side of the clearing, a hundred yards away, he slowed to a walk, crossing broadside in front of us. 'Wait until . . . ', but before I could finish advising Rodger to shoot when the buck stopped, he had already fired. The buck ran a few yards and dropped dead with a clean heart shot. Early years of shooting sparrows and starlings with catapult and airgun to feed his tame magpie and kestrel had made Rodger a natural shot.

His respect for the dead animals and his intense interest in them was impressive. A painting from memory, created a few days later was his first of roe and the product of watching them in summer coat for only less than a week. It illustrated his extraordinary photographic memory.

Wherever he has travelled Rodger has always been constantly observant of wildlife, and even in the city his keen eye has been evident.

'I actually saw a woodcock flying over Liverpool last week. I thought I was mistaken at first, but then it was followed by another. Either it's woodcock migration time or there's some lonely damp birch-coppice in the centre of town that I don't know about. Cities are full of wildlife. Two weeks ago I saw curlews, three miles from the Liver buildings, flying with a background of flats etc.'

One of the more memorable experiences that the art college provided was the opportunity to meet the well known artist C. F. Tunnicliffe and to see his studio. His tutor gave him a list of addresses and sent him off to Wales to meet various artists. Rodger did not know what to expect, but he was made welcome by all of them and stayed several nights in various studios in a sleeping bag. All the North Wales artists apparently knew each other and so they had some very good parties. During the day Rodger was up in the mountains or down by the coast, painting and sketching. Anglesey was swarming with birds and all other forms of wildlife, and he found it a treasure trove of experience. Stonechats seem to take the place of sparrows', he said, and the prolifera-tion of sea-birds delighted him.

He was a nervous of his first meeting with Charles Tunnicliffe because people had told him that the great artist had become a bit of a recluse since his wife had died, and didn't like seeing people. It was a lovely surprise for Rodger, therefore, to find that he got on well with the artist whose work he had much admired. Tunnicliffe was only too glad to show him all his sketchbooks and tell him all about his work and Anglesey. He invariably used the opportunity of any dead birds that came his way to make detailed sketches and notes.

Tunnicliffe lived beside the most beautiful estuary in Anglesey, near Newborough Warren, where shelducks, cormorants and oystercatchers were everywhere to be seen. Rodger also watched a large mullet

swimming in a tidal lake there too. Later he went up to South Stack in Holyhead for a few days and fell in love with the place and the huge towering cliffs covered in guillemots, razorbills puffins and numerous gulls. He watched fulmars from an unnerving angle on the cliff-top and when looking at the birds through binoculars he felt almost as if he himself was flying with them.

By 1976, when he left art college, Rodger was receiving many commissions through the Tryon Gallery and was kept extremely busy. One of these involved joining a group of people who had taken several days shooting of red-legged partridges in Spain, and who wished to have paintings made of this. Rodger much enjoyed the trip and the rowdy parties *après* shooting were as much part of the fun as the experience of shooting at huge numbers of driven red-legged partridges. A number of new friends were made too. Rodger took fifteen paintings down to the Tryon Gallery, although he was far from happy with at least five of these and heartily sick of painting Spanish partridges. However, an American who was a member of the shooting party which had commissioned the paintings, after much deliberation as to which of them might be turned into prints, finally decided to take all the paintings, at £150 – £200 each, with four of these being made into prints of editions of 250 each. Rodger was therefore pleased with the financial outcome; for in 1976 such prices were good for a comparatively new 23-year-old artist.

Another commission that year was the creation of a series of watercolours of sporting scenes and game birds. It was to be bound into a specially-made game book to be presented by long-standing members of a syndicate grouse shoot in eastern Scotland to the organiser of the annual shooting who was retiring. In itself this was a remarkable and much admired work; but it also led on to other things. Rodger had been chosen as one of the artists for a possible idea for a Silver Jubilee present for the Queen from the Royal Household. The idea was to have four paintings of scenes from Balmoral and Sandringham by Rodger showing pheasants, partridges, stags and grouse, with pictures of both houses by a well-known painter of houses, and others of pets by another artist. All these were also to be put onto plates. However, it eventually materialised that the project was going to be too expensive and this plan was shelved. Fortunately the Queen had seen the special game book and decided that she would like Rodger to paint Lochnagar and Sandringham. The ladies-in-waiting, who were arranging the Silver Jubilee present, got Rodger to do a little sketch of a Scottish scene for the Queen's

birthday card. At the same time the English members of the party on the Spanish partridge shoot commissioned a further six paintings of this from him.

The flow of commissions was constant, such that the one-man exhibition planned by the Tryon Gallery had to be deferred for a year to give more time to accumulate paintings for it. Amongst the pictures ordered from him at the time were two paintings requested for the boardroom of a sporting chairman, wildfowling scenes were wanted by somebody else, and some grouse moor owners sought paintings of drives on their ground, and so on.

Rodger managed brief outings between painting hours to go fishing with a friend for trout in a little brook. On one of these outings he discovered what at first he thought were small eels but which were actually brook lampreys, a species now in decline in some areas. It was typical of Rodger to investigate and catch one of these to examine it more closely, to have the experience of the lamprey sticking to his finger, and to enjoy an afternoon's fishing in a brook as much as he might have done had it been a fine salmon river.

On another outing he discovered some swans nesting on a lake and resolved to paint them. During the sketching the cob staged a couple of attacks, but without unfortunate effect. Whilst he was painting the swans two kingfishers chased each other about in the bright sunlight, offering him the opportunity observing another species sadly seldom seen these days. Later he was to have several enchanting opportunities of watching these delightful and colourful little birds when staying with Aylmer Tryon at his aptly named house, 'Kingfisher Mill', on the River Avon.

Now, as then, Rodger intently observes wildlife wherever he goes. Driving down Lancashire lanes near his home with him in autumn, he points out the flock of bramblings flitting across the road or a party of goosanders flying overhead, or a hare in the field. This observation is not just casual looking. He absorbs detail in a remarkable and almost photographic way, and it applies not merely to the more unusual birds and animals but to the everyday common ones as well. This is why he is able to sit down and paint a wren, jay or an oystercatcher, straight out of his head and without hesitation. Outside the room in which he worked in 'Catspiss Towers', his first house, there was a hawthorn tree on the edge of the field a few feet from the window. This gave Rodger the opportunity in winter to study at close range the redwings, fieldfares and mistle thrushes that came to feed on the berries.

No opportunities are missed to note coloration or movement. Fishing trips and grouse moors provide him with the opportunity for exciting sport, but more importantly the company of a wider range of creatures. Dippers bobbing on the stones of the rapids in the river or a sandpiper flitting along the shingle at the water's edge, barely noticed by so many fishers intent only upon the fish, are all carefully observed. The white rump of the cock wheatear is quickly spotted by Rodger as he waits for the grouse to appear, and even the meadow pipit will attract his attention.

I remember one beautiful sunny autumn morning. There had been an early frost, with the bracken turned orange, the rowans flame coloured and the birch trees golden. Rodger and I stood on the hill at 'Shannel', my Aberdeenshire farm, looking up into a birch tree studying a little flock of assorted finches in the branches. We had gone for a walk with guns and my dogs, hoping to pot a cock pheasant for the freezer. The walk had been leisurely and the pheasants were notably absent that day. I apologised to Rodger that he was yet to fire a shot. Typically Rodger replied, indeed echoing my own sentiments, that the gun was merely the *raison d'être*, the excuse for being there. He was enjoying the wonderful autumnal colours, the freshness of the air, the little birds in the trees and so on and the possibility of potting a pheasant and reaping this wild harvest simply added a little spice to the lovely walk.

Despite all the picture sales and apparent success, living as an artist with no other source of income is not easy. One needs to sell a lot of paintings to cover basic living expenses, and it is not always appreciated by others just how expensive are the materials needed for painting. Good quality paper, paints, and particularly brushes are costly. Those early years were difficult for Rodger. 'I'm in the worst mess that I've ever been in. Terribly overdrawn and expecting a tax demand any day now. If I sat and thought about it I'd go grey'.

A report in a Sunday paper mentioned that 'Lord Home's forthcoming book on field sports, *Border Reflections* is to have a most attractive cover. An inquisitive circle of birds, butterflies and fish surrounds the laird as he stands in a salmon pool. It has been painted with imagination and delicacy by Rodger McPhail, who at 25 is assured of a great future. He was "discovered" by Aylmer Tryon of the Tryon Gallery.' This book, published in 1979, did indeed have a superb coloured jacket painted by Rodger with numerous black and white illustrations in the text. I was shown a copy that had been inscribed by Lord Home for a friend of his, and subsequently inscribed by Rodger, who had stayed there later. I forget the exact wording, but Lord Home had written to the effect that 'Rodger McPhail is a promising young artist', and Rodger had written below 'Lord Home was a splendid old Prime Minister'! This caused a great deal of amusement.

In 1985 Rodger illustrated a similar book of reminiscences entitled *Kingfisher Mill*, written by Aylmer Tryon, with a foreword by Lord

Home. Again, the coloured jacket of the book is superb, and the sepia illustrations inside are even better than those of the earlier title.

Rodger went down to stay with Aylmer Tryon in order to meet Lord Home to discuss his book. He described Alec Douglas Home as a charming man, very easy-going and full of good stories. He found that he was asked to complete 32 – 40 black-and-white drawings and a dust cover in colour by the end of that month! Subsequently Lord Home invited Rodger and Aylmer for a memorable week's shooting at Douglas.

At this time Rodger was also painting some pictures commissioned by Whitbread Brewery of fishing scenes from various parts of Britain. Half of the pictures were to be by him and the other half by Colin Burns. He still found time for some fishing, having been invited for a couple of days on the River Wye with Aylmer Tryon. Rodger, always a keen fisher, had by then become a skilled and accomplished salmon fisherman, and two salmon that he had caught the previous summer on the Frome were the two biggest taken on that river that season (24 and 28lb). He had already been invited for fishing holidays on the River Findhorn, which were to become annual events and the inspiration for many paintings.

During this period Rodger also painted a picture entitled *The first drive after lunch*, showing a man asleep on a grouse moor, which the gallery made into an edition of prints. *Shooting Times* asked him to paint a wild boar as a cover for the magazine, but uncertain of the result he took his attempt to Kenneth Whitehead for criticism. The latter was familiar with the animals from shooting experiences in continental Europe. To the surprise and delight of the artist, who had little experience of the animals, Kenneth liked the picture and passed it as correct and realistic.

In 1980 Rodger finally acquired his own house, 'Briars Brow'. Although not in the countryside, it did at least back onto a field and stood next door to a small pub. The house had belonged to an old woman who kept a number of cats and seemingly the house stank of them. Rodger nicknamed the house 'Catspiss Towers'.

A short time afterwards, Rodger and Cecilia, by then engaged embarked upon a second trip to Africa for another joint commission. It was to design and paint several posters depicting various birds and animals, and also the various native tribes of Kenya. It meant funding the expenses but the venture subsequently proved rewarding and provided

a fascinating holiday but more particularly the establishment of new contacts and friends led to further trips in ensuing years. They crammed in a lot during their trip and saw a good deal of the country. First they went south to the foothills of Kilimanjaro, and then to Mzima Springs in Tsavo Game Park where they watched hippopotami in crystal clear water. A hide had been sunk into the water at the edge of the pool and they watched a huge hippo bouncing lightly past them in slow-motion through the glass. They also saw a myriad of dazzling birds and insects.

Next their host flew them up to Lake Rudolf in a tiny plane that was so buffeted and tossed about by the gales that Rodger thought that they might not survive! By this time they had both been struck down with 'Montezuma's Revenge', diarrhoea and vomiting, which added to the temporary misery! Rodger reported that Rudolph is the most god-forsaken baking desert with constant 40 mph hot winds. Despite the problems they caught several Nile perch – the biggest about 60 pounds. They had to be alert to crocodiles and carpet vipers whilst fishing at the edge of the lake. The journey back to the Aberdares in the same aeroplane was even worse – Rodger said later that he felt so ill that he wouldn't have cared if they had crashed!

They were then taken to a lake and saw thousands of pelicans literally millions of flamingoes, avocets and other birds before going up into the mountains to fish for trout. There they found it bitterly cold at night and it froze hard, but it was quite hot during the day. It was exciting for Rodger to follow, with great difficulty, the river and fish pools that had possibly never been fished before. At first he was frightened of meeting lions, but then relaxed as he concentrated upon the fishing until he walked right onto a sleeping buffalo bull! He told us later that he had never moved so fast in his life. Luckily the buffalo got a fright too and thundered off in the opposite direction. The trout were quite small, being about a pound in weight, and were very difficult to catch.

Next they spent three days buffalo hunting, but didn't find a suitable old bull to shoot. Not surprisingly Rodger found this experience fascinating, following the tracks through rhino infested thickets. ('If one charges, for God's sake don't shoot it!') At one stage the party all trooped over a puff adder – only the last man saw it, and it was fortunate that nobody was bitten. He found the hunting very hard work over steep hot rocky ground, sometimes crawling through thick undergrowth and sometimes almost running on the trail – and carrying a very heavy rifle. 'Every warthog or bushbuck that went crashing through the bushes had me close to an I. e. o. t. bowels (Involuntary evacuation of the).' he wrote later. Cecilia had stayed at home during the hunting as she had earlier been badly frightened by

some elephants and had gone off the idea of wandering about in the bush.

During this brief trip, albeit crammed with excitement, Rodger and Cecilia met many fascinating people, white hunters, artists and sculptors. The friendships and contacts that they subsequently made led on to many other experiences in later years, as well as providing the inspiration and material for many paintings.

Rodger and Cecilia were married on 12 May 1984. Furnishing the house and redecoration proceeded slowly as funds allowed and the burden of a mortgage added to the financial requirement of painting and illustrating.

Back at work again Rodger conceived the idea of a book of paintings and sketches of field sports and various birds and animals, along the lines of the books by Rien Poortvliet, whose work he so much admired. This would involve a massive amount of work, of course, stockpiling these pictures for the book between painting commissions and other work for the gallery to sell. The book was to be his successful and much acclaimed *Open Season*.

but found the experience worthwhile and enjoyed the coursing meeting, largely because he was able to spend most of the time with the 'slipper' – the man who releases the greyhounds – and so not only had a good view, but more importantly an explanation of what was happening. It was a fine day in lovely countryside and there were lots of hares. The trip was worthwhile and a valuable experience.

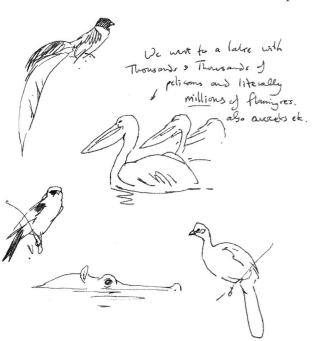

We went to a lake with Thousands & Thousands of pelicans and literally millions of flamingoes. also avocets etc.

With spring, the first lambs appeared in the field outside the room that Rodger used as a studio, and birds started to sing. A pair of bullfinches visited the hawthorn bush outside the window for several days, gobbling up the buds, and giving him a great chance to sketch them. Unfortunately another print edition produced by the gallery, showing various shooting scenes, turned out to be rather a flop and few sold, and so he learned that not all his work was guaranteed to be successful commercially. However, he had more posters to prepare for contacts in Africa, including one of Kenyan birds of prey. In the meantime he was still working hard on pictures for the proposed book.

In order to cover a wide range of field sports as subject matter for the book, Rodger had to widen his experience to include some pursuits of which he knew little. This included a trip to see hare coursing in Hampshire. He was not greatly enthusiastic before going,

Rodger's next important commission was a painting for the label of the 'Famous Grouse' whisky. Later this extended to other paintings for the firm, and Rodger enjoyed seeing his work on huge advertising hoardings in London and elsewhere.

Not all commissions are successful financially. Book illustration is badly paid anyway, but Rodger had the misfortune to produce some illustrations for a book on stalking only to find that the publisher did not like the text that had been written by another person. The publisher would not pay until a new author was found. On another occasion he painted twelve pictures for plate decorations and the man producing the plates disappeared without paying royalty money due. Moreover the original paintings later appeared in a sale-room, with Rodger receiving none of the proceeds. Fortunately he is fairly resilient, as all artists have to be, since success is by no means as easy to achieve as sometimes it might appear to others.

On the brighter side, he realised a lifelong ambition by diving down to swim amongst salmon and sea-trout. He swam with a friend who owned a stretch of a river in Lancashire. He found the experience fascinating and discovered that if he moved slowly he could actually touch the fish. His friend dived down and came up with a 3-lb sea-trout. Then he said to Rodger, 'Hand me the fly (attached to a rod) there's a big salmon under this rock – about 18 lb.' To Rodger's amazement he went down and stuck the fly in its mouth! It dashed off downstream into a big deep pool and Rodger gave his friend the rod and while he went in and watched the fight from under water! The salmon escaped after a while, but they were not concerned because the episode had served its purpose.

Subsequent paintings of fish seen under water have been painted as a result of experience and not merely imagination.

A book by the famous P. G. Wodehouse, *Sir Agravaine,* reprinted by Blandford Press, came out at that time, illustrated with superb full page cartoon paintings by Rodger. He thought that it looked good, if rather thin for £5. A disappointment was that the *Shooting Times* decided that it would not join the gallery in financing Rodger's own proposed book. He began to get the feeling that everyone was getting cold feet about the project into which he had already put a lot of work. Fortunately at that point Swan Hill Press saw the potential of Rodger's book of field sports paintings and sketches and took over the publication of *Open Season.* Their view was correct and the format that they chose was successful, as were sales.

In wildlife painting attention to detail is important, but as I have said, that does not mean painting every feather of a bird or every petal of a flower. The purpose of a painting is to convey an impression, not to display photographic imagery. However it is important to depict basic detail correctly, such as the relative size of the subject to the environment, and to show a realistic background. This involves showing correct flowers and foliage for the season, and so on. I had mentioned this point to Rodger, and he replied 'I do take your point about correct background flora etc. I hope I am getting slightly better. Work on my book is making me add details of seasonal plants, butterflies etc. I am horribly ignorant about flowers and insects, but getting more and more interested.' This improvement in background detail became noticeable in his paintings.

The demand for commissioned paintings continued to increase each year, and as a result Rodger received invitations to several of the best grouse moors, sometimes to spectate, with a view to painting a scene of a drive, but increasingly often to shoot. There can be no doubt that the excitement generated by participation must somehow be reflected in a subsequent painting of the subject. Fishing invitations came too, including days on some of the finest water of the River Test and other rivers. A shooting and fishing friend who had recently acquired a new house, commissioned a big oil painting of deer, 6 feet by 4½ feet, for a very large room. This was to be the largest oil painting that Rodger had yet tackled and he was rather horrified to discover the cost of the canvas alone for such a size. The finished painting was a very fine one of stags on a hillside. Few artists can paint deer satisfactorily, but Rodger demonstrated in this splendid picture that he is one of those who can.

Another painting commission took him to Lincolnshire and the wolds, where he found lovely rolling country. The purpose of the trip was to paint the scene of a big shoot in which he was not participating. At one drive he saw a most extraordinary thing. As the beaters went into the wood, a dog fox and a vixen came out and ran up the field next to the guns. About 500 yards away they stopped and another dog fox appeared and there was a fight! By this time the drive had started and there was much gunfire. The foxes ignored this completely and one of the dog foxes covered the vixen twice, in full view and sound of the pheasant drive in bright sunlight in the middle of a snowy field.

The main drive of this shoot, the one that Rodger had come to paint, was a spectacle. Two high woods with guns in the valley between. In bright snowy sunlight 800 – 1000 pheasants flooded over the guns, very high and most of them out of shot. Amongst them were several Reeves pheasants, with tails a yard long, and also silver pheasants, dazzling in the sunlight, which must have been a spectacular sight. Of course none of these fancy pheasants were shot, and they were present entirely because the owner regarded them as decorative amongst the ordinary pheasants.

Included amongst the considerable variety of commissions executed by Rodger have been a number of requests for designs for the engraving of the lock plates of guns and rifles. One such completed at this time, was for scenes depicting Persian big game, including ibex, urial sheep and Persian fallow deer, to decorate a double rifle being made for an Iranian prince. Having completed the sketches for the designs he took these to Kenneth Whitehead for his critical appraisal of the animals drawn. He was pleased to receive approval of his work, and discovered that the rifle was being made for a man whom Kenneth knew.

Rodger has painted a large number of greetings cards for The Paper House Ltd over the years. The versatility and humour in these demonstrates his extraordinary talent. Some cards are humorous or

slightly naughty cartoons, and yet others are remarkable animal caricatures depicting mice and other creatures in enchanting situations. For the latter he uses the pseudonym of Cecilia with her maiden name. These cards demonstrate Rodger's spontaneous humour, his skill with a brush and his keen observation of the subjects.

Between commissions and creating pictures for his own book, Rodger worked on illustrations for other books too, and this time he was completing black-and-white illustrations for a third book by Norman Mursell, a retired head keeper from the estate of the Duke of Westminster, having already illustrated the previous books. The three were *Come Dawn Come Dusk, Green and Pleasant Land,* and *The Forgotten Skills* published in 1981, 1983, and 1985 respectively.

Paintings, book illustrations, greetings cards, cartoons, brochure drawings, and even candle-shades were all grist to Rodger's mill. The Duchess of Westminster had telephoned him to ask that he go over to Abbeystead on Good Friday to look at some little candle-shades with a view to drawing grouse on them.

The north of Scotland fishing trip had become a regular event and happily Cecilia became indoctrinated into fishing too. Late spring 1985 saw Cecilia catch her first salmon on the Findhorn river. There were only four caught all week but they had bad luck and lost several. Rodger lost a big one and told me, to my embarrassment, that a strange prawn imitation that I had given to him, and with which he had used to hook the fish, had maddeningly broken off at the hook-bend when he had almost had the fish beaten and on its side. It was at least 15 lb. Cecilia's fish, caught on a fly, was 9 lb and very fresh. They found a dipper's nest under a waterfall and ospreys had nested there. Counting bird species seen on these holidays had become a traditional amusement for the McPhails and they tallied 58 species on that trip. The Findhorn river, the birds and the ospreys all became subjects of paintings subsequently.

The prices of Rodger's paintings were still at modest levels then, partly at his own instigation. After all, one can demand huge prices for a picture, but if it is not sold it is actually worthless, whatever the prospective seller may protest. So there is much merit in ensuring the sale of all work, especially when the income from sales is of great immediate importance. Rodger went down to London to visit the Tryon Gallery again to see the exhibition of Robert Bateman paintings and told me that he thought the show was superb! He was filled with admiration for Bateman's work, regarding him as amongst the best living wildlife painters, and remarked that his compositions were stunning. He was able to have a good long talk with the artist and found him to be a very friendly modest man, very eager to impart technique. His prices for paintings were very high of course,

with some up to £40,000. Everything was balloted and sold on the first day. Many other celebrated wildlife artists were present at the private view of the Bateman exhibition and Rodger was able to meet and talk to these, which was a wonderful opportunity. Raymond Ching was there and Keith Shackleton and Peter Scott, and so also was David Attenborough.

Writing later, describing the exhibition and his opportunity of talking to these well known artists, Rodger plaintively asked 'How wealthy these painters must be! I look around me at the bare walls and carpetless floors. Where am I going wrong?' He was impatient of course, since he was considerably younger than these other artists, and his skill had yet to be more widely recognised. In my view, he differs from these others, in the wide range of his work, which covers such an amazing variety of subjects, not only in the field of wildlife and sporting pictures.

His increasing success carried with it the disadvantage of pressure of work. With household bills and mortgage commitments to meet he had to accept and execute as many of the commissions that he was offered as he could. At the same time he had to continue stockpiling work for his proposed book, for which payment was still well in the future. So when a friend who owned a stretch of a famous salmon river in Norway telephoned to ask Cecilia and himself over to join him for a week and reported that the river was then fishing well and even offered to pay their fares, they were desolated at having to refuse the invitation. They simply could not go because of deadlines to meet.

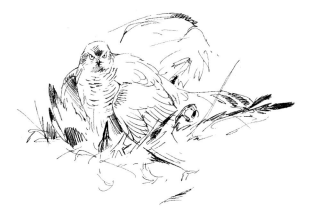

The deadlines referred to included pictures for the Tryon Gallery to show at the Game Fair and some for a local exhibition, plus the commissions. One of the latter resulted from a painting featured on the cover of the *Shooting Times*. We had introduced Rodger some years earlier to the late Alan Hamilton, who wanted someone to paint a hare coursing scene, or somesuch, and had asked my wife Diana. She had suggested Rodger. They subsequently became

friends, fishing together in a tiny stream and so on. Alan was a keen shooter, stalker, fisherman, and indeed enthusiastic about anything to do with the countryside. His daughter was married to the son of the Prime Minister at the time, Harold Macmillan, who was to become the Earl of Stockton on his father's death. Through this connection Rodger obtained a commission to paint four generations of Macmillans on a shoot together. He also painted a picture of Alan Hamilton sitting in an armchair in front of the fire, dram in hand, dreaming of the various animals and birds depicted skilfully around him. This painting was in a McPhail exhibition at the Tryon Gallery, and happily seen there by both Alan and his wife Liv, just before both died. The painting was acquired by their son-in-law. It was also seen by a wealthy American, who then commissioned a similar, but bigger, type of painting of himself, dreaming about big game in much the same way, but of Indian big game, including a tiger and a peacock etc. This in turn was later seen by a fellow American friend of his, who immediately wanted a large painting of himself, this time showing lions, buffaloes, leopards and other African big game.

Rodger managed to complete all these pictures on time and was fairly pleased with what he had painted: three for the Game Fair, two for the SWLA exhibition at Martin Mere, and several other small commissions, as well as the big composite picture of the American dream of all the big game hunting experiences.

As well as concerns about financial matters, including completing decoration and furnishing of the house, Rodger had the further distressful knowledge that his mother had developed cancer. They were due to go off on holiday, with two days at the Game Fair, and then a week's fishing on the Brora. All this depended upon his mother's health. She had been diagnosed as inoperable. Rodger commented that she was being amazingly brave, still getting about and going shopping despite being so thin and frail (6 stone), and with the knowledge that she might very suddenly deteriorate. He was amazed that she could be so brave and calm, knowing that she would never see another summer or see her grandchildren grow up. Perhaps this was partly due to her strong religious faith, he felt. Sadly his mother died shortly afterwards, two days before Rodger's sister was due to be married. The wedding was postponed as a result.

Some time later another trip to Spain for partridge shooting was planned and he wrote to tell us of it. 'The Italian count came yesterday with his son, and another high-powered Italian and a Frenchman,' he wrote. 'They had all been everywhere, know everybody and have shot everything from snipe to elephants. They seemed very pleasant and it was quite a jolly lunch. I'm going out to Spain for a few days in October to paint them shooting partridges.' The Spanish partridge shooting trip was an enjoyable experience because

although Rodger was not expecting to shoot, he was given the opportunity to participate during a couple of the drives each day. He shot well and doubtless this contributed to his success with the hosts, amongst whom were a member of the Italian Cinzano family, Cartier the French jeweller, Nestlé of chocolate fame and Eric Rothschild who makes Château Lafite. On this occasion they were not as far south in Spain as he had been previously and the wildlife was not as varied or numerous, but he noted whinchats, black redstarts, Sardinian warblers (which he identified later in England), little bustards and a ring ouzel.

The variety of the work continued. As well as painting partridge shooting scenes in Spain, he illustrated a splendid poem by Christopher Curtis in cartoon form, entitled *The Country Seat*. Then the task was more drawings portraying British field sports for engraving on the lock plates of a set of guns being made by Holland & Holland.

Next, a trip to America to paint some commissioned work was arranged for three weeks in the coming winter, with another trip in the following May to go big game hunting in Botswana with the wealthy American for whom he had painted the big game scene. He had loved his painting so much that he had paid Rodger more than he had asked for it. The amount was the most that Rodger had ever been paid for a picture at that time.

In 1985 Rodger attended the parties held by Aylmer Tryon to launch his new little book, *Kingfisher Mill,* as well as an exhibition for the sale of the original drawings, which contributed greatly to the book. There were two parties, one at the gallery and one at Aylmer's house. Rodger and Cecilia enjoyed both and Rodger drew small sketches in everyone's books, including a drunken elephant in David Shepherd's and a dilapidated horse in Sue Crawford's. The original illustrations sold surprisingly well for monochromes as he was pleased to discover.

With only three more weeks to finish *Open Season* before the trip to America, they had to turn down another wonderful invitation for two days' salmon fishing on the Tweed. It had been arranged that Tony Jackson of the *Shooting Times* would write the text for the book. Rodger did not feel that the publishers would have been impressed with his own literary efforts.

A particularly unusual commission intrigued Rodger. A friend was shooting grouse near Tomintoul and winged one which fell nearby, closely followed by a peregrine. The wounded grouse attacked the peregrine with great fury and drove it off! The chap sent his dog in and it too was driven off by the grouse. He felt sorry to kill such a brave bird. As a result of this unusual episode he asked Rodger to paint a scene reminiscent of the incident. Of course it is impossible

for an artist, unable to witness the scene, to reproduce precisely what occurred, but Rodger did his best, and the result proved acceptable.

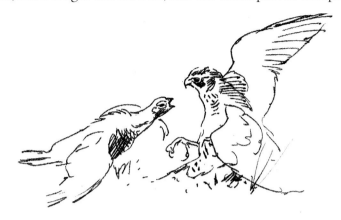

1986 started with shooting again, and some sadness. He received commissions for portrait painting from time to time – his talent in this type of painting is not as widely recognised as it deserves. He had been invited to a pheasant shoot in Staffordshire and had gone down with the intention of painting his friend Francis Fitzherbert's father. Unfortunately he died during the night (making Francis Earl of Stafford). In spite of this they carried on with the arrangements of the shoot. To begin the day they drove ducks off a big pond surrounded by trees followed by two or three minutes of hectic shooting. Rodger observed that the ducks looked magnificent, lit from below by light reflected by the snow. When he returned home that evening he found that his uncle, who lived half-a-mile away from them, had died too. So it was a sad day, both men being only in their mid-fifties.

Rodger wrote to me after their trip to America.

'The American trip was very interesting. Most of our time was spent in Washington or New York. (Don't ever feel tempted to visit New York, Ian, I don't think it's your sort of place.) We spent some time in Virginia in the fox hunting town of Middleburg. The fox hunting is largely artificial and they consider it a disaster if the fox is caught. The whole town is restaurants and antique shops and nothing can be found that does not have a picture of a fox on it! I was forbidden to go wandering in the woods because the deer shooting season had started and four people had been killed already in that district. How many people get killed, wounded and missed in the whole of the USA? We passed, on the main road, a mile or so of national woodland that had 70 – 100 cars parked nose to tail and dozens of orange-hatted men strolling about, squinting down the sights of their rifles. A nightmare! Deer shooting seems to be a slightly second-class sport there. My hosts seemed slightly surprised when I asked to try for one. I sat

up a tree for a couple of evenings but only saw does. The bird life is interesting, blue jays, cardinals, vultures etc. We went on a raccoon hunt one night with a local hill-billy type character – a retired army vet who hunts bear with a bow and arrow. He had some magnificent 'coon hounds – a sort of cross between a fox/bloodhound, lovely long ears and lovely voices when they got scent of a 'coon – like something out of the *Hound of the Baskervilles*. We chased through the pitch-black rainy woodlands following these hounds and eventually they "treed" a raccoon. For a long time we couldn't see it, then our friend pointed out its ear in the torchlight poking out of a bunch of leaves like a squirrels' drey. I shot it with a .22 and skinned it. Couldn't bring the skin back to England of course because of rabies. They are lovely animals, with hands like a monkey and beautiful soft feet.'

This great attention to, and appreciation of, detail is characteristic of Rodger. On the occasion when he shot his first pheasants, I drove three cocks off stubble over him one sunny autumn afternoon and he shot the three perfectly, one after the other. I was not allowed to pick them up by the necks in conventional manner, and we had to carry them back to the house carefully by their feet to avoid ruffling the feathers of the lovely birds. When we arrived he examined the birds in detail. Since then, of course, he has had countless opportunities to familiarise himself thoroughly with the differing aspects of their flight, hence his outstanding ability to capture the excitement of a pheasant being flushed or the midst of a drive.

It is this ability to capture in a painting the impression of the thrill of the moment that sets Rodger's work apart from so many other pictures, be it a pheasant seen through the eyes of a shooter, a deer seen at the final moment after a careful stalk, the strike at a trout rising to a fly, or the discovery of a woodcock crouched amongst the fallen leaves. In my opinion many wildlife pictures are little more than studies of bird or animal, detailed and beautifully drawn but failing to convey to the viewer the impression of life. 'Bird-on-a-branch' pictures I call them; they tell no story.

Rodger inherited his father's fiddle and often played for his own amusement, somewhat after the 'Sherlock Holmes' fashion. His musical talents have apparently been passed on to, and exceeded by, his eldest son Gavin, who has already started to play in an ensemble, to the delight of his parents. The flow of painting commissions permitted little time for developing his own musical talent however. Abercrombie & Kent, the travel agents, had requested an illustrated version of 'The Owl and the Pussy Cat' which they wished to have printed and given to their honeymoon couples. Then the Queen asked him to paint two big watercolours of a woodcock and a partridge to give to the King of Spain on his state visit in the summer.

There was also a long oil painting of grouse shooting requested for an American and the whisky company Famous Grouse asked him to paint yet another advertisement for them. The next one-man exhibition at the Tryon Gallery had been arranged for the end of June shortly after his return from the trip to Botswana and Okavango. Rodger decided to borrow the huge oil painting of stags, which he had created for his friend's new house, and show this at the exhibition.

One of the many visitors to the 'Briars Brow' house was the well-known South African photographer Peter Johnson, who came with his wife to see the McPhails. The purpose of the visit was to interview Rodger and to take photographs of the artist at work for a book that he was producing called *The World of Shooting*, which was to be full of his photographs taken all over the world. One section was to be on painters, and for these he had chosen Jack Cowan for America, Rien Poortvliet for the continent and Rodger McPhail for Britain! Rodger was very flattered. Another accolade accorded to him was to be made an honorary life member of The British Field Sports Society, a result of designing their Christmas card for that year.

His book *Open Season* was a great success and has been reprinted several times. The original pictures for the book formed part of his exhibition at the Tryon Gallery, which was highly successful. Rodger wrote to me 'I am pleased that you like *Open Season*. As you know, I value your opinion more than anyone else's, as most people either 'ooh and ahh' no matter what they think, or don't really know what they are talking about. Just a note to tell you how the exhibition went – terrific! We sold nearly everything on the first day, including a lot of unframed stuff that I thought no one would want. Over 100 paintings in all! We had a good party afterwards.'

In early 1988 Rodger and Cecilia decided to move house. They had started a family when their first son Gavin was born on 10 August 1987. They decided to put their house on the market and then rent accommodation whilst looking for another house. Unfortunately, at that time the housing market was a difficult one and selling property was not easy.

His publisher (Swan Hill Press) was keen to have a follow-up book to be called *Fishing Season*, and Rodger agreed to this, which meant once again turning thoughts to stockpiling a large number of paintings and drawings to illustrate this book. However, as a result of the first book's receipts and the sale of the paintings and drawings from this, the McPhail finances started to improve sufficiently to encourage the prospect of taking on the responsibility of a better house. Rodger wrote 'At this rate we can send Gavin to a good school and have him clean baths with a razor blade! (This was a jocular reference to my relating that in my days at Winchester the tin hip-baths were cleaned once a term, or less, by some malingering boy as a punishment, scraping the grease from them with an old razor blade.) PS. I'll be doing an ad for Jaguar cars!'

On one of his regular visits to stay with us at 'Shannel', Rodger had shown my wife Diana an American magazine specialising in wildlife art. Later he wrote to us ' . . . has shown me more of the *Wildlife Art News* magazines. Big business over there (America) isn't it. Most of it is rubbish and Bateman copies. I wish they didn't all feel compelled to make these pretentious arty-farty comments about their work. Paintings should speak for themselves.' This comment expresses much the same sentiment as the view that I continually express, which is that the difference between a painting and a photograph is that the latter captures an instant, whereas a painting or drawing should convey an impression, or tell a story. Bruno Liljefors, 'The Master', whose oil paintings in an exhibition in Holland captivated me as few paintings have ever done, conveyed the impression of exactness; but close examination revealed no minute detail. I wished that Rodger could have been with us to see these astonishing paintings by that artist whom both Rodger and Rien Poortvliet regarded as the foremost of all wildlife painters.

I recall a painting of oystercatchers in one of our hayfields that Rodger made and kindly gave us on one visit. A couple of days after he had painted it we were returning home when two oystercatchers rose from the roadside in front of the vehicle. 'I've got the white on one of those oystercatchers wrong' said Rodger, and when we got home he altered it. Later he painted a similar picture for his exhibition. We were all amused when the purchaser of the painting at the exhibition asked for the eyes of the oystercatchers to be painted in. Rodger did this for them of course, but we were amused because one cannot see the eyes of an oystercatcher at fifty yards' distance.

Later Rodger was asked to exhibit at the Game – Coin conference in Texas. He had been asked to their previous one two years earlier but unfortunately was just too busy. This time they agreed to go. Other exhibitors included Americans Jack Cowan and Guy Coleach, and from Britain David Shepherd, so Rodger felt flattered to be asked to exhibit with them.

The following year another annual summer trip to the rivers Brora and Findhorn for fishing was arranged.

'The Brora was lovely but too low to fish. It was so low I foul-hooked a salmon on a trout rod when I was after sea-trout. What a battle! I very nearly got it after about 20 minutes, but the fly came out when it rolled over (it was hooked in the pectoral fin). We saw redstarts, merlins, ospreys etc. Saw a new bird for me – crossbills. The ospreys nested on one of the pools and we got good views of them bringing

in fish. They had a record week on the Findhorn, 33 fish! I'm ashamed to say I only caught one, but Cecilia caught three to save the McPhail name. Now she wants her own rod and tackle. One of Cecilia's fish was caught in a slow smooth run. I was up on a bank above watching the fly come across, so I clearly saw the salmon looming out of the depth to take the fly – very exciting (12 pounds). We had to dash back to see a Jersey bull that I have to paint in Staffordshire.'

Autumn 1986 brought Rodger a trip to Italy to hunt chamois.

'The chamois hunting trip was fantastic. Two days stalking on Mont Blanc – or Monte Bianco – we were on the Italian side. The scenery was magnificent, quite the most beautiful I have ever seen. Great cathedral-like peaks – mighty glaciers and terrifying chasms. Sometimes we were stalking along places where a lost footing would have meant certain death. I shot a chamois and it was certainly well earned; good job I was fairly fit after Jura [where he was stalking red deer]. We had to take very long shots – my chammy was about 300 yards away across a chasm. We also saw marmots, a sort of big fat cat-sized squirrel, Alpine accentors and Alpine choughs – a most un-crowlike corvid, more like a blackbird. I thought I saw a wall creeper, but couldn't be sure. I heard woodpeckers but didn't see them. Presumably these were the great black woodpeckers.'

The McPhails had failed to find a buyer for their house for many months, owing to difficulties in the housing market and Rodger wrote again from there later, shortly before they finally made a sale and were able to move.

'The most exciting thing happened two weeks ago. I was walking through Wheelton and saw what I thought was a sparrowhawk being mobbed by birds. It came right over my head 40 yards up and I saw to my amazement that the mobbing birds were rooks and the "sparrow-hawk" was bigger than them! A goshawk in Wheelton! I've not seen it since. Falconers have since told me that they breed fairly frequently in Britain now and several pairs are in North Lancashire.'

Not all the painting is easy, and not every result of effort spent at the drawing board or easel meets the satisfaction of the artist. Indeed, it is perhaps something of a comfort to those interested in art, especially other artists, to know that even talented exponents have

what they consider to be 'off days'. 'I ruined everything I did today.' Rodger wrote to us. 'The 6th attempt at a punt-gunning commission. I was speechless with rage. One more day's work before we go south and I won't get much done then, as I have promised to cook a meal for our wedding anniversary and it takes me all day.'

Through 1989 Rodger worked on pictures for the follow-up book *Fishing Season*, in between commissions and trips here and there, shooting and fishing, many of which trips not only provided material for painting but also produced further commissions. The McPhails finally managed to sell 'Catspiss Towers', the house at Wheelton, and rented a cottage near Garstang whilst they continued to look for a house to buy. Furthermore their commitments grew!

'Our main news is that Cecilia is pregnant again, baby due in May. She is feeling pretty sick but should be past that stage soon. Gavin broke his leg and is stumping around with a full plaster. It's not a bad break and he doesn't seem to mind very much. He's very tough. . . . We had two fishing holidays on the Findhorn. . . . One day I was by a spectacular pool in the deep gorge and hearing mighty wingbeats looked up to see a cock caper being chased, or rather followed, by a peregrine! It seems such a corny, unlikely thing to see that I've not told anyone about it. I certainly won't paint it, no-one would believe it! . . . Still got 7 more pages to do of the book. It has taken me a lot longer than I thought . . . An Indian prince came to lunch recently. Prince Sat he's called. Got a great long flowing beard that he ties up with an elastic band when he eats. He was very friendly. A great enthusiast about wildlife and painting.'

Rodger and Cecilia moved into their rented house, 'Ashtree Cottage', in October 1988 and stayed there until October 1990, whilst they continued their search for a house that they liked and could afford. There was a great deal more bird life around their new accommodation.

'A sparrowhawk took a bird off the bird-feeder yesterday. I think I have now seen over a dozen sparrowhawk kills or attacks. A lot of chukor partridges have appeared round the house. Very tame. Someone must have put them down for shooting.

The baby is due any minute. I will telephone you when the baby turns up and let you know events. I swung a ring on a thread over the bump and it registered a boy. Apparently Tunnicliffe used the ring method for sexing birds for his measured drawings, later dissecting them to find out, and he was never wrong. The only variation was male duck in eclipse, they apparently register as females. I got all the proofs of my fishing book. It looks quite good. Should have some

finished copies in three weeks. I'll send one as soon as they arrive. . . . There was a partridge calling from the chimney stack today.'

The baby arrived on 7 May 1990: Alastair, a little boy. This naturally involved Rodger in additional family and household pre-occupations, together with the search for a house, but his work continued and he still managed to plan another short trip to America. He wrote to us later:

'My commission to paint at 'Mar Lodge' in August has been post-poned – Mrs Kluge has been divorced. The Saatchi job is a one-off back-lit advertisement for Famous Grouse for Edinburgh airport, 15ft by 1½ ft. My new toy arrived last week from America – a hunting bow! It is wonderful. Very powerful and accurate – I'm off to Texas in October to try for a whitetail deer and a turkey. I can hit an apple at 20 yd, but am less accurate at 30. You have to be very close to your victim, it must be very exciting. I have a fishing attachment too. Can I come and harpoon one of your rainbows? The hunting arrows have terrifying razor sharp heads and apparently go right through a deer and out the other side. We had a quail here last week. It was calling in the young corn opposite the house. I tried to flush it, but it wouldn't get up. Only stayed one night. That makes 57 varieties (like Heinz) of birds seen or heard from this house.'

The house hunting finally produced results in late summer 1990 when Rodger and Cecilia found and purchased the house they wanted in Arkholme, Lancashire. The garage was to be converted into a proper self-contained studio for Rodger. All this took time and they finally moved into 'Thorneys' in October 1990.

'The studio warming party is this Saturday, but the studio won't be finished in time. We have 40 or 50 people coming to it. (4 days later – forgot to post this letter) The studio party was very noisy as there were no carpets down and the echoes were deafening. There was to be a Belgian party there, but during the morning one of them came and said they couldn't make it and gave me a huge bottle of champagne, I could hardly carry it. It got the party off to a flying start.

We have seen 40 different birds from the house since we came here. Should get another 6 or 10 when the summer migrants start to arrive. Just getting to the end of my commissions. (Two huge oils to do and a few watercolours). Then I will start on my exhibition work. We went to meet our new bank manager last week to warn him that there will be no income for a year. I put a watercolour of pheasants in the Christies bird sale last week and it went for £5½ thousand in

spite of the recession! . . Alastair is crawling about now and should soon be speaking. Gavin is going to school in September. (He can practically read already.)'

Rodger and Cecilia had recently been to stay with us en route to a fishing trip up north, and they had the children with them. We were astonished that young Gavin, aged three-years-old was able to identify both the birds in paintings on the walls around our living room, and also the live birds on the feeder outside the window.

The fishing trip was an invitation to the River Naver in Sutherland, of which he had been commissioned to make a painting, and the invitation had included taking the whole family and some fishing too. There was a large party there that week and a total of 22 fish were caught. Rodger managed to land two of these but Cecilia was unfortunately unsuccessful. Although they thought this a very successful catch of fish for the week the ghillies were very gloomy about the declining numbers of salmon. One of the ghillies told Rodger that there were adders on the islands of the very beautiful Loch Syre so he rowed Gavin across to look and found one within 5

minutes! A lovely little reddish one. Later they took Gavin to the beach at Bettyhill – his first seaside trip. He came across a bunch of dried bladderwrack seaweed and said 'Look – I've found a tadpole bush'. That described it so perfectly. Out of the mouths of babes and sucklings, Rodger said.

Back home again they discovered that a grey squirrel was building a drey at eye level outside the studio.

'I should shoot it but it is so active and pretty. Also a mother hedgehog and two large babies about in broad daylight. The young ones are delightful and don't roll up if you pick them up. Lots of goldfinches here too, with young, eating our huge dandelion crop. The huge success of the small birds here is, I think, due to locals with

Larsen traps who have made the magpie an endangered species round here. Saw a rarity on the Lune here a few weeks ago – a little ringed plover. . . . We stayed with Aylmer a few weeks ago and saw the most spectacular Mayfly hatch I've ever seen! It was like a snowstorm. The weed rack in front of Aylmer's house had a belt of scum 2 feet thick and 15 feet long that was solid Mayfly! I'm off to America soon for this duck stamp. I have to sign my name 19½ thousand times (but I'm getting paid lots of cash!)'

Unfortunately things were not quite as expected in America. Rodger had to sit in a small room with no windows and sign his name 44 thousand times; more than twice what he had been led to believe. Moreover, the financial aspect of the venture appeared to be much less promising than anticipated.

The Duck Stamp was not the American one, of course, which is big business over there, and the opportunity to paint this is a much coveted honour amongst American wildfowl artists, since it means instant fame and fortune, but was the new British version.

In 1991 the Wildlife Habitat Trust decided to follow the Duck Stamp schemes now operating in a number of countries, including Canada and Australia, New Zealand, Ireland, and Costa Rica, following the success of the American example. Since 1930 the United States Federal Duck Stamp has raised millions of dollars for conservation projects. Each year the stamp, depicting a waterfowl painting by a well-known artist, has to be purchased to validate a hunting licence. Further money is raised by the sale of stamps and prints to collectors. With valuable assistance from Ducks Unlimited Inc. in the USA, the United Kingdom Duck Stamp was launched and Rodger was the first artist to be asked to provide the painting for it.

The consolation for the ordeal of all this signing of his name was a two-day break as a guest of the American organisation 'Ducks Unlimited'. The object was a dove shoot and they flew him down to South Carolina for this. He was not especially impressed with the dove shooting, but was absolutely fascinated by the alligators in the lakes there. They varied in size from quite small babies to 12 foot long specimens, and apparently were numerous. He discovered that these alligators could sometimes be induced to grab a surface plug fishing bait. He managed to hook seven altogether, including a ten-foot specimen, but only managed to land a baby one because they were so strong, and either the hooks eventually came out or straightened, or the line broke. He vowed that if he ever went back there he would take some heavy sea-fishing tackle and a revolver. He also caught some bass.

He enjoyed seeing the wonderful bird life including herons, egrets and ospreys. He watched a hobby stooping repeatedly on a small species of swift and commented that the falcon looked just like a larger version of the swifts. On the first morning he discovered a snake of some sort in the swimming pool of the house where he stayed.

He returned from America to get down to completing a series of watercolour commissions, and also, as he put it, to struggle with oil paintings. One of the commissions was a set of small watercolours to be bound into a book as a present for the Duke of Edinburgh. Family life also took up more of his time, since by then Gavin had started to go to school and young Alastair was already walking.

At long last the studio was completely finished, with a large window facing a small piece of enclosed lawn and a large hedge at the back on one side and some low fruit trees on the other. Rodger puts copious quantities of food on the grass within a few feet of the window and in autumn there is also fallen fruit. More recently he has constructed a tiny pond or bird bath outside the big window. The result is visits by large numbers of birds, from pheasants to bramblings, feeding within a few feet of the window and offering wonderful opportunities for observation and painting from life.

He wrote to me about the completed studio:

'The studio is pure bliss to work in. Still struggling through the oil paints. I've done a 4x3 foot capercaillie, one slightly smaller of French partridges, two small ones of white ducks (yours), one of a sow and piglets, a game cock in a farm court, muscovy ducks, Texas whitetail deer, redshank etc., etc. Sometimes I think I've got it, but the feeling only lasts for a few minutes. Raymond Ching tells me that when it comes, it comes overnight – I'm still waiting! Julian Novorol is coming to stay soon so I can pick his brains.'

The planned bow-hunting trip to Texas came next, followed by an invitation to join a snipe shooting party on the Isle of Lewis. Both trips were very successful. The Texan trip was very interesting – he was able to see a totally new variety of birds and creatures. Huge grasshoppers and butterflies, rattlesnakes, armadillos, cacti, skunks, lizards, raccoons etc., and many new birds all fascinated him. The purpose was to try to hunt both a turkey and a deer with the bow,

but the only turkeys that he saw were from the car. Rodger shot two deer, both does. He found bow hunting very exciting and said that at 20 yards' range you feel that you could almost reach out and touch the deer, and that when the quarry appeared close his heart felt as if it was going to break his ribs.

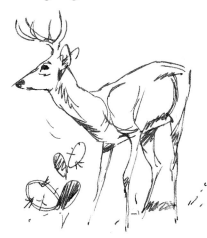

Many parents do not allow their small children into their workplace, but Rodger lets his boys into his studio to draw or amuse themselves, especially when he is looking after them if Cecilia has to go out. Children in a studio are not without risk, however.

'Alastair is going to be an art critic when he grows up. The other week he attacked a near-finished watercolour with a screwdriver and completely ruined it. He will be very lucky to make his teens that boy. Halfway to the exhibition now with 24 pictures. We have had a flock of 30 bramblings in the garden for weeks, but on a recent trip south the bird food ran out and they have deserted us. Lovely birds, I was very sorry to lose them. We have a G. S. woodpecker visiting the nuts outside the studio. A sparrowhawk killed a blackbird in front of the house on Boxing Day. Plucked it before carrying it off. We have just got back from shooting at Middleton (in Hampshire). The first day was for squirrels. Great fun. We poked the dreys out with long poles. Not many squirrels got away but it took a lot of cartridges. We shot 40 but I was assured that if the weather had been hard it would have been 100. Our festive season was the usual hectic round of wild parties.'

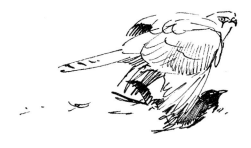

In 1992 the Tryon Gallery had arranged with Rodger to hold his fifth one-man exhibition. The portents were not encouraging because the recession had taken a firm hold and reports were that paintings were not selling at all well.

'I've been working day and night and now have 20 watercolours and 23 oils (aiming for 60, but I don't think I'll make it). Sue Crawford is calling tomorrow, I can show off my latest stuff. A big oil (3×4ft) of an otter chasing salmon is, I think, my best painting to date. I may ask £10,000 for it. . . . Longing for some time off. I can't even go fishing now that the weather is warming up. Such is the pressure of a huge mortgage. If the pictures sell I could cut out a chunk of it. . . . The boys have chicken pox. Alastair looked so repulsive that I was going to make our local MP kiss him when he came round canvassing. Unfortunately Alastair was asleep, so he (the MP) got off the hook!'

Rodger need not have worried about the exhibition, as it subsequently transpired, since almost all the pictures sold at the evening private viewing before the exhibition opened officially. One American telephoned to buy several paintings unseen. The exhibition was the usual outstanding success, despite the recession and general financial gloom in the country.

An example of Rodger's skill with his hands in other ways, and his interest in how some things work, is demonstrated by his brief boomerang craze. He bought one of these at the local Aughton 'Pudding Festival' and found it great fun, having discovered the technique for throwing it. Subsequently he bought three others, slightly different, and then set about making one for himself. It turned out to be as good as, or better than, the bought ones.

The next time that the McPhails came to stay, Rodger brought the boomerangs and we spent an hour or two in a field playing with these amazing instruments. Rodger was quite adept at throwing the boomerang to return close to hand, although actually catching it is more tricky. This craze did not last long. However, the episode illustrates both his enquiring mind and his dexterity. I have also been impressed by the wonderful life-like papier-mâché masks and other toys that he has made for the boys to play with.

The next trip was to Kenya for a week's big game fishing and then a week visiting friends. A planned camel safari had to be cancelled but Rodger was hoping to get a chance at a buffalo on a friend's ranch. He hoped too that he might be going to fulfil a lifelong ambition and fish for bonefish. An American who runs a bonefishing club in the Florida Keys heard that they were going to be in New Orleans in May and invited them down for a few days. They were very excited at the prospect and Rodger said that if he managed to catch a bonefish and get a buffalo he would have to dream up some new ambitions. Both of these ambitions were fulfilled eventually, although on that first bonefishing trip it was Cecilia who caught the bonefish, despite both of them catching other species. His buffalo experience

was to be one that was remarkable and typical of Rodger's extraordinary and exceptional escapades.

The African trip was good fun, but initially fraught with disaster. The film about Anthony Duckworth, with Rodger as a bit-part had to be aborted. First Anthony got malaria about two weeks before they went out, so the film crew had no-one to film. Then they discovered after a month of filming, that the camera was letting light in and they had got nothing. Then the producer/director went down with malaria too! The fishing was no good. Anthony Duckworth caught one sailfish while Rodger was vomiting over the side of the boat with terrible sea-sickness, and apart from a few dorado they caught nothing else and gave up.

The highlight of the holiday without doubt was shooting his first buffalo. Typically this turned out to be the experience of a lifetime. Their friend, Mike Pretejohn, who took Rodger out to try for a buffalo on their previous visit to Kenya, took him up to his son's ranch, 20 minutes flight away, to hunt. They saw the backs of some buffaloes about ½ mile away. These were in-between two elephants and a big herd of zebra in low bush. The zebras moved off without any trouble but they could only see little bits of buffalo as they walked along. Suddenly a big bull stepped into a clear patch about 60 yd off. Rodger fired and hit the buffalo in the neck, but the animal shot off to his right and out of sight. Mike's son, Giles, fired at the animal, since a wounded buffalo is exceptionally dangerous and every effort must be made to stop it. He shouted 'It's coming!' There were buffalo thundering everywhere and elephants screaming. Because of the bush in front of Rodger he could only see the back of the bull as it came at them, but Giles had a clear view and fired again, shooting it in the side of the face. The huge bull came round the side of the bush and stood only 10 yards from Rodger. He put up the rifle and fired at it and, to his horror, there was a loud click. Mike's ancient ammunition had misfired. Luckily for him the bull was blind in its left eye from an old injury, and it stood facing away from him. He quickly chambered another bullet and stepped to one side and shot it behind the ear. The huge bull went down with a thud that made the earth jump. They then realised that they were covered in ants and being badly bitten.

The whole incident could have been very nasty – Mike didn't have a rifle due to some misunderstanding about which gun Rodger would use. It was very, very exciting, he said. The boys who came out to cut it up recognised the animal immediately. It was the biggest bull ever seen on the ranch (46 inch-wide head) and had been terrorising the herdsmen for weeks. Apart from its blind eye, it had a sore foot and its scrotum was red and swollen, so no wonder it was in a bad mood. Mike said that an old bull like that would not suit European tastes but it fed 150 locals that night.

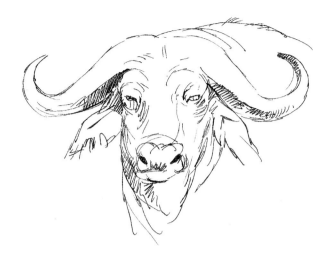

Typically, Rodger had no idea of the type or calibre of the rifle that he used to shoot the buffalo. Apparently he was not allowed a shot beforehand to try it out because his host felt that since Rodger is small and slightly built, the recoil might well alarm him and put him off when the time came to use the weapon on a live target.

They saw a great many species of birds on that holiday, and on one day alone counted over 80 different species.

In 1993 Rodger was asked to illustrate *A Country Naturalist's Year* written by Colin McKelvie, for which the latter had sent him a long list of drawings and paintings required. By then the list of books that he had illustrated was already quite long and varied. In addition to those already mentioned, Rodger had been asked to illustrate a strange book called *Up The Boo-Aye* for Mike Harding, the comedian, in 1980. Four years later he painted the pictures for the re-published version of *Sir Agravaine* by P. G. Woodhouse and also produced illustrations for *Sporting Birds of the British Isles* by Brian Martin. In 1985 he was asked for drawings for *Modern Roe Stalking* by Richard Prior and the following year *Practical Deerstalking* by Kenneth Whitehead. In 1988 Aylmer Tryon produced another small volume entitled *The Quiet Waters By* and Rodger illustrated this too, and then in 1989 Robin Page published a small humorous booklet as a skit on birdwatching for which Rodger produced a series of cartoons.

In 1993, following upon the many pictures for *A Country Naturalist's Year,* he also produced more illustrations for a book called *A Passion for Angling* based upon a BBC television series. More recently, in 1995, he made black-and-white drawings and painted the cover for Richard Prior's monograph *The Roe Deer*, and kindly illustrated my own *A Hill Farmer's Year* with some superb paintings and a large number of sepia drawings. The work for both of these last two books, plus a number of other paintings, including a superb portrait of the first Lady High Sheriff of Lancashire, and a huge oil

painting of, appropriately, *The Artist's Pool on the Findhorn*, composed the 1995 one-man exhibition at the Tryon Gallery. Despite the economy still being in a depression and finances generally tight throughout the country, almost all the pictures on display had sold before the end of the private view. In my view, the painting of *The Artist's Pool*, with a superbly portrayed roebuck standing on the bank and wonderfully depicted water, in an altogether stunning composition, is one of Rodger's finest paintings to date, together with his more recent picture of *Two Gulls on the Shore*, which I found equally captivating. The composition and the wonderful light in the water of the waves and ripples are exceptional, and a fine example of capturing an impressive picture from a simple scene.

One of Rodger's highlights in recent years has been participation in a local community performance of Gilbert and Sullivan operettas, latterly in one of the leading roles. He has always been somewhat of a raconteur and had he not been a painter he might perhaps have ended on the stage. With his interest in and skill at sleight of hand and conjuring tricks, and with some musical talent, he might well have succeeded as a professional entertainer. Naturally he painted some of the scenery too, and for *Ruddigore* he painted life-sized pictures of half-a-dozen of his fellow actors for the scene where ancestors emerge from their portraits. These were a tremendous success on the nights of the performances. Subsequently he gave these portraits to those involved, for a bottle of whisky. One wonders if the recipients appreciated that these pictures done on canvas and in a frame might have sold for four figure sums! He worked until 11.30 p.m. for two nights on the three full portraits and finished these in two days.

The Hornby Occasionals was the group of amateur enthusiasts which he joined. These had been going for many years before Rodger joined them in 1993 with a part in the chorus of *The Gondoliers*. Towards the end of the rehearsals he went on one of his trips to Africa, where he picked up some unidentified bug. On his return home he was suddenly struck down with fever and vomiting, so they packed him off to hospital to discover whether it was malaria or some other tropical disease. They took endless blood samples and infused him with antibiotics. Two days later he felt much better but was furious to have missed the dress rehearsal for *The Gondoliers*. As they showed no signs of letting him out of hospital in spite of the fact that he felt that he had recovered, he discharged himself, fearful

that he would have missed the first night. The doctors never did put a name to the illness after all their tests. He felt rather weak and wobbly for the first two performances of the four, but was delighted not to miss them and enjoyed the whole effort. His hope was that he might get a principal role in the production the next year.

The following year, 1994, this ambition was fulfilled and he got his first main part, as Sir Ruthven Murgatroyd, the bad baronet of Ruddigore castle (alias Robin Oakapple). The next year the company performed *HMS Pinafore* and Rodger played the captain. In 1996 they performed *Utopia Ltd* and again Rodger had a leading part, as Scapphio, for which he had to purchase a pair of tap-dancing shoes and learn to dance in them. The latest production was *The Mikado*, for which he painted some superb scenery, particularly for the second act, which was represented by a huge 'willow pattern' plate. Rodger played Ko-ko, the Lord High Executioner, and he diverted from the original script by concocting his own 'little list'. In this role he demonstrated a strong Lancashire accent, unlike *Ruddigore*, where he actually had elocution lessons from a friend in order to develop a posh accent to sound like a baronet.

I was always amused, and perhaps impressed, that in speaking to or corresponding with Rodger it was clear to me that he attached more importance to his role in these Gilbert and Sullivan local productions than the sale of some expensive painting or the receipt of some impressive commission. This is typical of Rodger.

After *The Mikado* performances he received a telephone call purporting to be from a theatrical agent who had seen him on stage and wanted him to join a Gilbert and Sullivan touring company. Rodger was greatly flattered but declined because he was just too busy with commissions for painting. At that point Gavin mentioned to him the date. It was April 1st! The caller was a cousin of Cecilia!

Rodger agreed to do a stint at the SWAN (Society of Wildlife Art for the Nation) permanent exhibition in Gloucestershire on several occasions. This involved going down to stay there for a couple of days and work on view as the current resident artist. Shortly after one visit there he wrote to us 'Down in Glos. I watched a thrush out of my bedroom window have a mammoth struggle to get a big worm out of the lawn. When it finally succeeded a moorhen dashed

over and pinched it! Watched two mini-buns, not much bigger than cricket balls, copulating on the lawn yesterday!'

The Society for Wildlife Art for the Nation is a registered charity set up in the early 1990s. It owns Nature In Art, which is a permanent exhibition of its collection at Wallsworth Hall, Twigworth, Gloucestershire. It is a member of the Museums Association and other similar bodies, and aims to operate as a centre for international wildlife art of all kinds, of a high standard, encompassing not only conventional painting, sculpture, and so on, but also oriental work, ancient mosaic, abstract interpretations, glass engraving, origami, and other art forms. As well as the comprehensive collection of wildlife art of all these kinds on view, a feature is the regular artist in residence, where visitors have the opportunity of watching a well-known artist at work. The list of invited artists, who may be in residence for a couple of days to a week at a time, covers a wide range of art types and some of the artists conduct courses at Wallsworth Hall.

A visit to Florida Keys in the hope of catching a bonefish, reputed to be one of the toughest fighters of all fish caught on rod and line, filled both Rodger and Cecilia with anticipation. The experience subsequently filled both of them with the enthusiasm to try again.

'This sort of fishing on the "Flats" is fascinating. Just like marine chalk streams. You cast to fish that you can see in the very shallow water. I didn't catch a bonefish but Cecilia did (6½ pounds). She says it was 3 or 4 times stronger than a salmon of similar weight. We caught small sharks, barracudas and other fish. Caught several 6 pound bonnet sharks – like a little hammerhead. They fight very well. All fish put back. Cast to tarpon bigger than me with a single-handed trout rod. Couldn't get them to take. These tarpon and bonefish are very spooky. I've decided I've got to go back – I loved it. Also lots of bird life. Ospreys abound, pelicans, frigate birds, mocking birds, night-hawks, all sorts of herons etc. The frigate birds are gorgeous things with a huge wingspan. Their feathers are not waterproof so if they land on the sea they drown. They pick the fish off the surface or rob other birds like a skua. There were manatees in the area but I didn't see one. Watched a pelican diving for little fish. Every move followed by a tern. Each time the pelican settled on the water the tern landed

on its head and tried to steal the fish out of its beak. The bonefish – ocean dynamite – are like big silver gudgeon, almost circular in cross-section – solid muscle.

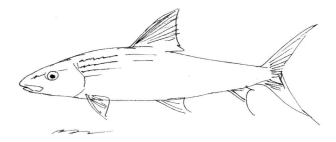

We came home to summer. All the mayflower gone and head-high grass. A cluster of baby tree creepers clinging to the wall. Young birds everywhere, eaves full of House martins' nests. Had a day on the Tyne with Ralph Percy yesterday and got a nice fresh 10-pounder in spite of low water and bright sunshine. Nose to the grindstone now. Got a nice stuffed rattlesnake in the old market in New Orleans.'

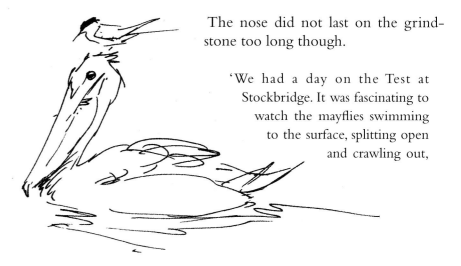

The nose did not last on the grindstone too long though.

'We had a day on the Test at Stockbridge. It was fascinating to watch the mayflies swimming to the surface, splitting open and crawling out, unfolding and flying off. The whole process sometimes takes less than a minute. I am very excited about the Icelandic trip – end of this month. The bird life is supposed to be wonderful. I am so swamped with work that I have had to stop all commissions. Nearly finished the huge oil of an osprey taking a fish.'

For all the fishing and other trips, Rodger works hard and seriously in his studio and often, like many serious artists, it is almost a nine to five work routine – indeed very often he works substantially longer hours than this, often late into the night. On a number of occasions when staying with us he has been asked by friends of mine if he would do them a small painting. They have offered to pay him there and then. Invariably Rodger declines, saying

that he is on holiday, despite the fact that in an hour he could produce a painting that would delight them, and despite his usually offering to do a painting as a present for us. On one occasion the family had stayed with us over night on the way home from fishing in the Findhorn or Helmsdale and were due to head south again after lunch. Diana announced that lunch would be ready in half an hour. 'I'll do you a painting while we are waiting' said Rodger. 'What would you like?' We had just been talking about wrens, so I suggested a wren. We went over to Diana's studio and coincidentally there was a little wren sitting on a fence post outside the window. It conveniently stayed there for several minutes, flitting from post to stone, hunting insects; not that Rodger needed a model. He sat down at Diana's table and young Gavin sat beside him drawing animals on a sheet of paper. I had often watched Rodger painting previously of course, but on this occasion I thought that it would be fun to photo-graph the painting in stages with a view to pasting the prints on the back of the picture in due course. The lovely little picture was completed by the time lunch was ready.

One of the painting presents that he generously gave us, years ago and before he was married, stands out in my mind. He had been staying with the late Lord Astor at Tillypronie, his Aberdeenshire estate, quite close to 'Shannel', our farm, and had then come on to stay a few days with us. He had been watching, but not participating in, grouse driving on the Astor moor and had been commissioned to paint several pictures. On the evening that he arrived we went up to my little flight pond to try for a duck. Next day it was raining, and Rodger retired to the little portacabin that we call 'the doghouse', at one time used as my farm office. At that time it was Diana's studio and Rodger went out there to do some painting. Later in the morning I went out to take him a cup of tea and found him with Diana's two easels in front of him painting two watercolours at once. One of these was of grouse skimming over heather towards butts and the other was an evening scene over a familiar little pond. I assumed that these were two of the commissions for Lord Astor. This was the first grouse picture that Rodger had painted after actually seeing them thus. It so happened that the previous day I had been shooting driven grouse on a neighbour's moor and so had the picture of the birds fresh in my mind. I told Rodger that he had captured them perfectly. 'What do you want in this other one?' he said. I was surprised. 'These are for you' he said. Delighted, I asked him to put in a couple of mallard dropping into the pond, which he did.

I was amused when quite recently, looking at this grouse painting in our house, he commented that the wings were too short. Rodger has considerably more recent experience of grouse than myself, particularly since I decided to give up grouse shooting about ten years ago. In fact I disagree with him in this criticism, except perhaps in the case of one bird with blurred wings. At the time, I had a clear picture of grouse heading towards the butt fresh in my mind, and I considered then, and now, that he captured the impression perfectly, and that his self-criticism is unwarranted. Nevertheless, once again, such an instance shows his quick eye for recording detail and his confidence, as well as our own frank interchange of opinions.

Punting, the wildfowling variety, was bound to appeal to Rodger, and having told him of my own experiences as a young man he was delighted when an opportunity came for him to find out for himself. He went down to stay with Julian Novorol, a painter of excellent wildfowling pictures and a keen wildfowling man himself, and had two days of punting with him. They got four shots altogether. One of these was a miss, which I know is all too easy with the big punt gun, two small shots and a more successful one at a party of teal. Rodger discovered that shooting with a punt gun is very much more difficult than one might think and the approach to take a shot can be arduous, extremely exciting and offers the marvellous opportunity for very close, often eye-level, views of various shore birds.

David Bigham ran the Tryon Gallery with Aylmer for a good many years and when Aylmer retired he took over in conjunction with others, until his own retirement in 1997. Consequently Rodger has known David for many years. He kindly invited the whole McPhail family over to Ireland for a holiday one recent summer. Rodger described the holiday to us later and his frustrating fishing disaster.

'Have I told you about Ireland? We had a wonderful time. David Bigham's place – Dereen, in Kerry, is very beautiful indeed, with magnificent gardens and surrounding countryside. The coast is wild and rocky. We went sea fishing and sailing, caught shrimps and prawns, walked along the beaches, fished for salmon and sea-trout in the tiny river, and generally had a lovely time. The only drawback is

getting there – an awful journey. You could get to South Africa quicker! The only salmon hooked in the tiny poached river was by me, on a 3 lb cast on a tiny fly rod – no gaff or net and no-one to help. Amazingly it was actually beaten after a very careful fight, but it was tangled in the mulberry bushes at my feet, there was no beach, just a steep overgrown bank, and eventually the flimsy cast broke! I was lying on my stomach trying to get a finger in its gills. The water was very high, but I leapt into the river as the fish was still on its side and attached to the bush, but I lost it. I have never regretted losing a salmon more as they are very scarce there. It would have been a great triumph to bring home a fish. To make up for that, last night I had had a rotten day with everything ending up in the bin, so I phoned a friend and asked if I could go and fish his bit of the Lune. I got there with half an hour of light left and caught a 15½ pounder. My first Lune fish. Been here two years, but I've been too busy or away or the river has been out of order, so its the first time I have tried.'

Soon after these visits he went down south to meet Chris Yates and Bob James. They are gurus of the coarse fishing world. Yates caught the record British carp, and there was a TV series about them called *A Passion for Angling* made by the superb film-maker Hugh Miles (who also filmed the wonderful television films *Flight of the Condor, Life on Earth, Kingdom of the Icebear* etc.). They all stayed at Hugh Miles' house and Rodger got on with them all very well indeed. The idea was for him to do illustrations for the book, already mentioned, to go with the series. They took him fishing and he caught, or rather they caught for him his first carp, weighing 12½ lb, his first barbel which weighed 7½ lb and several large chubb. He saw water rails, cetti's warblers, a sparrowhawk attack on a flock of starlings and had a very enjoyable and instructive time.

The following year, 1994, Rodger was invited to Patagonia, in the south of Argentina, by Hugh Miles, who was filming there for months, with a view to doing illustrations for a book on the film when it came out. Chile was a long long way away and Rodger had three days of awful travelling. However he felt this was all well worthwhile to see the Andes and local wildlife – llamas, condors, pumas, skunks, foxes, rheas and others. He spent a whole day galloping over the Pampas on a horse and could barely walk for a week as a result.

Rodger regarded it as an honour to be asked by this well-known maker of such wonderful wildlife films to go out to Chile to join him and his assistant Donny McIver. They had been filming, or trying to film, pumas for several years. Rodger was much impressed by the tolerance of cold and boredom shown by these two, waiting for days in awful conditions for the chance of a picture. The little foxes there were very tame and came into camp looking for scraps of food. The scenery was spectacular, and apart from the discomfort of living in a tent for a week, he felt the trip was a wonderful experience. On his return he painted a picture of llamas and another of a puma.

In 1996 Rodger and Cecilia were invited by the photographer Peter Johnson to join a party for a week on a luxurious private train for a journey through southern Africa with stops for bird-shooting forays. The train is hired to parties on a commercial basis and on this trip it had been taken by the gunmaking section of Aspreys, and Rodger and Cecilia were added to the group as guests of the owner. The train started from Victoria Falls and journeyed south to South Africa, stopping each day for the guests to be transported to pre-arranged shooting venues where assorted game birds, francolins and guinea fowl and doves and so, on were driven for them by local people, often womenfolk. The train itself was like a luxury mobile hotel and the holiday was a wonderful experience. On his return Rodger painted a large picture representing memories of the trip and had prints made of this.

When we first met Rodger we were impressed by the small dapper young man who came to stay with us. Years later my wife, Diana, commented to Cecilia how Rodger always looked neat and tidy and she herself agreed that she was aware of this when she first knew him. Another characteristic was his compulsive sketching and doodling. We often stayed sitting at the table after supper was finished, drinking our wine or having a dram, and while we talked Rodger would sit drawing, or rather doodling, filling pieces of paper with innumerable little sketches of an extraordinary variety of subjects that must have crossed his mind, whilst still carrying on the conversation with us. I still have a number of these sheets.

His letters too were full of drawings, often depicting subjects or events more eloquently than words could have conveyed. In the early years he wrote the letters on one side of the paper and filled the backs with drawings, but in recent years, as he became busier and time more at a premium with work and family, the drawings in letters became fewer and restricted to the illustration of particular events or sightings. I believe that in these doodles and drawings his talent is even more evident than in grand, finished hard-worked paintings, for he has the ability to convey perfectly the impression and unmistakeable characteristics of his subject in just the barest minimum of lines.

Being interested in the subject, once as a minor collector of paintings and later with a wife who is a professional wildlife artist, I am conscious of the considerable number of artists there are who paint animals and birds in this country. If one looks through the American magazine *Wildlife Art*, the number of wildlife artists in the USA is astonishing. Of all these, producing great numbers of decorative pictures, only a few would qualify, in my view, as out-standing artists. Through interest in paintings and in the creature sub-jects themselves, one learns to recognise those pictures that are copied from photographs, into which category so many fall. Others are clearly painted from models or dead creatures. I have never much cared for the work of the famous Archibald Thorburn because I have felt that so many of his subjects lack life and do not seem to convey any story, but perhaps this is because one gathers that so much of his work emanated from painting from skins in his south of England studio. However, the most impressive Thorburn work that I have seen was in fact several tiny pencil sketches of partridges. I realised then that Thorburn had this talent, and probably my criticism is based upon the influence on him of so much work as an illustrator.

The late Rien Poortvliet, whose work Rodger so much admires, and whom we both believe to be one of the most outstanding artists of the century, had this skill of conveying perfectly the impression in a few strokes of a pencil or brush. He demonstrated this one day to Diana and myself, and perhaps Rodger was there too, I forget, by kneeling on the floor with a piece of paper and some paint on a finger, and creating a splendid roe deer. Rodger shares this talent; like Rien, he has the wonderful ability to record detail in his head and recall it when required. He also shares with Rien the unusual talent of being able to paint and draw animals and birds, people and landscape as well. Few wildlife artists who paint birds can also paint animals well, and even fewer of these can paint people to a high standard.

I have described how a couple of days after painting a picture of oystercatchers, a glimpse from a car window caused Rodger to note some tiny error in the marking that he had painted. When we were about to discuss illustrations for my book *A Hill Farmer's Year* Rodger said to me 'I'll paint you a picture while we are talking. What do you want?' A little earlier in the day I had commented upon the increase in jays in this area and that recently I had seen several crossing the field in front of the house in the mornings, so I suggested that he painted a jay. We went into Diana's studio and put on a CD of opera, rather loud, and Rodger sat at her table whilst I sat in the chair with the text of the book. He immediately outlined the jay on the paper in pencil and started to paint the background, straight out of his head, whilst we talked. I suggested a list of subjects for illustrations that I had in mind and marked the text as I went through it. Rodger agreed them all and our discussion and Rodger's painting were finished by the time that the CD had come to the end. The jay painting now hangs on our sitting-room wall.

I suppose that it's a matter of one's trade and the concentration of thought on this, but artists seem to remember pictures that they have painted a long time previously – not merely recognising these, but visualising them unseen. I was astonished recently when talking to Rodger and mentioning a couple of his early paintings, that he recalled precisely on which wall of our house these hung. Other notable artists that we have known shared this memory of not only their own work but that of others too. Talking to the late Eric Ennion and Maurice Wilson some years ago at an exhibition of the Society of Wildlife Artists, of which they were leading figures, they both told me that they reckoned that they could recall most wildlife photographs that they had seen and detect these if used in the paintings of others submitted for exhibition.

Until the move to 'Thorneys' and the new studio, Rodger painted only in watercolour. I recall his telling me how much he looked forward to experimenting with oil painting when he had the room to do so, and how he loved the smell of oil paints. I am not competent to comment on the technicalities of oil painting, but on the practical side it has the advantage of allowing the artist to paint substantially larger pictures than in watercolour. This means that a larger studio space is required. Oil painting also has the advantage that one can paint over mistakes, which cannot be done successfully with watercolour. Oil paintings also have the perhaps unjustifiable, but nevertheless factual advantage that they mostly sell for higher prices and it is an inescapable fact that the value of much art is related to size, so that large oil paintings sell for larger sums. Because oil paintings are more adaptable for the artist, I can imagine that working on them can give more satisfaction. In his fine new purpose-built studio at 'Thorneys' Rodger was able to start painting in oils as well as watercolour.

The exception to the limited size of watercolour paintings was a

commission that he received from the owner of the wonderful House of Bruar shopping centre, north of Blair Atholl in Perthshire, who requested two huge watercolours five feet long, plus several smaller pictures, to decorate the premises. The large watercolours showed a cock capercaillie surrounded by his hens in spectacular scenery of a Findhorn gorge, and grouse on a track in the hills. Watercolours of this size present many problems; not least of which is obtaining specially-made paper of this size. Rodger bought huge boards on which to stretch the paper, and painted the background washes with a 6-inch wide decorator's brush. Since watercolours on a very large scale tend to have a rather bland flat look, he mixed some gum arabic with the paint for the foreground. This enriches and intensifies the colour. Once the paintings were finished the problem became that of the framer; mounting board and framing glass of these sizes are not normally obtainable either. However, these problems were overcome and the paintings went on display as planned.

Most paintings of capercaillie, or stuffed birds, show the cock birds with tails fanned upright and wings rigidly stretched at their sides in display posture, but Rodger chose to show the cock in a more normal situation, pointing out that the actual display only takes place at brief periods.

He has explained to me his techniques in both styles of painting. The watercolours are all painted on Saunders hot-pressed water-colour paper, which he soaks and then stretches on board. He starts with a thumbnail sketch of the general idea of the picture and works up from that. His preliminary drawing is done on 'layout' paper. The main birds, animals, people, houses or objects in the proposed painting are then drawn, traced and retraced until he feels that they are right. These are then arranged on the stretched paper and traced down. Much the same basic preparation applies to oil paintings as well. As I know from the experience of watching Rodger work, most birds and animals he can sketch straight out of his head, but of course when painting some commission depicting a specific building or person it is inevitable that reference has to be made to photographs to check detail.

For watercolour paintings Rodger uses very few colours; perhaps only four or five for most pictures. The main subjects of the picture he often protects with masking fluid after drawing these onto the paper, and then proceeds to paint-in the background. The masking fluid dries to a waterproof rubbery skin that can subsequently be peeled off to leave the white paper underneath. The purpose is to avoid the necessity of great care with the background painting to ensure that it does not impinge upon the main subject. Final high-lights in the painting, such as pale bits of grass for instance, are created in opaque egg tempera, because, as he explained to me, pure watercolour is translucent and you cannot paint light on top of dark. Sometimes he will use a coloured pencil to soften edges.

The oil paintings are done on gesso-treated board or canvas. He usually completes the underpainting in acrylic, he has told me, since this dries very quickly and enables him to get on with the painting. With the oils he uses more colours, perhaps eight or ten for most pictures, as some of the pigments are opaque and some translucent.

Once the basic idea of the picture has been decided upon he amasses and studies all the references that he can obtain on that subject. He takes hundreds of photographs for background reference purposes, such as pieces of rock, plants, dead birds, skies and different weather conditions. He also has a library of reference books on birds and animals and so on. It is often necessary to check minute detail, especially, for instance, with the markings of some bird that he may not have seen for a while, or perhaps to ensure that the pale markings on the forehead of a sika deer are in just the correct place to give the animals that fierce frowning expression.

People, apart from formal portraits, are painted from photographs; because of course there is no other way to achieve this if he is commissioned to paint, say, a shoot with the owner or principal subject participating. In such paintings the detail, not only of the people portrayed, but of the background too, has to be accurate. The person commissioning some favourite scene will be familiar with this and will not pleased if some bush is in the wrong place or a tree missing from a familiar background.

Painting from photographs is fraught with snags and as such are usually easily recognised by the experienced eye. A photograph captures a moment of time and, whilst accurate, may convey totally the wrong impression than is required. Animals can get into weird positions, and to paint them thus would often be absurd. As Rodger says, working from photographs presents many pitfalls, the greatest being that one is working from something that is two dimensional and so unless the artist uses (as Rodger put it) guile and trickery – but I would describe it as artistic skill – the resulting painting can look even flatter still. As I have said previously, a painting should convey an impression, tell a little story, and not capture a moment in time. That is the difference between the art of a painter and the skill of a photographer. As Rodger puts it, cameras can distort things or the light may not match the background, and high-speed photography of birds in flight often freezes them in a position that the human eye normally never sees. Photographs should be used as reference, to remind the artist of the subject, but should never be used as a basis for a painting. This is the distinction between art and skill, perhaps, and the reason why the work of some artists stands out from the others.

Another important facet of wildlife art is a knowledge of anatomy. I recall the late Maurice Wilson pointing this out to me twenty-five years ago, and demonstrating by sketching the skeleton of a deer to show which positions of the leg were possible. Other little tips of Maurice's included injecting the eye of a dead animal with water to brighten it again and the use of proportional dividers to ensure the accuracy of sketched records. It is all too easy for an artist to get proportions wrong, especially when under pressure. Diana and I have often commented upon the work of other artists with this fault, where an otherwise excellent drawing of a badger beside a fence suggests a remarkably large badger or an unusually low fence, or a sketch of wolves pursuing a roe, where either the roe was red deer-sized or the wolves only the stature of Shetland collies. Rodger's willingness to deal with game, pluck pheasants, gralloch and butcher deer, and clean and prepare fish, has contributed to his knowledge of the anatomy of these creatures.

Indeed, he has always been enthusiastic to try anything new and learn, whether it be helping me on the farm installing a new gate post or building a new ferret cage or even trying out the experience of riding a horse. Though a suitable size for a jockey, I seem to recall his mentioning once that he nearly had a racehorse run away with him on his first riding attempt, and he has not seemed anxious to repeat the experience on our ponies! One day he kindly offered to help me tattoo the ear of one of my Hereford calves. For some reason the society had been slow in issuing the annual number for the tattoo mark and this calf was well over a month old by then. I anticipated that trying to catch and tattoo it on my own might be problematical. I managed to lasso the calf and Rodger and I fell on the animal and pinned it to the ground. I wound the rope around its legs and asked Rodger to hold it down whilst I got the tattoo pliers and paste ready. Whilst doing this I heard a commotion and saw Rodger valiantly hanging on to the rope, being towed across the field by the calf which had escaped. However, he finally managed to stop and hold the animal after a hundred yards or so and we were able to immobilise the beast and do the necessary marking.

On one visit Rodger told us that he had been visiting a friend who had taught him to dowse for water. I asked him to demonstrate and to teach me. I had read that in fact most people possess the ability to carry out simple dowsing and I had also read that pieces of fencing wire made into rods with a right-angle bend worked as well as wood. So I prepared four pieces of wire and we went out into a field where I had been searching for a drain that had been blocked by cattle trampling the outlet into the ditch. Rodger led the way and I was amazed to see the rods move. I was even more amazed when the same happened to me. Digging revealed that we had indeed found the drain. Rodger told me that when they were building his studio it was necessary to locate the water pipe and he found this by dowsing for it.

I believe that the reason for Rodger receiving abundant invitations to so many interesting ventures and sporting opportunities is not merely his talent and success as an artist, but also his affable companionship and his enviable ability to be at ease with people from all strata of society. He is always a fund of stories and jokes and often a practical joker. His humour is obvious in the many wonderful cartoons depicted in the great variety of greetings cards that he has had published. An instance of his mischievous tricks was the occasion when he was on a fishing holiday where his host was a very keen roe stalker. Rodger concocted a model that resembled a roe buck, using a stuffed head out of the lodge and a cardboard body and partly hid this in bushes. He then excitedly drew the attention of his host to this deer. His host promptly shot it, but was not best pleased when he discovered the joke.

Another occasion was during his Okavango safari. The hunting firm laid on everything in style for their wealthy clients during the safari. One of the team was an excellent native tracker, called Joseph, who was able to detect spoor and tiny signs on the trail and determine animal sizes and species from footprints and droppings with great skill. The food was splendid, prepared by a very competent chef, mostly from fresh game meat. On this occasion they were lunching on *Wiener schnitzel* made from the meat of some antelope. Rodger picked up a piece of this *Wiener schnitzel*, moulded it into an appropriate shape, and very carefully placed it on a clean patch at the bottom of a tree behind him. Shortly afterwards Joseph walked by and Rodger pointed to this and asked Joseph 'What is that?' 'Baboon shit' Joseph replied. Rodger carefully picked up the piece of *Wiener schnitzel* and ate it with relish, to the amusement of the others at the table. Joseph would not speak to him for three days after that!

It has been of great satisfaction to me to observe the impoverished young art student develop over the years through the stages of being a struggling young artist. It is an occupation in which to make a living is far from easy and to finally achieve the success of reasonable financial comfort is difficult. Rodger now has an abundant demand for his work and has become a well-known name, particularly amongst country people, naturalists and sportsmen and sportswoman of many kinds in various parts of the world. This success has not been without the influence of Cecilia, who acts as Rodger's manager in many respects and enables him to enjoy his lovely family. She keeps the household running whilst he pursues his work in the studio or enjoys his many adventures, only some of which she is able to share. How nice it is that she shares his enthusiasm for fishing. I hope that

the boys may follow suit. She handles all the organisation of, alterations to and decoration of the house, arrangements for the schooling of the children and trying to keep Rodger's ever-full appointments diary in order. She copes with the household budget and with frequent entertaining, often at short notice. This has enabled Rodger to carry on with the work of painting and to indulge in his frequent trips away from home. The partnership is a successful one and Rodger is the first to acknowledge his dependence upon Cecilia.

For my part, it has been fun to know Rodger, then Cecilia, and later the boys, and to watch the development of his success over the years thus far. I never cease to be amazed at the great variety of his skills and talent and the amount of work that he achieves; but he does this by working hard for long hours in his studio. It is easy for others to forget that painting for a living is hard work, under pressure to complete commissions it is quite different from the amateur approach when people amuse themselves by painting for relaxation.

Rodger and his family are still comparatively young. His success has been well deserved and they have not been spoiled by this. It is no surprise that the name of McPhail is foremost amongst British wildlife artists and I believe that future generations will regard it thus on an international basis too. This will particularly be so when the remarkable variety of his talent is more widely known.

Sand sculptures at Bracklesham

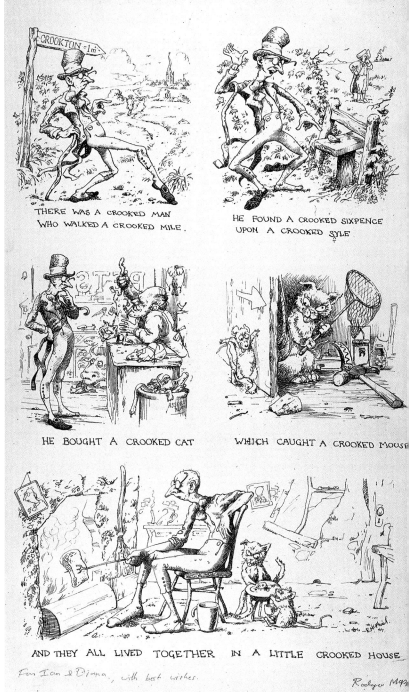

THERE WAS A CROOKED MAN WHO WALKED A CROOKED MILE.

HE FOUND A CROOKED SIXPENCE UPON A CROOKED SYLE

HE BOUGHT A CROOKED CAT

WHICH CAUGHT A CROOKED MOUSE

AND THEY ALL LIVED TOGETHER IN A LITTLE CROOKED HOUSE

For Ian & Diana, with best wishes.

Rodger McP

These are early works done when I was still at art college.

Above: Crooked Man 20″ x 15″ pen & ink

Left: Theseus & The Minotaur 18″ x 14″ water-colour

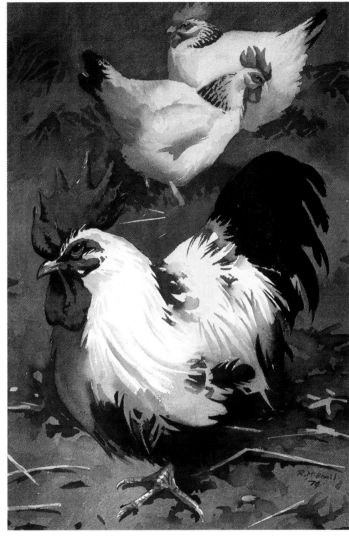

Dorking Cock and Light Sussex Hens
20″ x 15″ water-colour

Dutch Sketches 8″ x 22″ water-colour

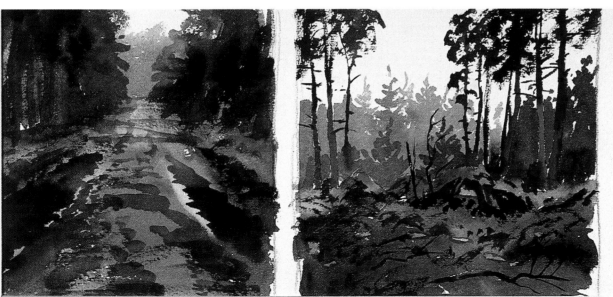

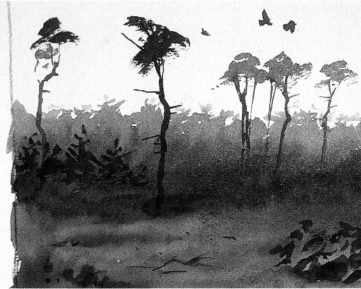

These are from a children's ABC that I did as part of my diploma show at Liverpool art college.

A few years later it was published in *The London Illustrated News*.

Right: Dragon and Darts

Below: Insect on Ice

Right:
Anteater and
Ant

Below:
Kangaroo and
Keys

Pig Painting

Quartet of Quails

Zebra & Zig-Zag

Rats Racing

More early works.

Right: Grouse on High Ground 10″ x 15″
(a sketch for a finished painting)

Below: Muscovies & Fuchsia 12″ x 15″ water-colour

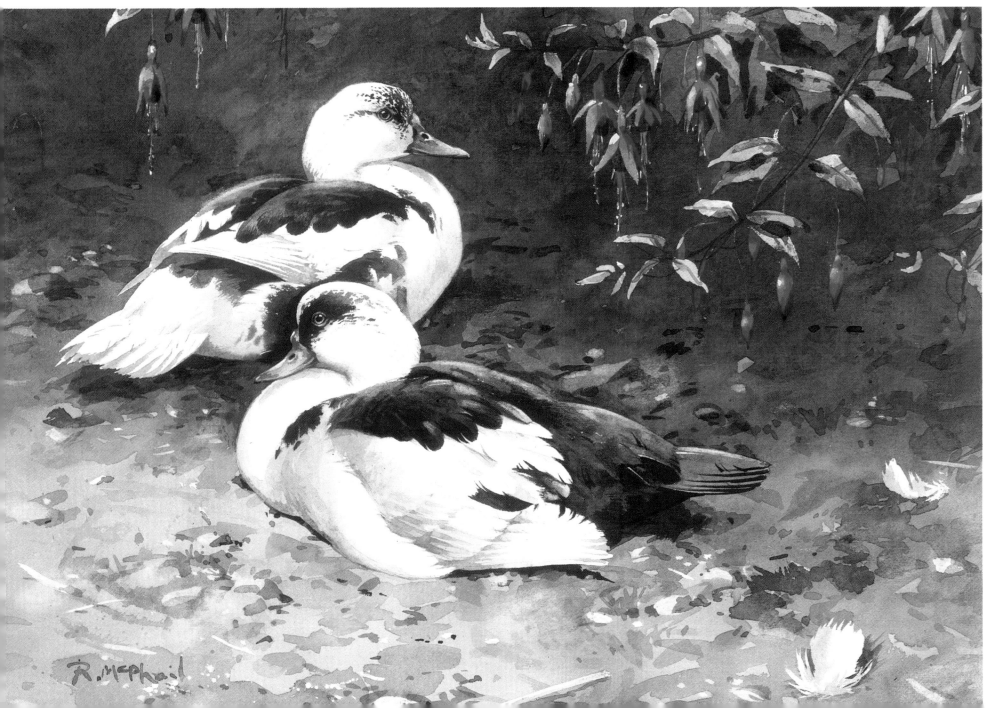

R. McPhail

Barn Owl & Fire 14″ x 18″ water-colour

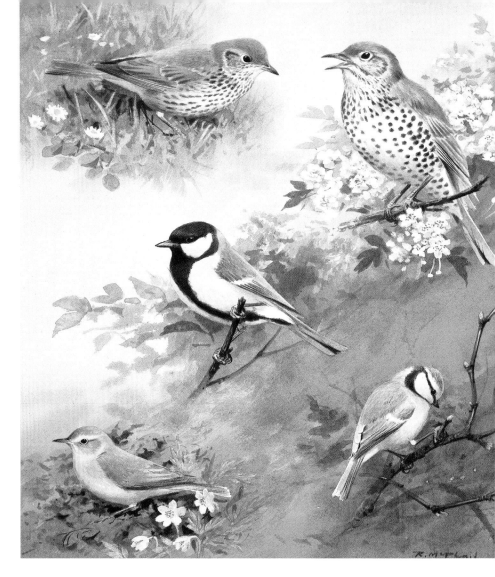

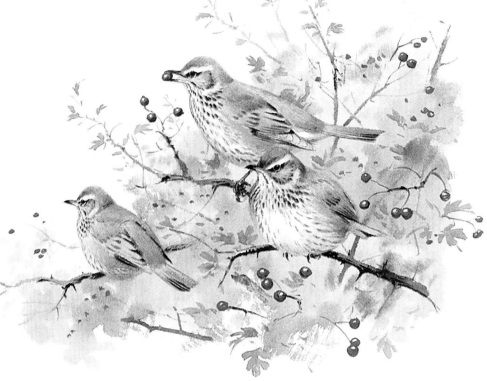

Clockwise:
Goldfinches 20″ x 14″ water-colour
Garden Birds 10″ x 12″ water-colour
Redwings (From A Country Naturalist's Year)

Opposite/Clockwise:
Heron 14″ x 11″ oil
Nightjar 14″ x 18″ water-colour
Starling and Quince Blossom 15″ x 20″ water-colour

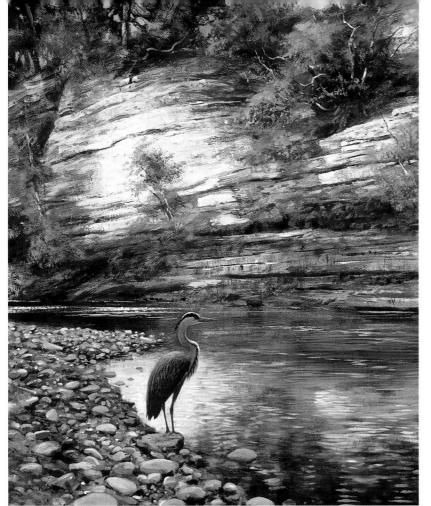

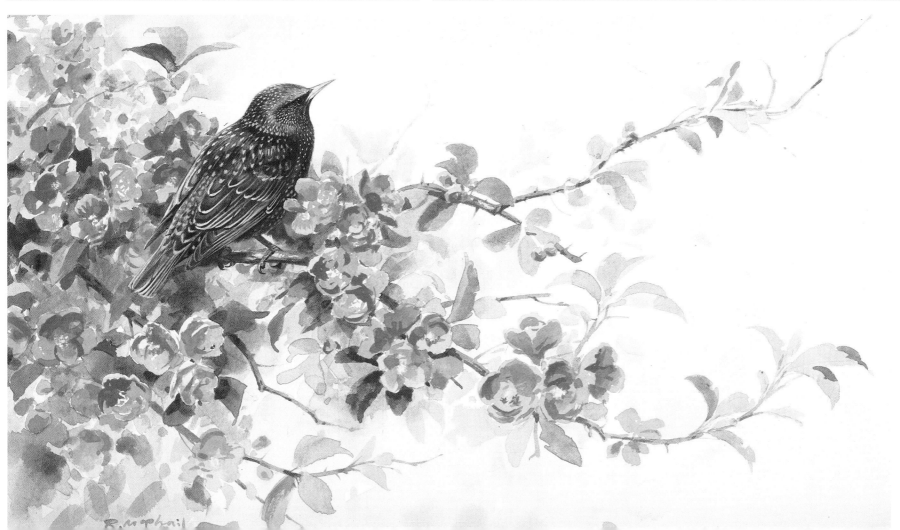

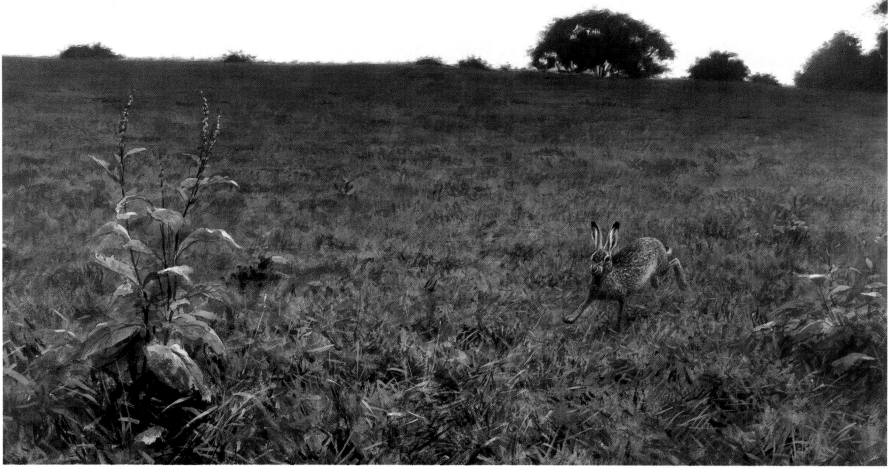

*Above: Hare at Dusk 18″ x 22″ water-
colour*
Right: Young Owl water-colour
Far Right: Gt Bustard 13″ x 10″ oil

Avocets 10″ x 12″ water-colour

Gulls on the Shore 16″ x 25″
oil

R. McPhail

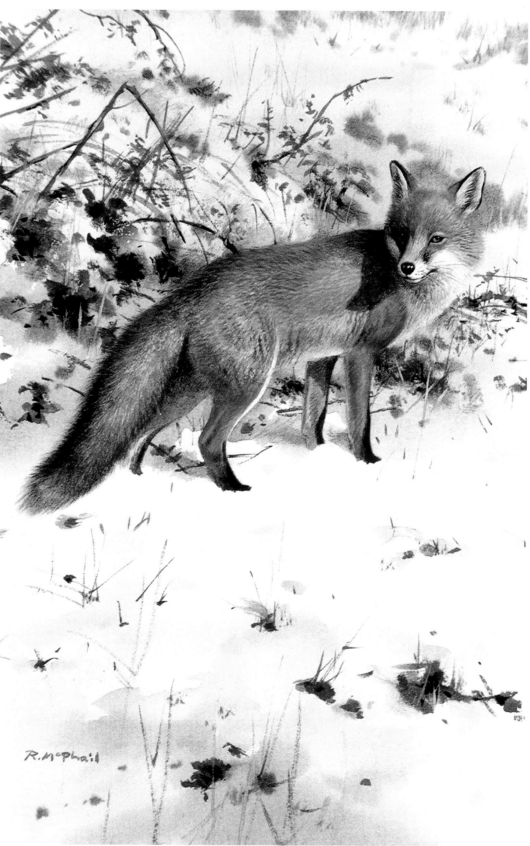

Above: Peregrine and Chicks
(From A Country Naturalist's Year*)*

Right: Fox 20″ x 14″ water-colour
(From the Fur, Feather and Fin *series.)*
Signet Press 1995

Opposite Page:
Lapwing and Weasel 19″ x 25″ water-colour

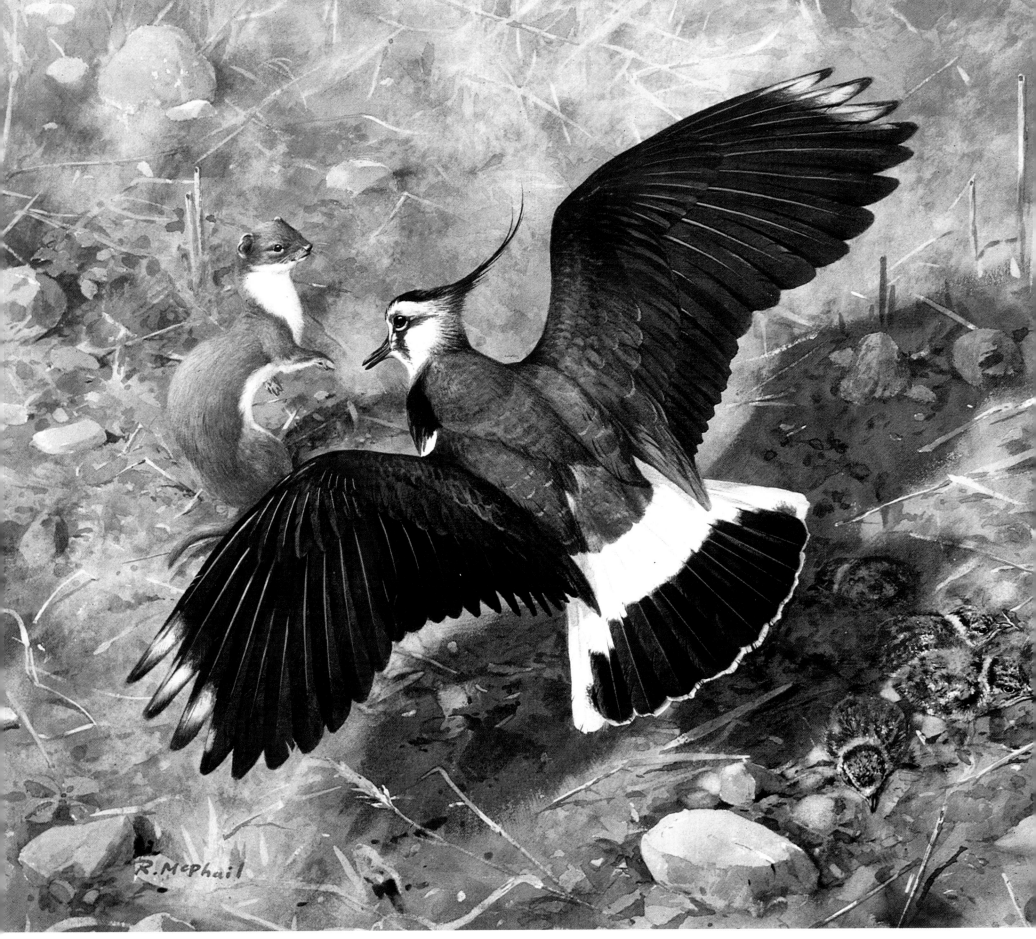

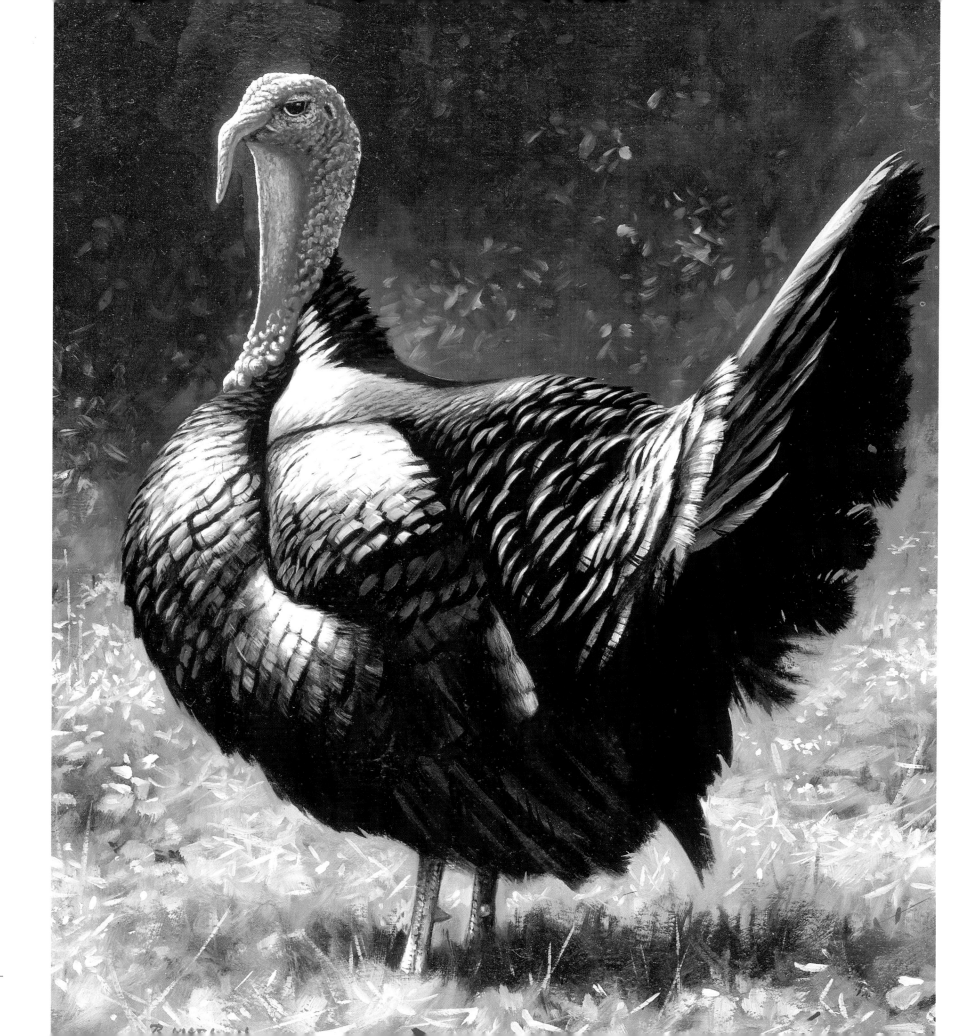

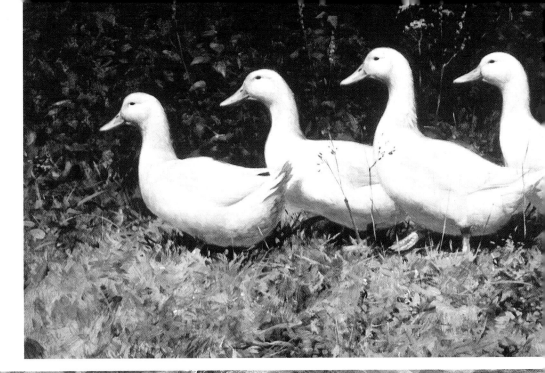

Opposite: Turkey 18″ x 14″ oil

Great fun painting those feathers – like metal plates in contrast to the flesh of the head and neck.

Right: Four White Ducks 10″ x 15″ oil

At one of my London exhibitions, this little oil was the most popular painting in the show.
I'm constantly surprised by which pictures are popular and which are not.

Below: Muscovies on a Muddy Track 10″ x 15″ water-colour

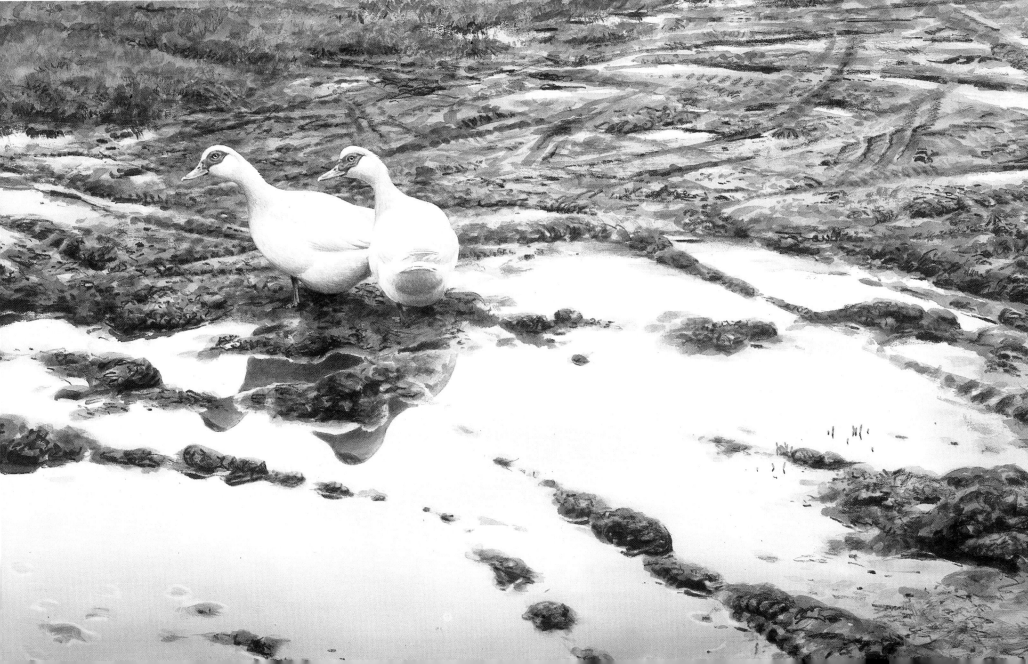

Right: Bantam & Chicks 12″ x 14″ water-colour

Below: Gamecock in the Country Yard 19″ x 23″ oil

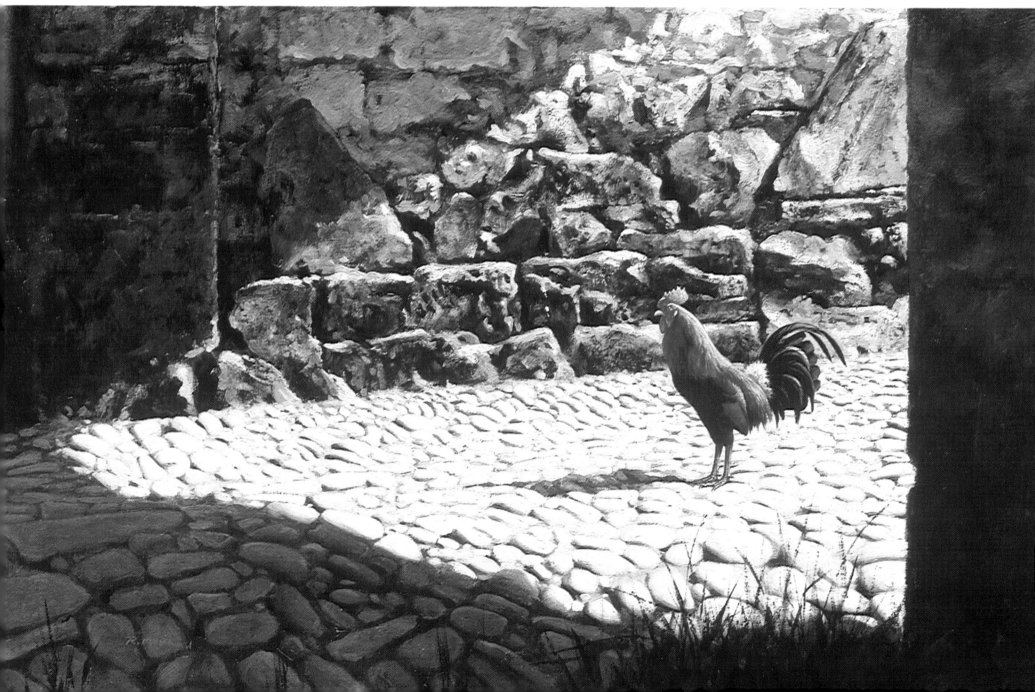

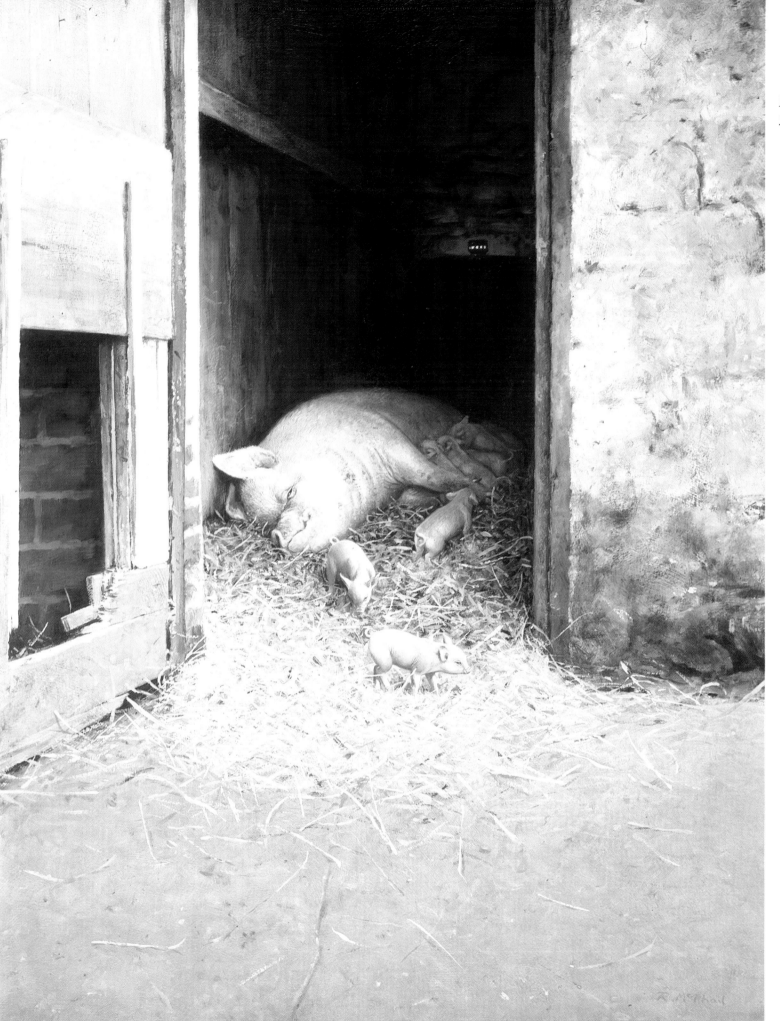

Pig and Piglets
29" x 22" oil

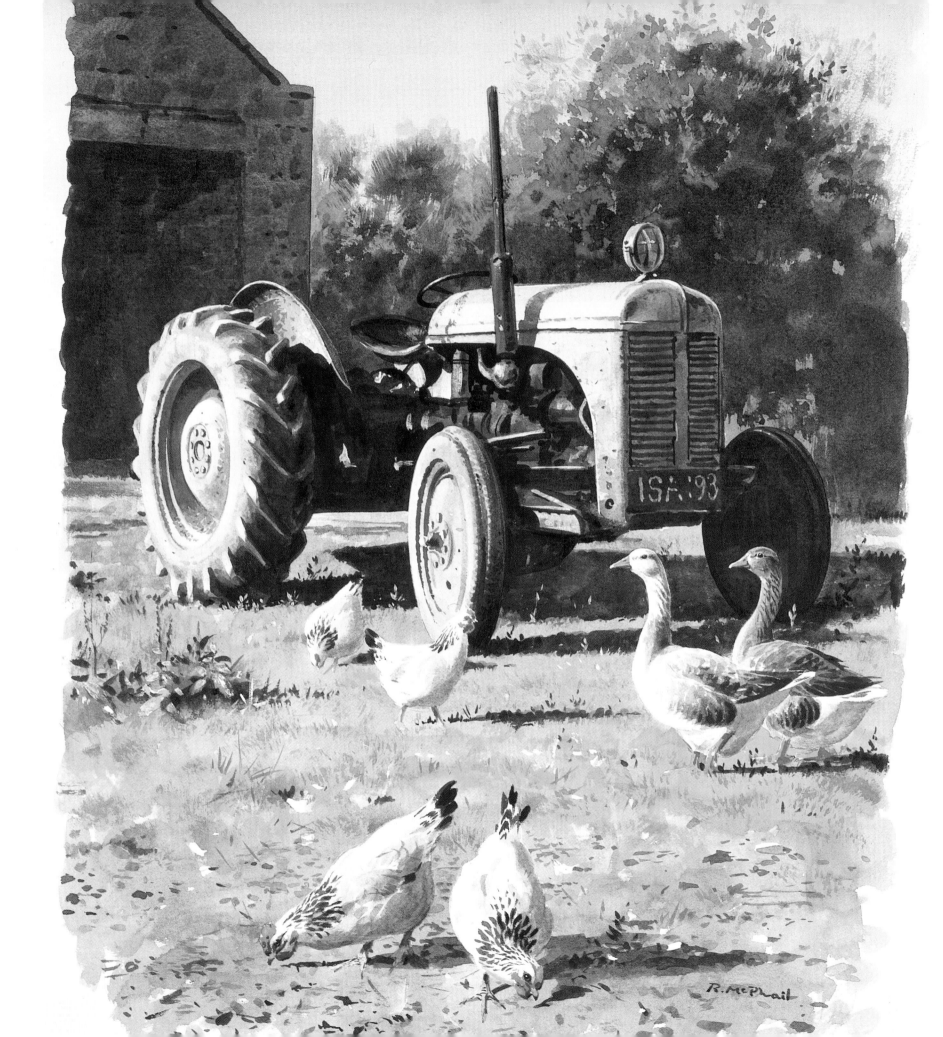

R. McPhail

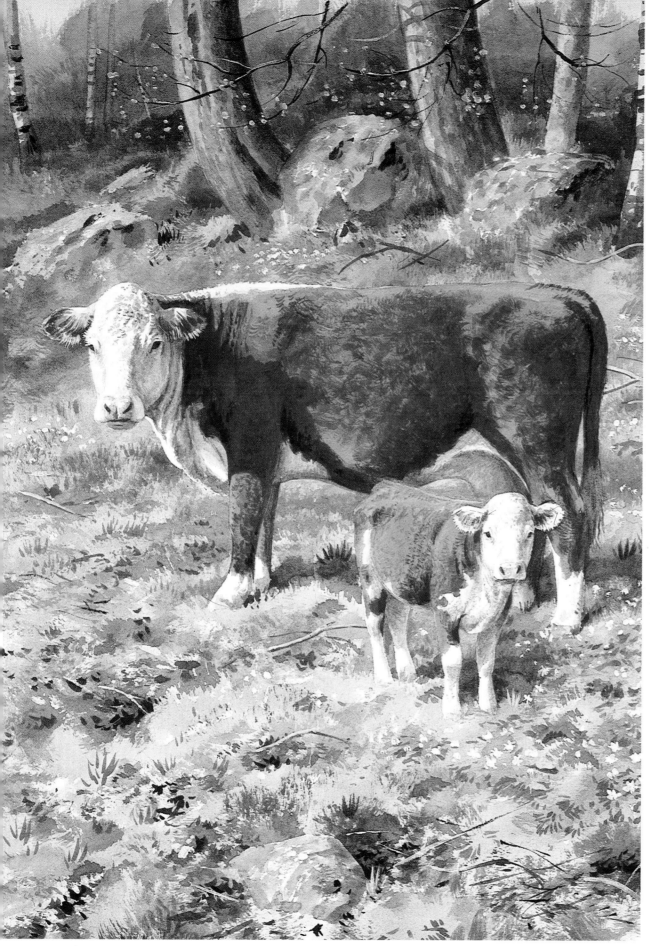

From A Hill Farmer's Year
by Ian Alcock
Swan Hill Press 1995

I found those tractor tyres *very* difficult to
paint.

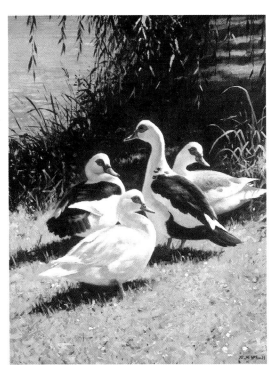

Left: Muscovy Ducks at Aylmer's House 32″ x 24″ oil

Opposite Page: The Cock Fight 18″ x 24″ water-colour

I actually did see this cock fight, many years ago
in an old slaughterhouse behind the police station in a small
Lancashire town! We ate one of the losers. Very tough.

Below: Budgie and Sheet Music 17″ x 22″ oil

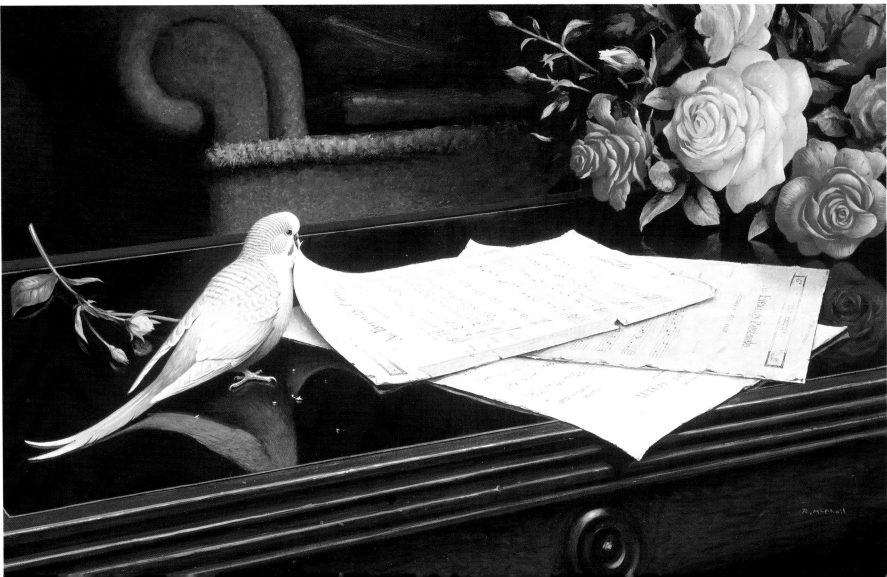

Town Pigeons 16" x 24" oil

Above: Glen Feshie 22″ x 28″ oil

Right: Ringed Plover water-colour

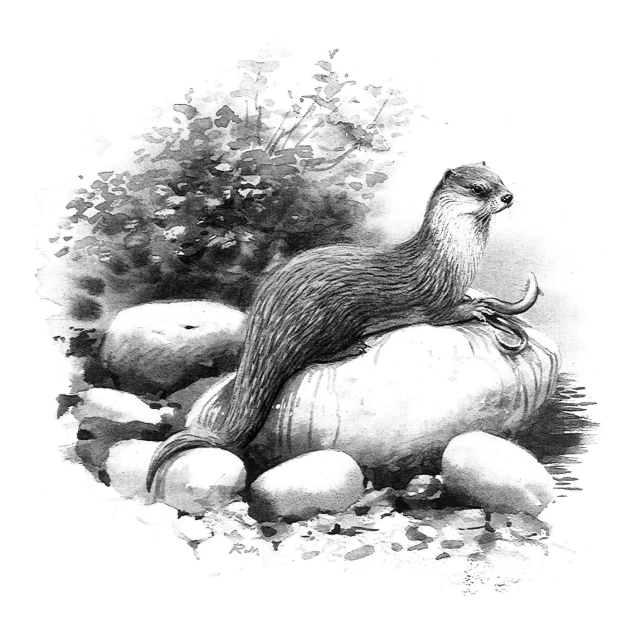

Right: Otter in the House Pool 48" x 60" oil

On a fishing holiday to the Etive, it was so hot that fishing was impossible. All the fish were crowded into the deep "House Pool" below Dalness House. We put masks and snorkels on and swam amongst the salmon. The water was gin clear and the visibility superb. We didn't see an otter, but the experience inspired this big oil painting.

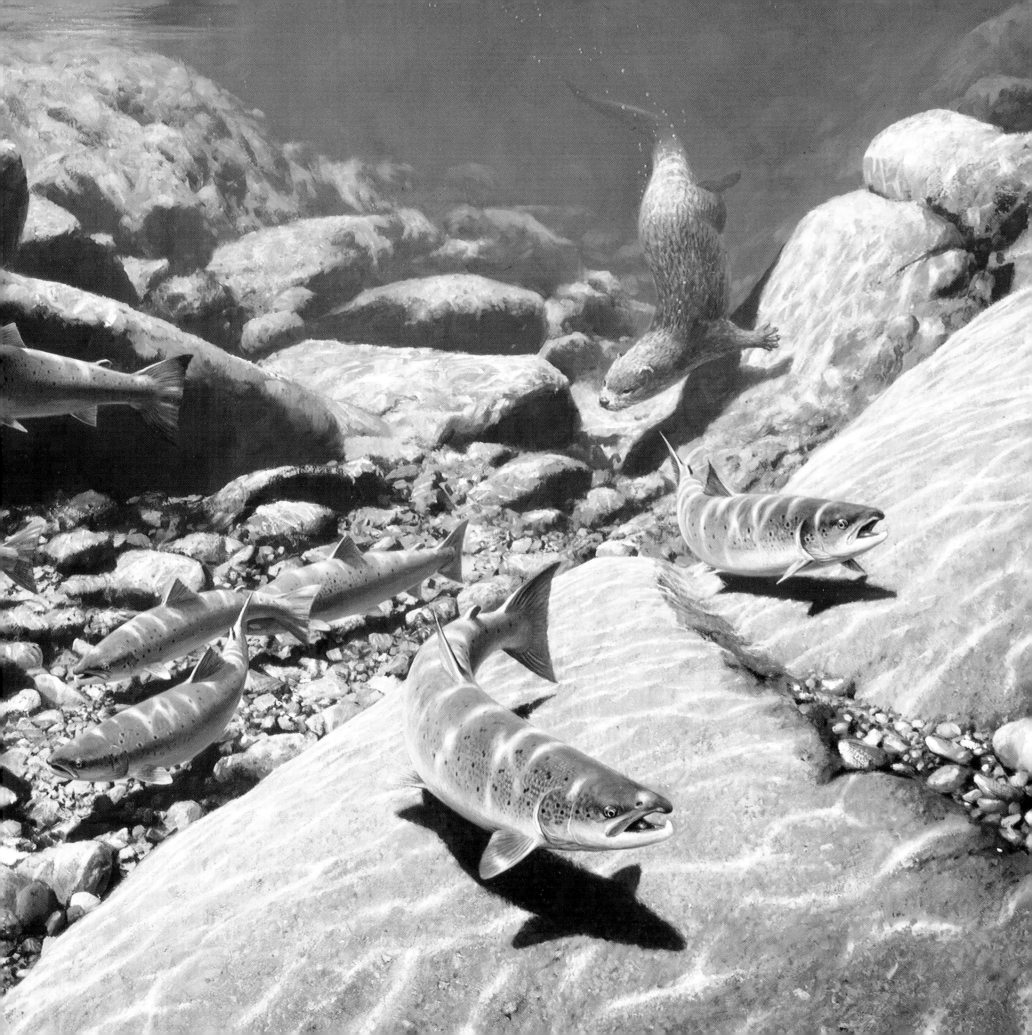

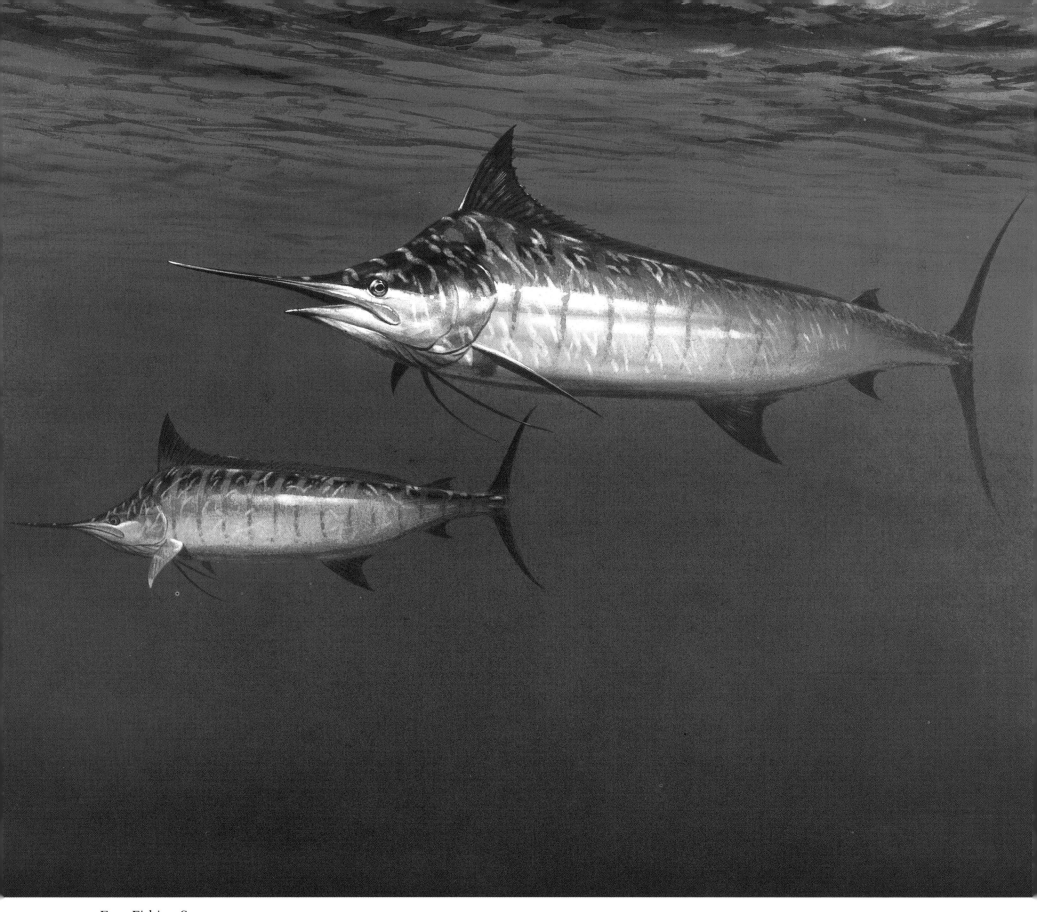

From Fishing Season
Swan Hill Press 1990

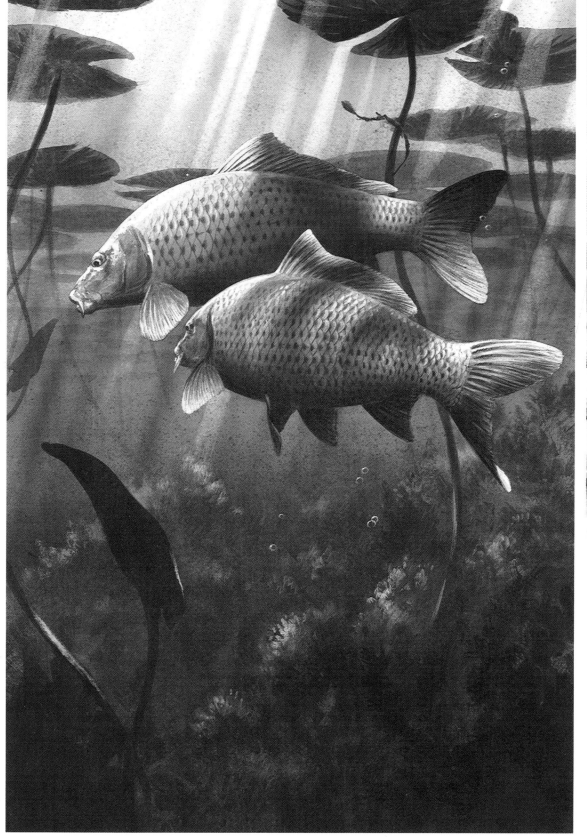

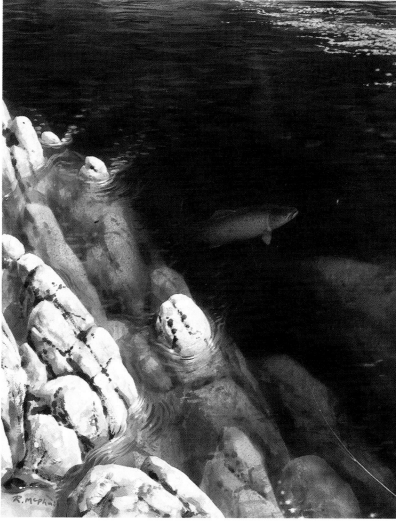

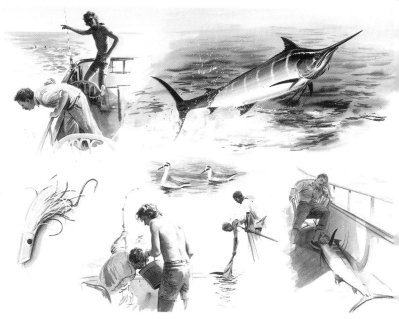

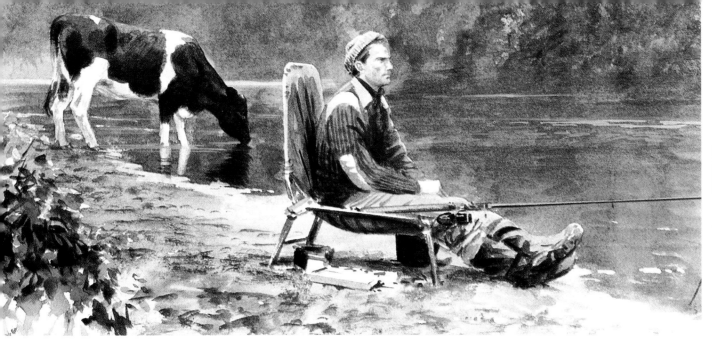

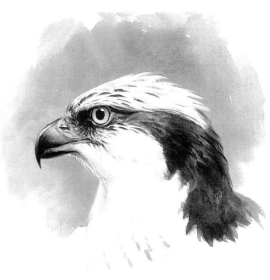

From Fishing Season
Swan Hill Press 1990

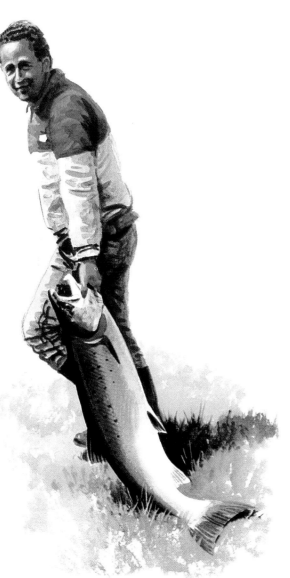

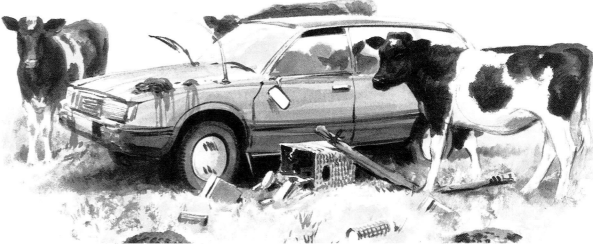

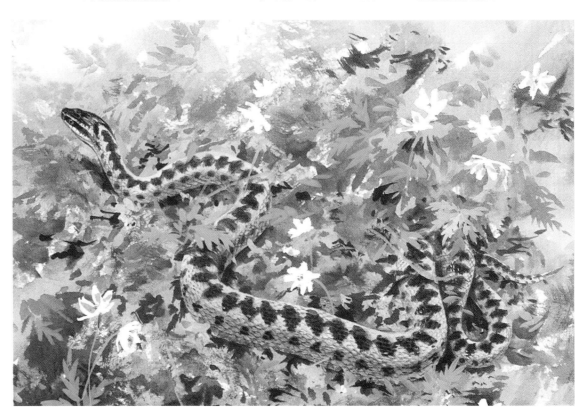

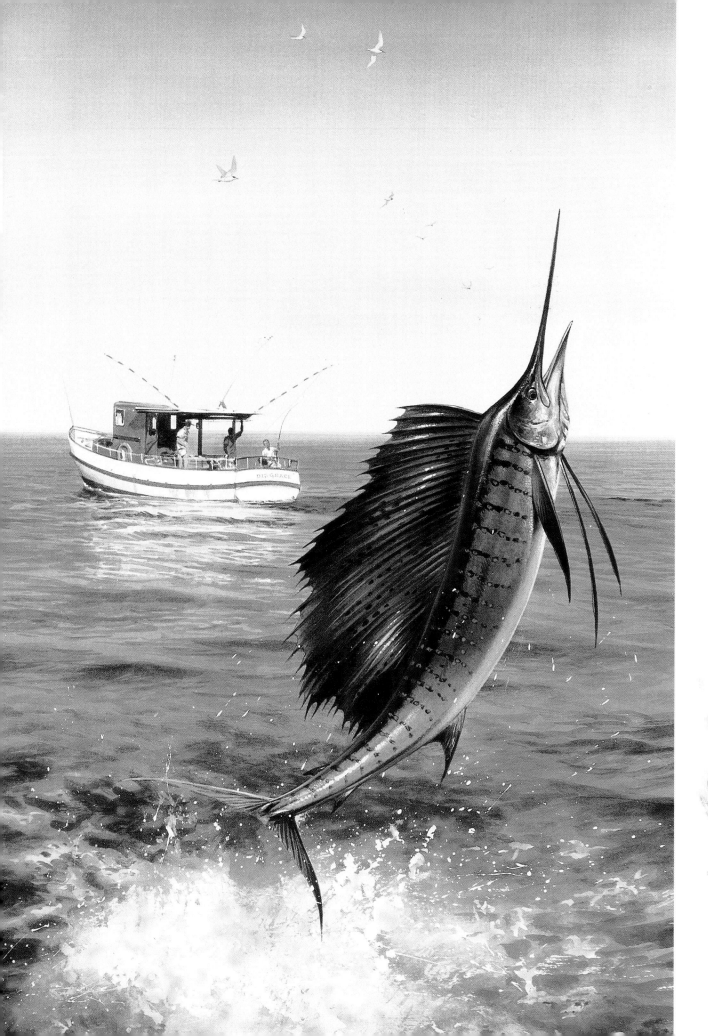

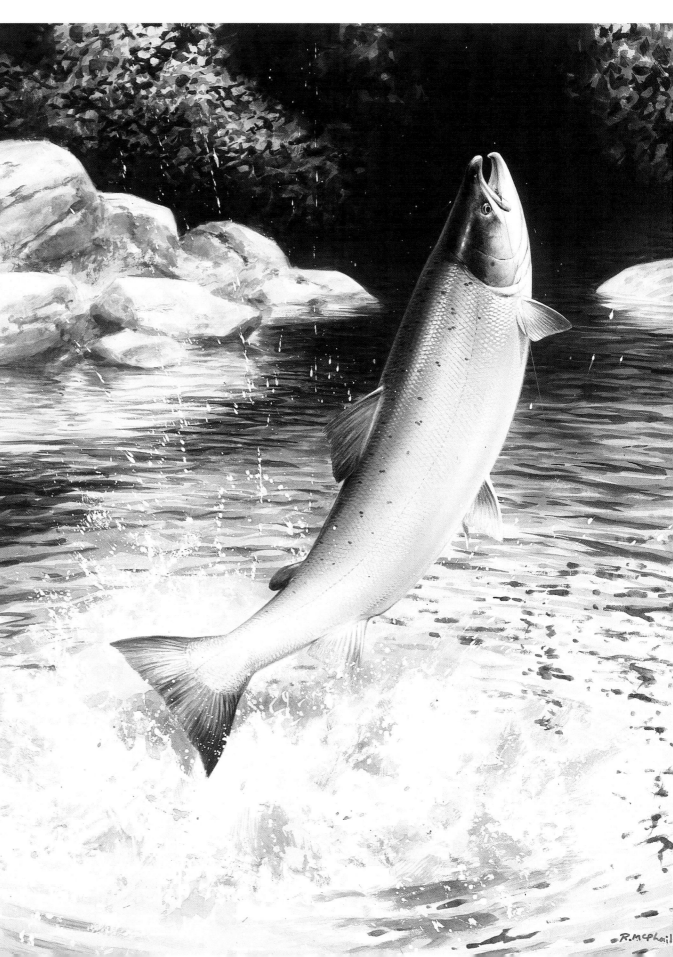

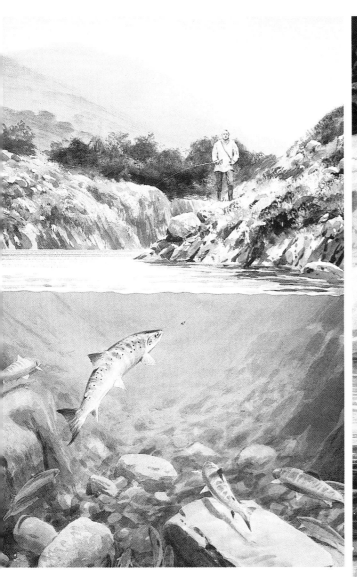

Above: Salmon coming to a Fly 20″ x 12″
sepia (*From* Fishing Season)

Right: Leaping Salmon 23″ x 15″
water-colour

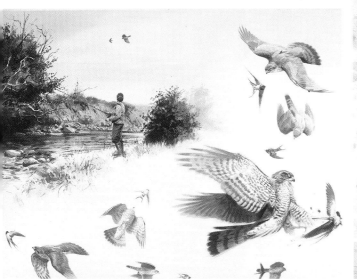

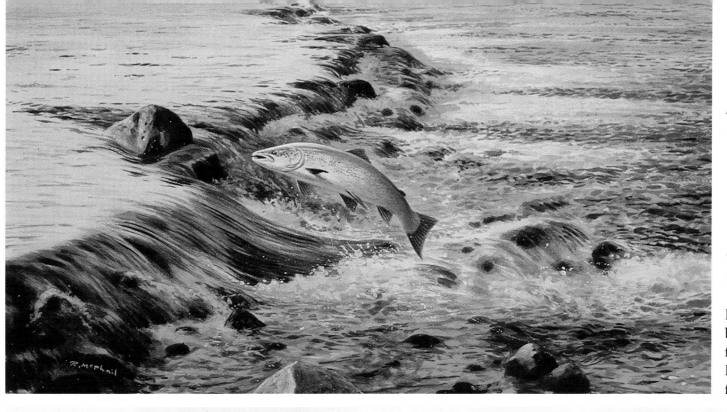

Salmon and Weir
13″ x 22″ water-colour

The Junction Pool
15″ x 24″ water-colour

In the background is the bridge at Kelso and the famous Ednam House Hotel – mecca of salmon fishing.

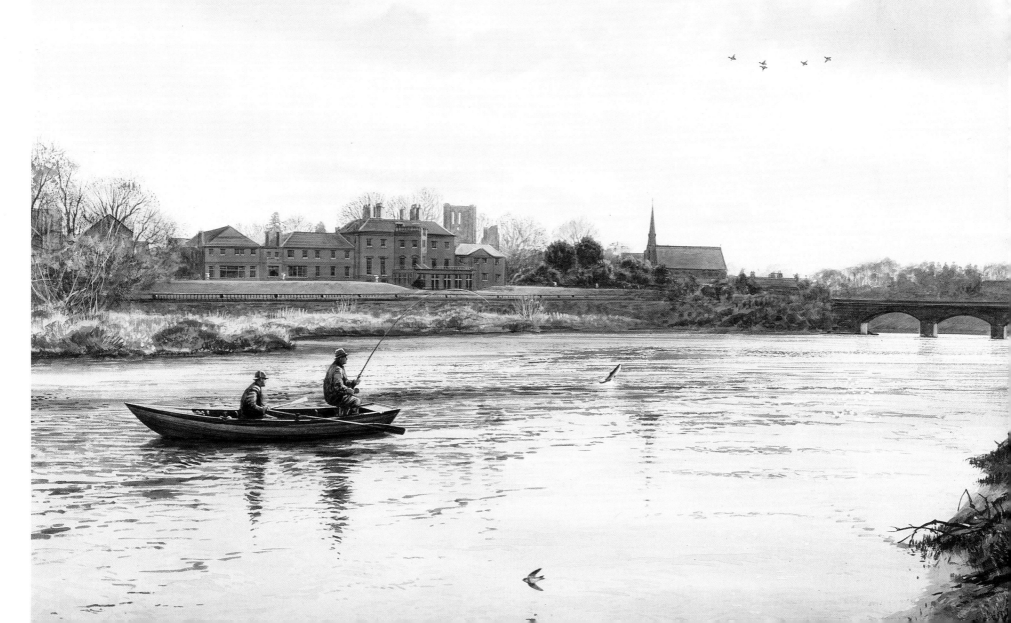

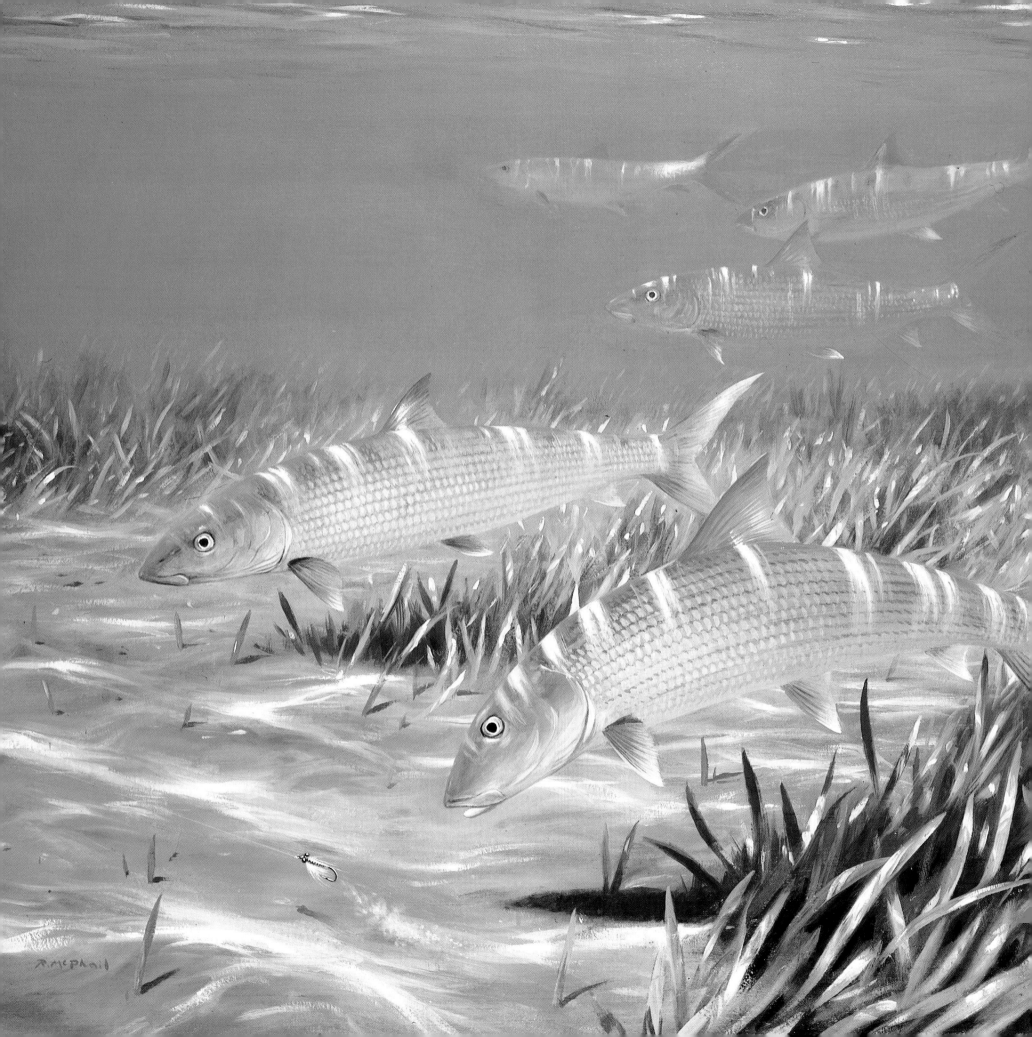

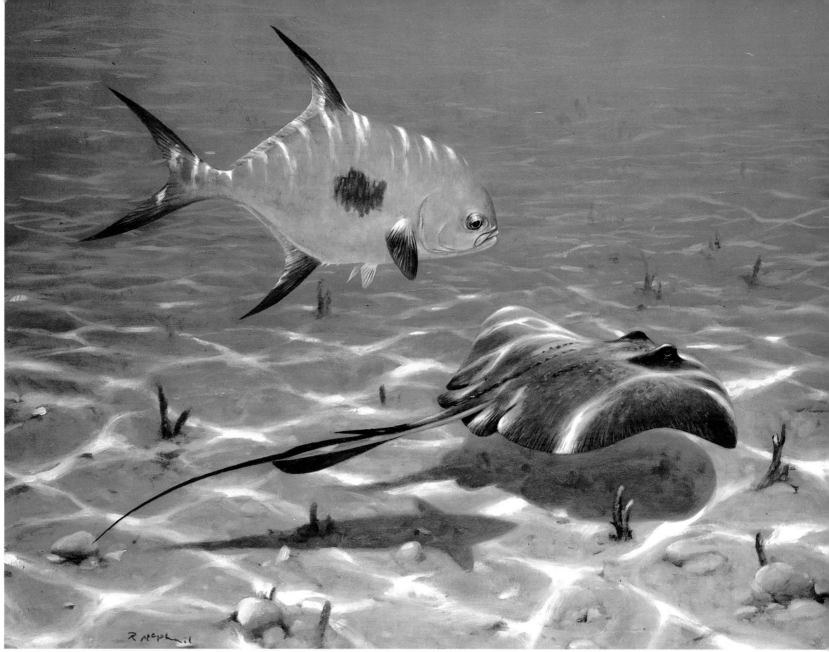

Above: Permit & Stingray 15″ x 22″ oil

"Flats" fishing in shallow water for Bonefish and Permit is the most
exciting sport because you are fishing for the fish that you can *see.*
It's like chalk-stream trout, but in salt water. Both these fish are very
strong fighters and difficult to catch on a fly.
In shallow water the Permits' fins and tails show above the surface.
In deeper water they are difficult to spot, but one way of finding them
is to check all the Stingrays (they show up like black dustbin lids!)
If you are lucky you might find a Permit escort, hoping for shrimps etc.
disturbed by the ray.

Opposite Page: Bonefish 16″ x 25″ oil

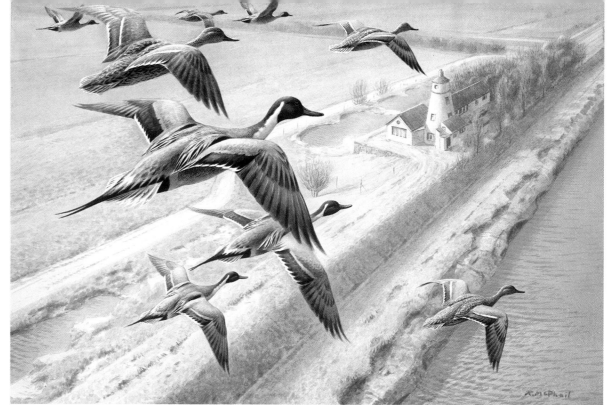

Right: Pintails 15″ x 20″ water-colour

This was the first ever Wildfowl & Wetlands Stamp. I was asked to paint Peter Scott's Lighthouse as the background.

Below: Teal at Burntwick Island 15″ x 22″ water-colour

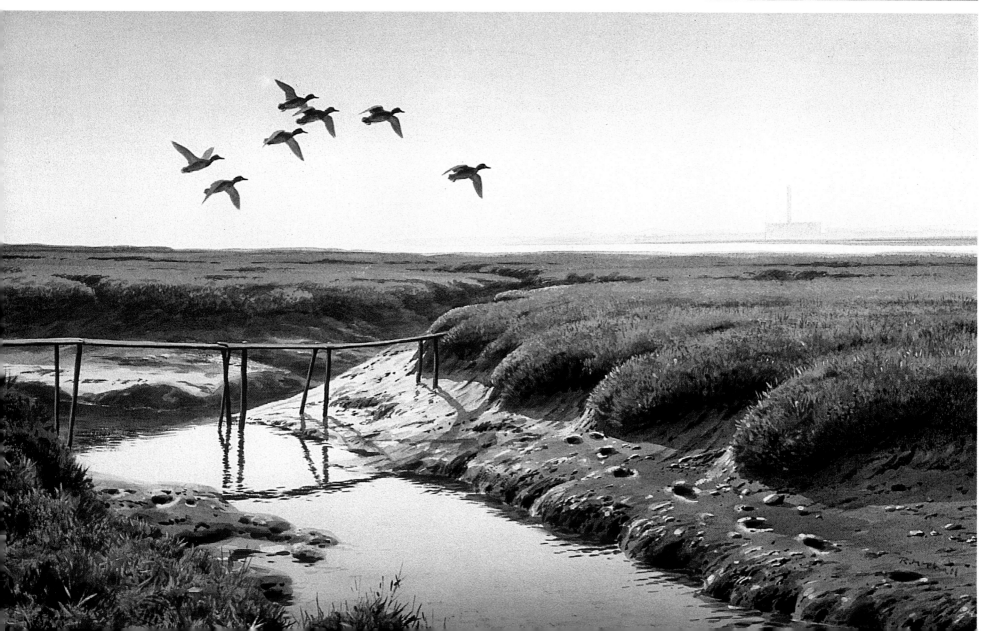

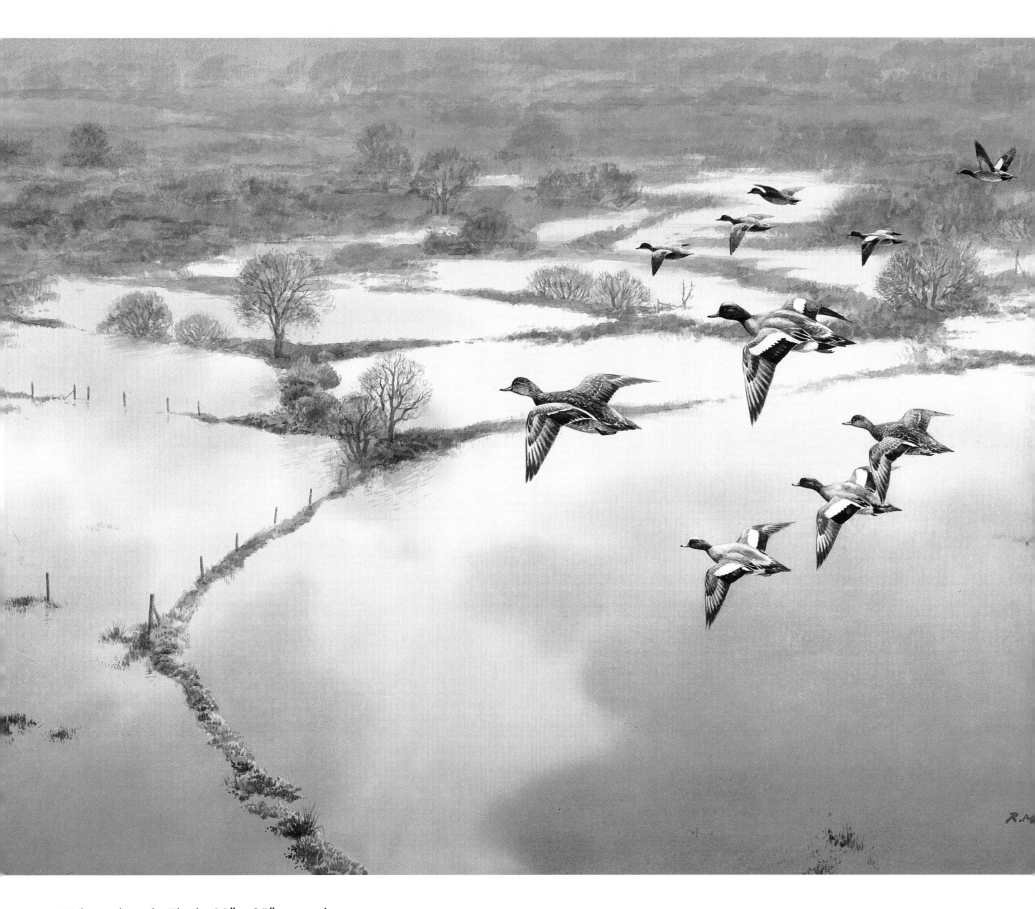

Widgeon above the Floods 20″ x 25″ water-colour

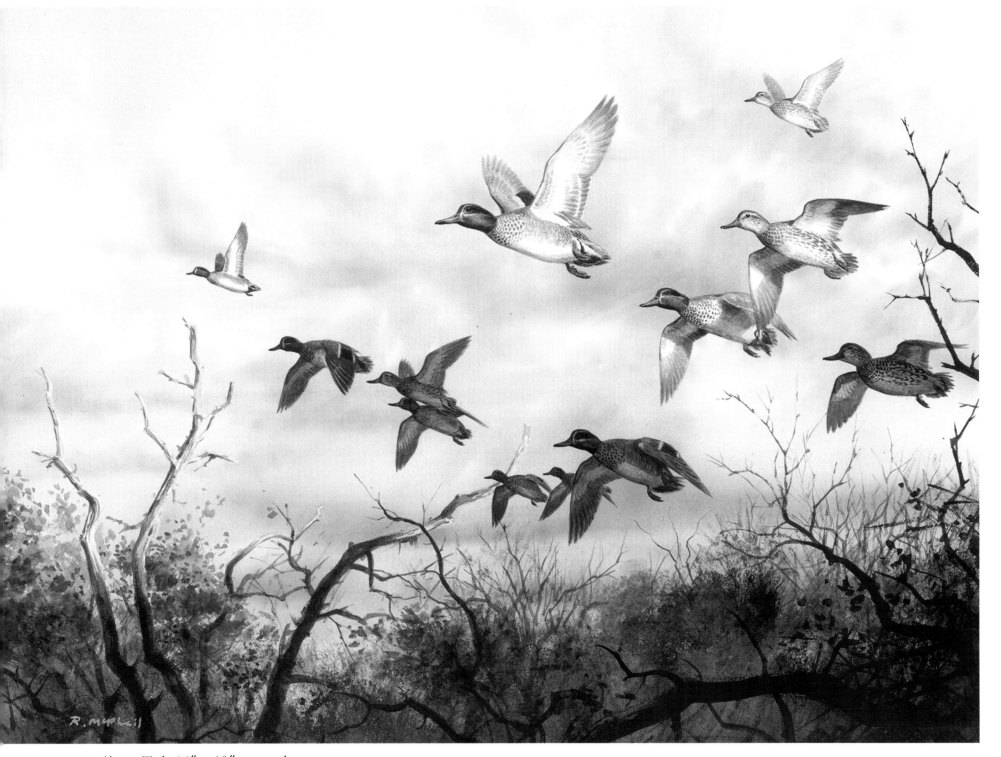

Above: Teal 14″ x 18″ water-colour

Opposite Page: French Partridges
24″ x 36″ oil

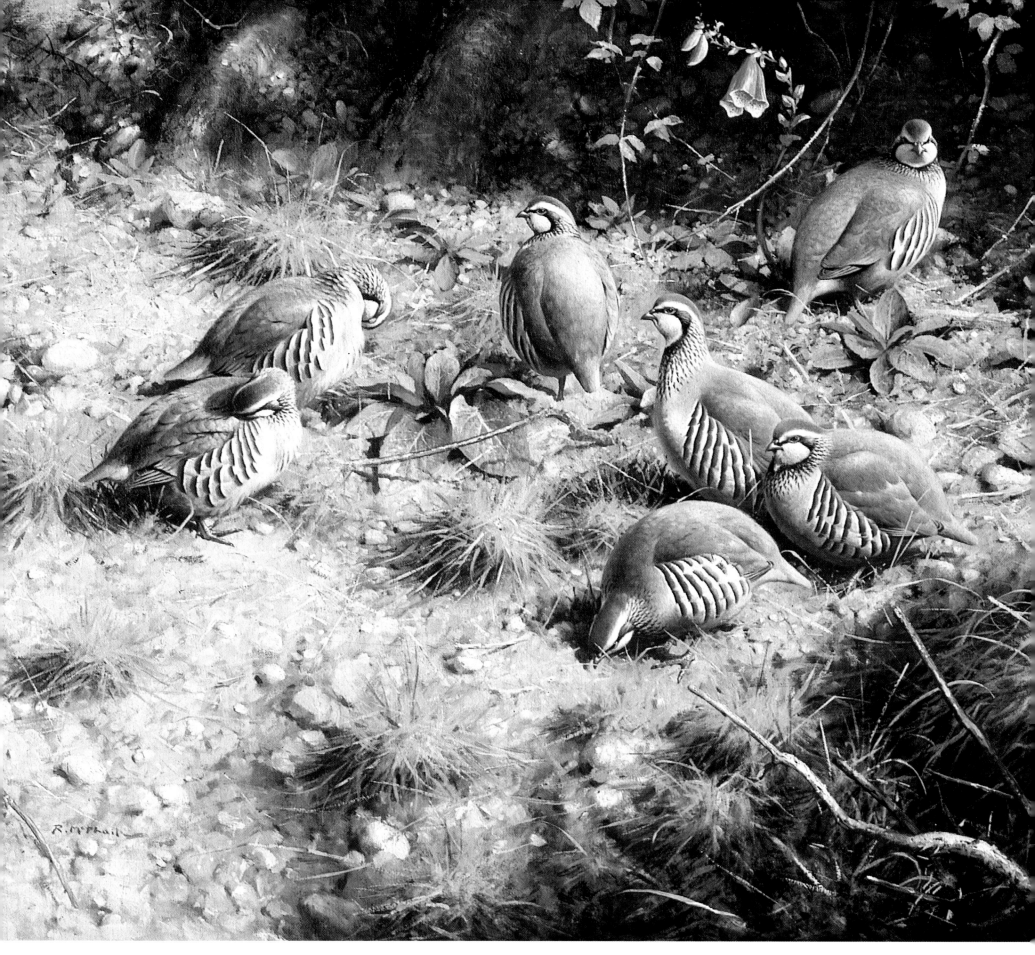

Right: Ptarmigan 25″ x 18″
water-colour

Below: Ptarmigan (From A Country
Naturalist's Year)

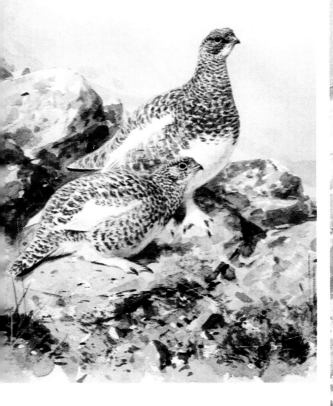

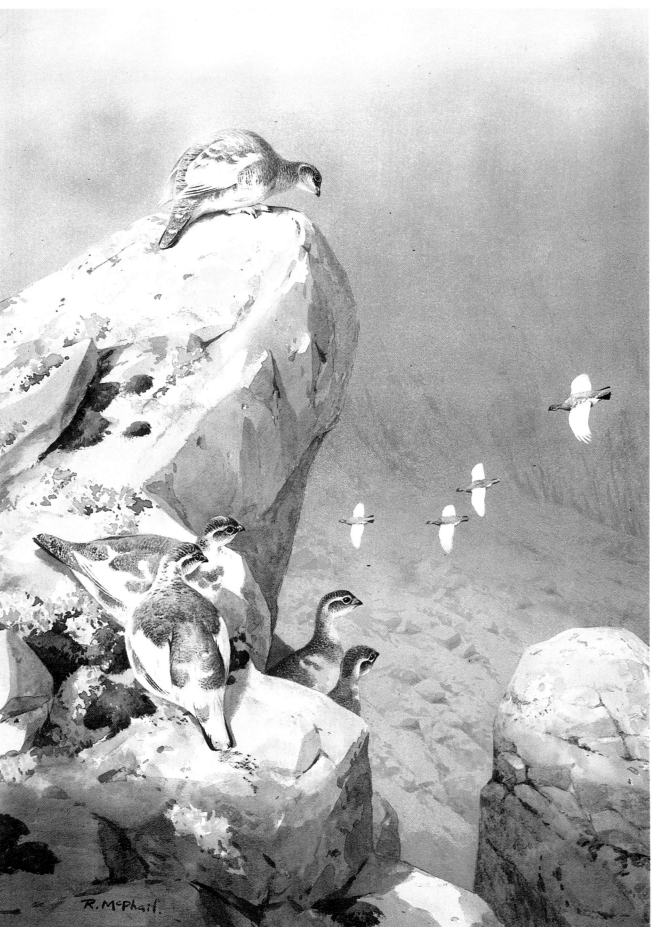

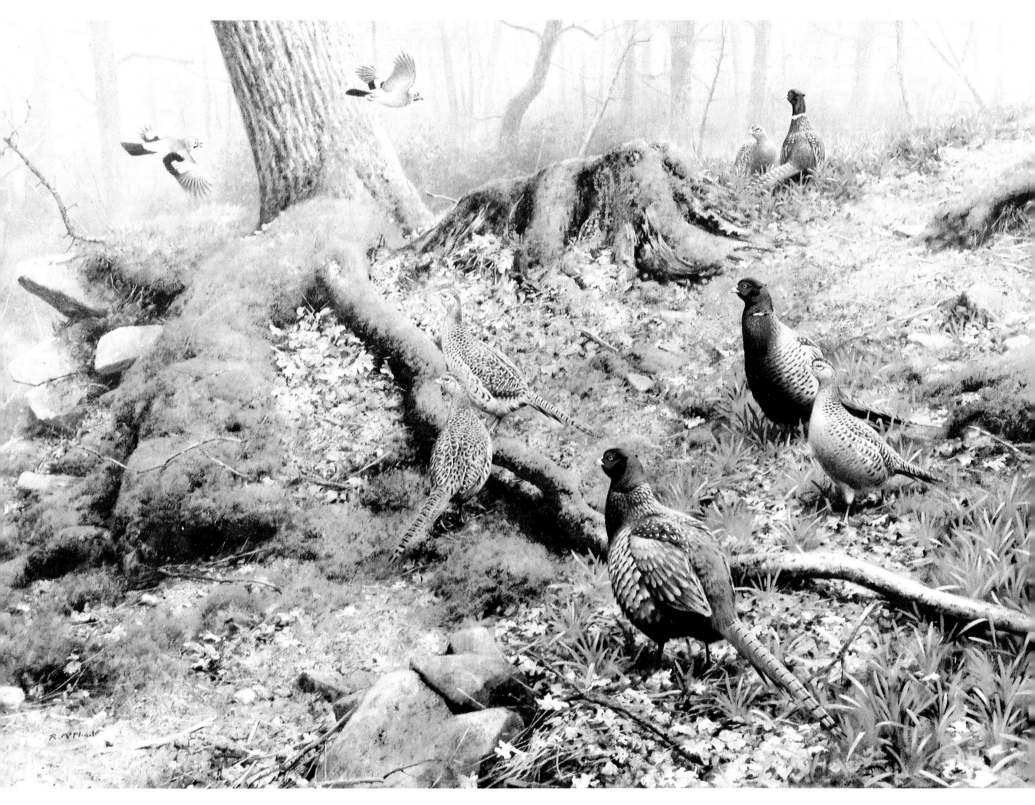

The Start of the Drive 36″ x 54″ oil

Pheasants in a Snowy Landscape 48″ x 60″
oil on canvas

This huge oil was commissioned by a Cypriot who
enjoys shooting in Britain.
The background is fictional, as is often the case in my
paintings.

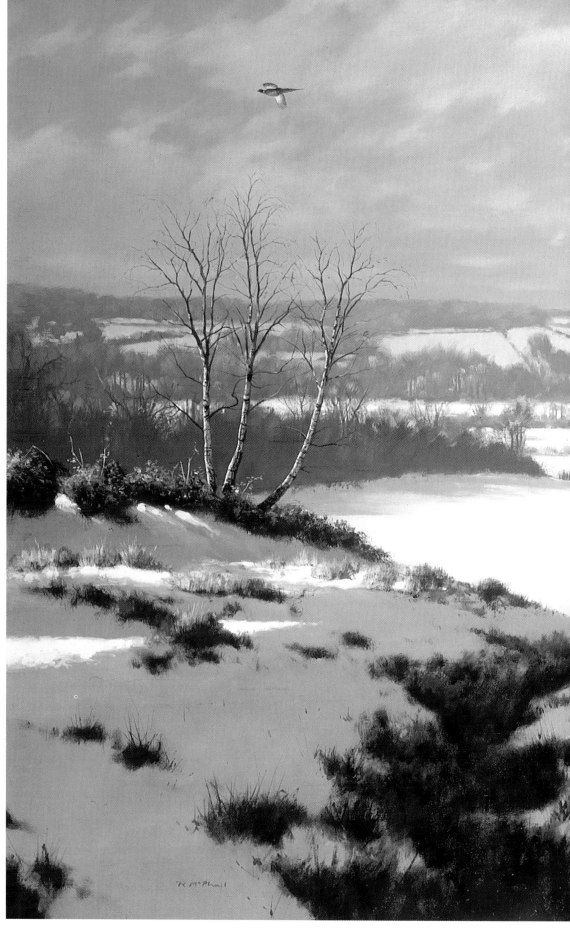

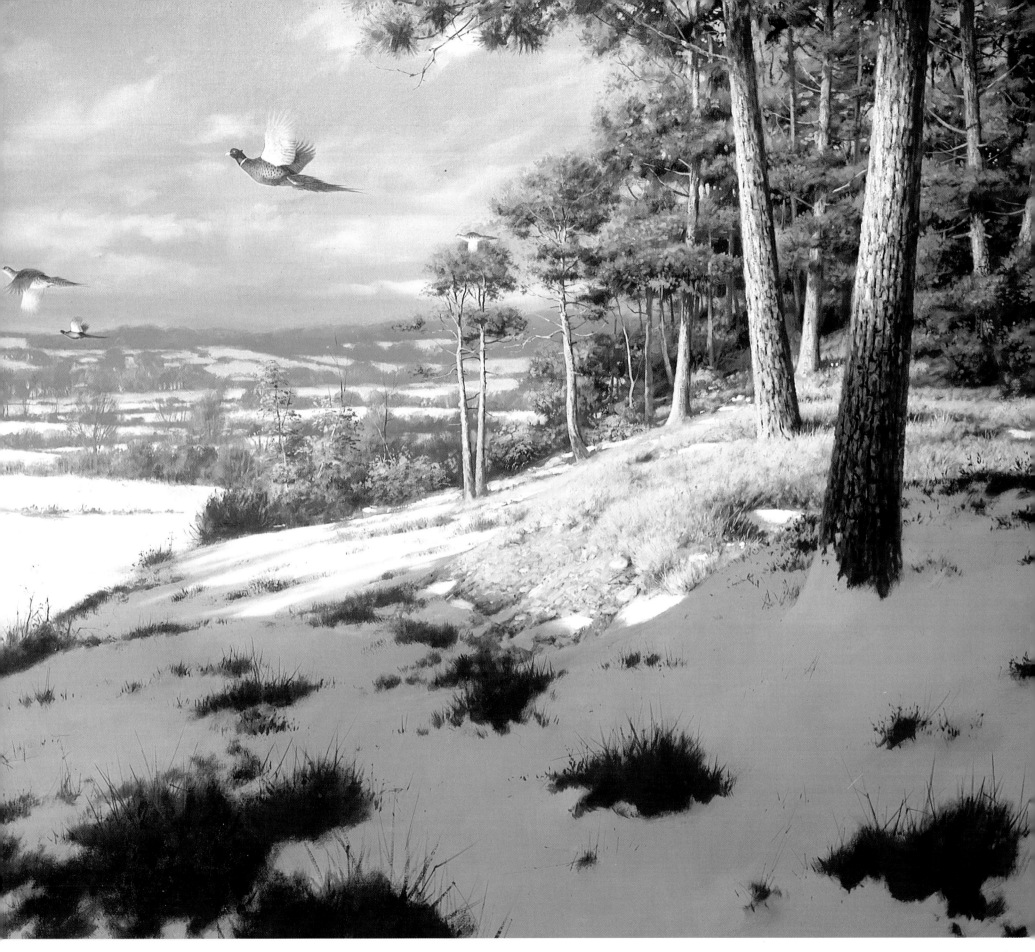

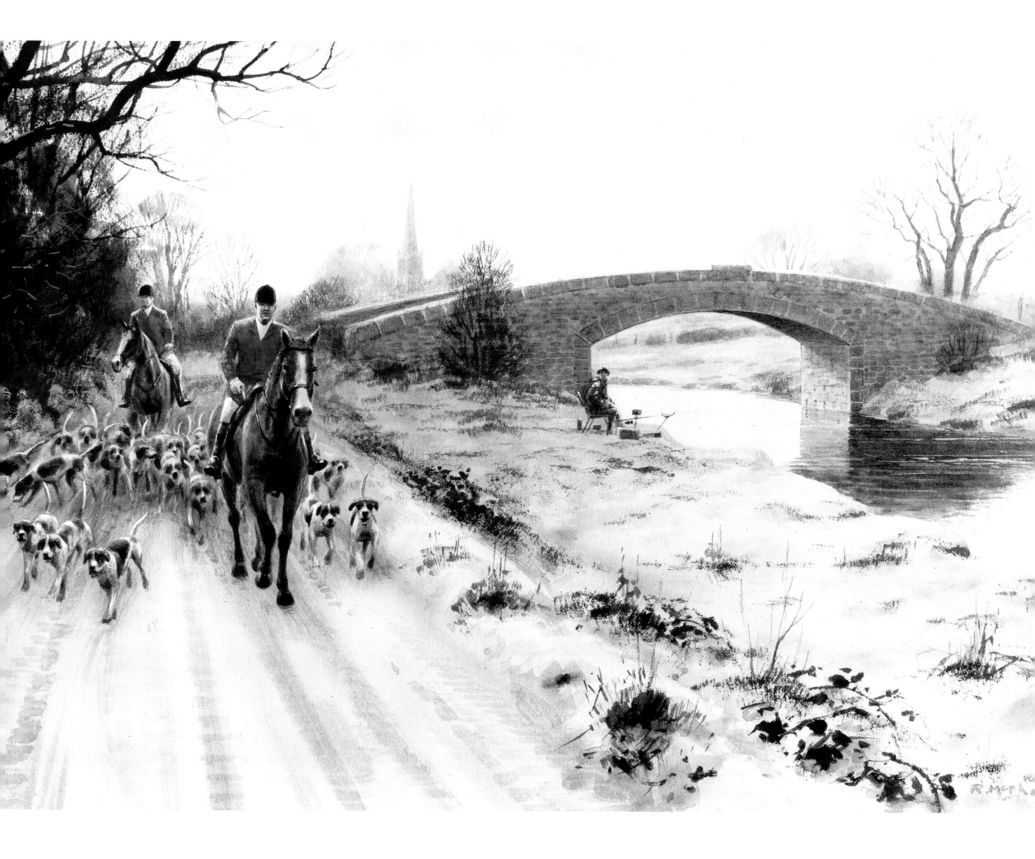

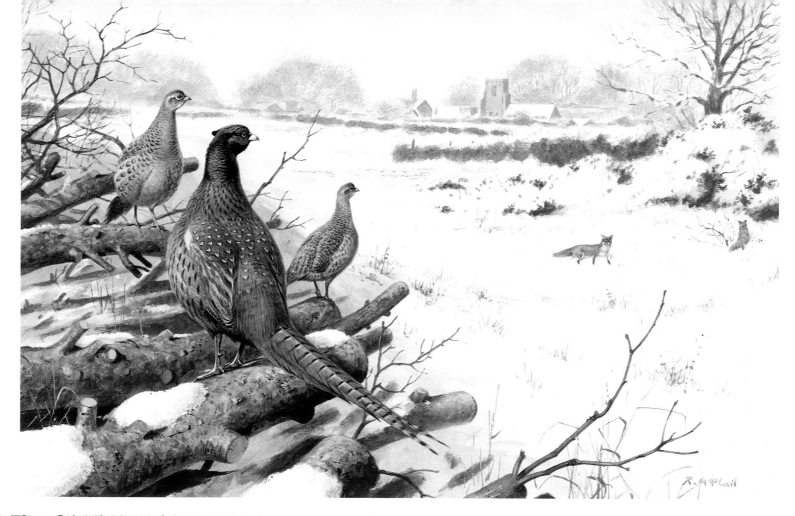

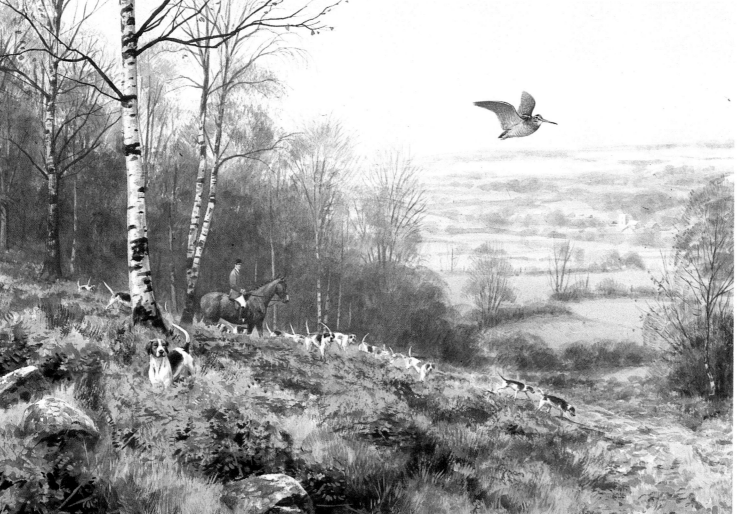

B.F.S.S. Christmas Cards

I did the B.F.S.S. Christmas cards for six or seven years. They always wanted a church in the background, and more than one sport depicted.
The one of pheasants originally had just one fox, but the birds appeared to be looking somewhere to its right, so I had to put another one in.

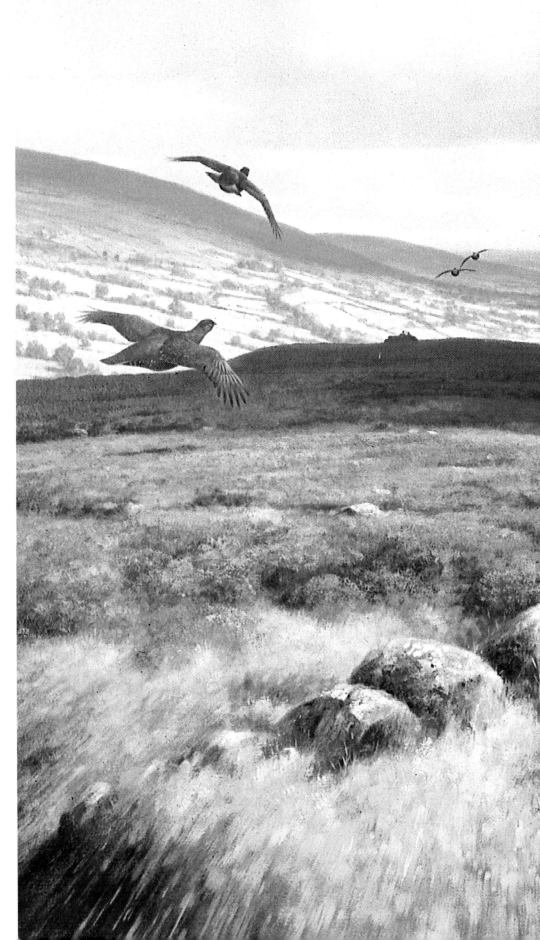

Towards the Butts 48″ x 60″ oil

This big oil was auctioned at the Game Conservancy Ball at Syon House.

I had started the painting with the foreground done in the conventional manner but when I had had a few hours sledging with the boys I thought I would try to convey the sense of skimming along at speed, by blurring the nearby rocks and grass.

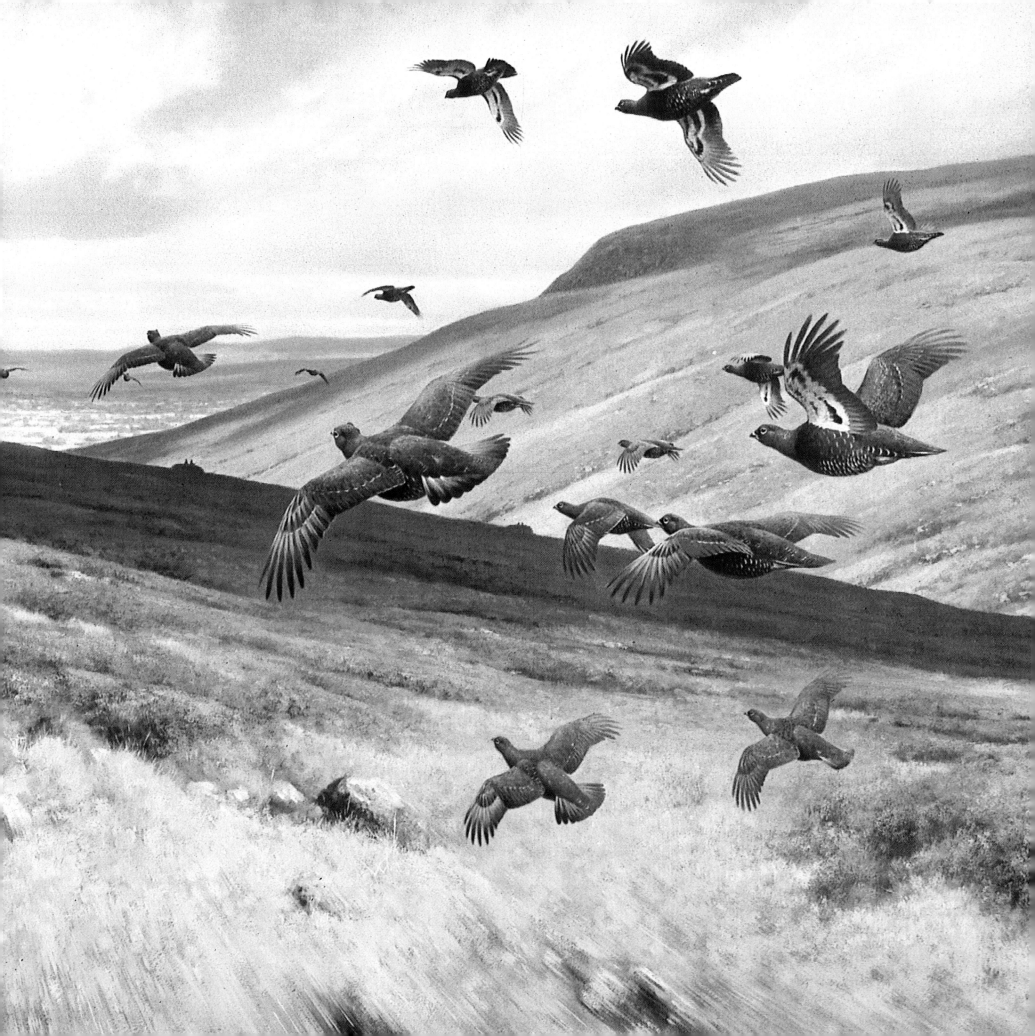

Paintings from Open Season
Swan Hill Press
1986

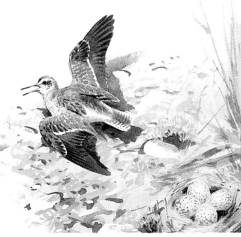

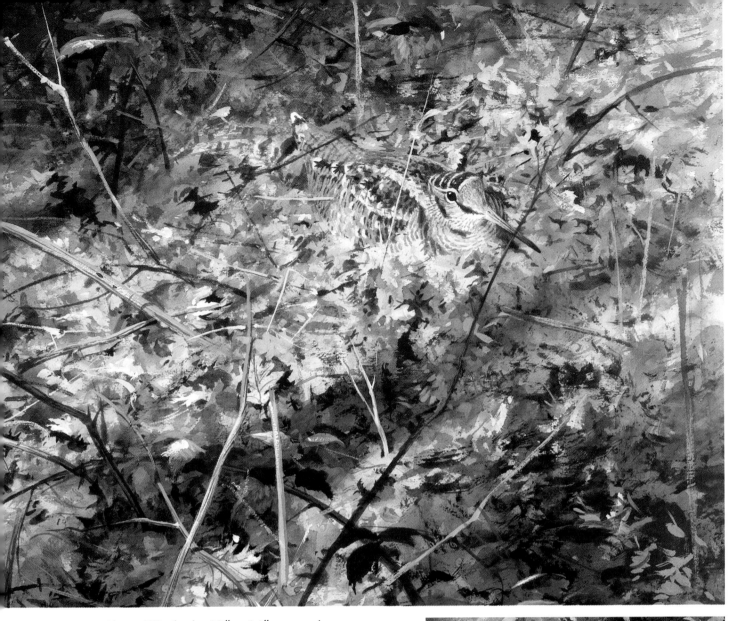

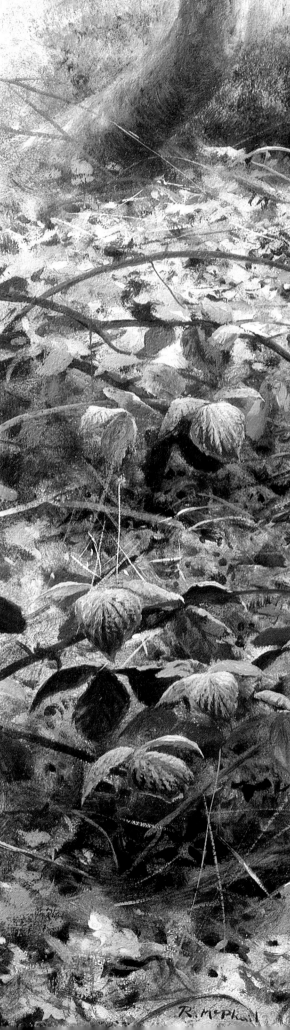

Above: Woodcock 10″ x 14″ water-colour

Opposite: Woodcock 20″ x 26″ oil

I like everything about woodcock,
they offer exciting sport, they are delicious to eat
and a real challenge to paint – their plumage
is miraculous.
Woodcock are mysterious birds, usually seen when
flushed from cover or when "roding" in the spring.
I could count on my fingers the number of times
I've seen them on the ground.

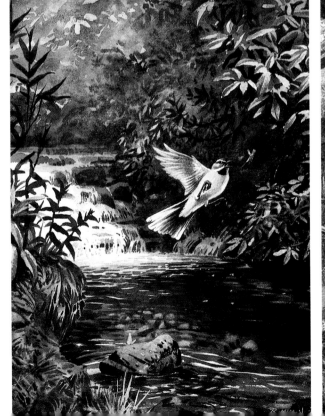

Right: Wagtail Over a Stream 18″ x 14″ water-colour

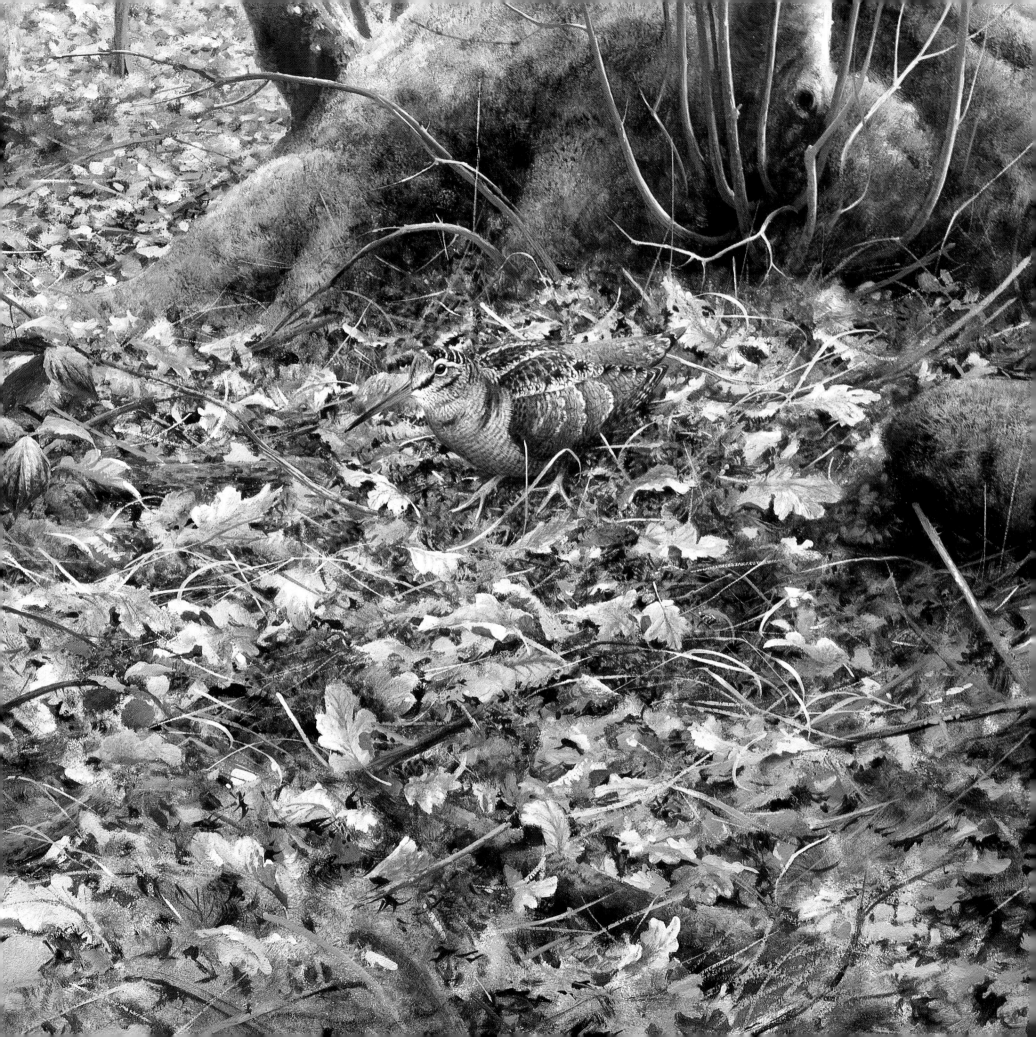

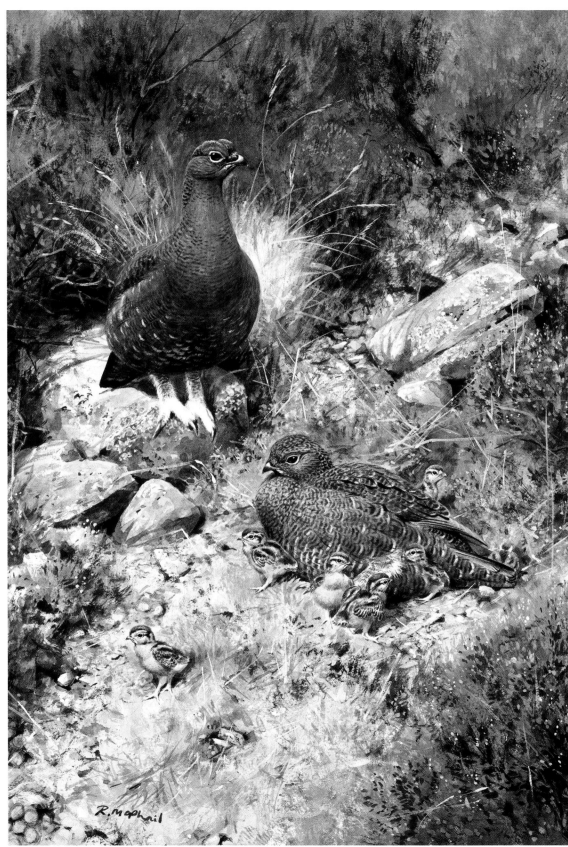

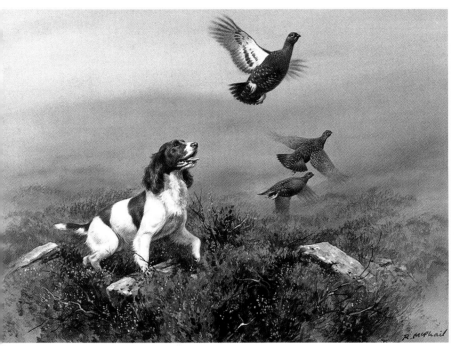

Above: Spaniel and Grouse 12″ x 15″ water-colour

This was a prize-winning dog.
I don't mind doing portraits of spaniels, but black
Labradors are a nightmare! They all look the same to me,
but of course their owners know their individual
characteristics.
We call commissions that are more trouble than they are
worth "Black dog jobs".

Opposite page: Partridges in the Mist 23″ x 30″ water-colour
Right: Grouse Family 22″ x 15″ water-colour
For 'Famous Grouse' whisky.

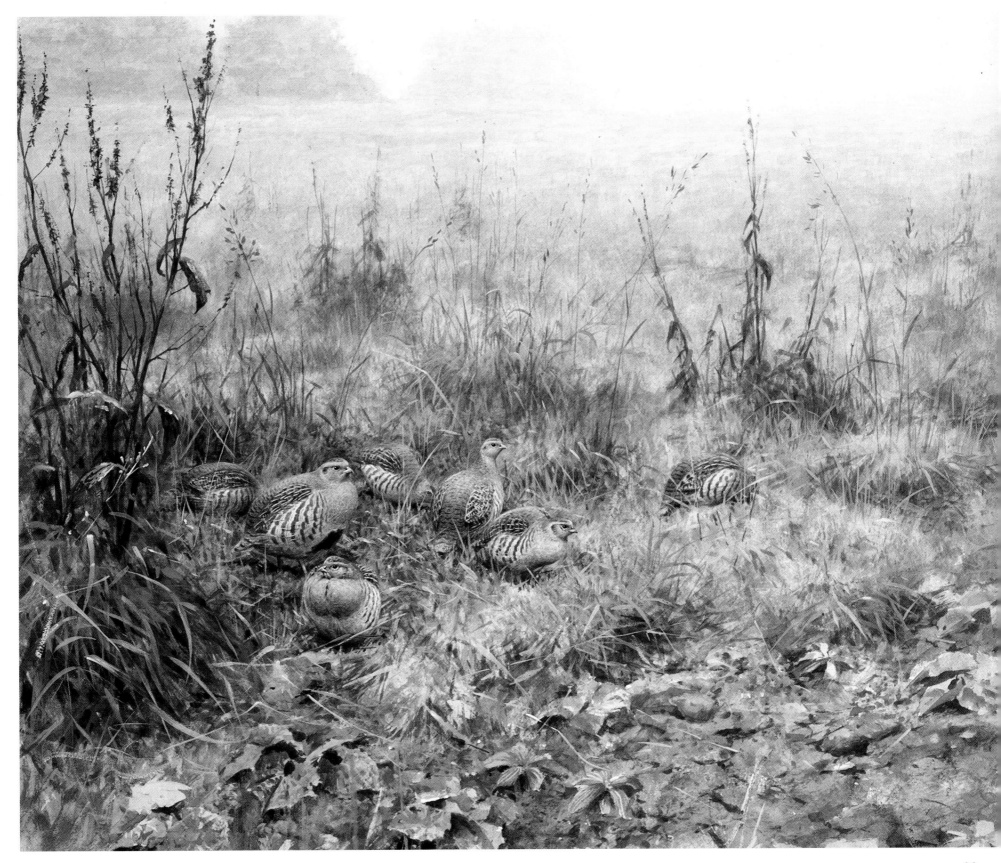

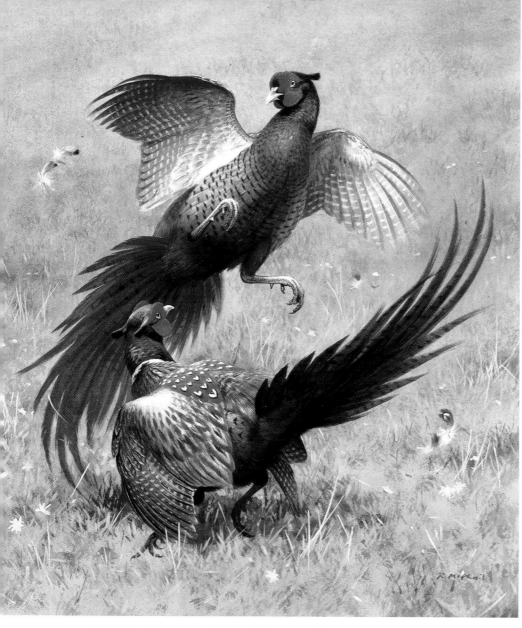

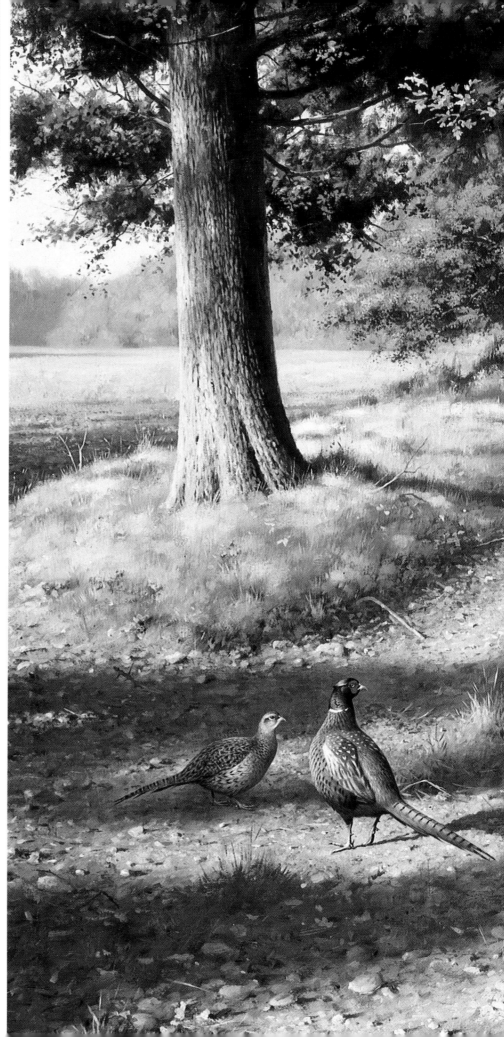

Fighting Pheasants 18" x 12" water-colour

These fighting pheasants were made to look ridiculous by the intervention of a lamb that was determined to act as referee.

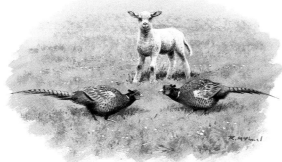

Opposite Page: Roebuck and Pheasants 40" x 50" oil

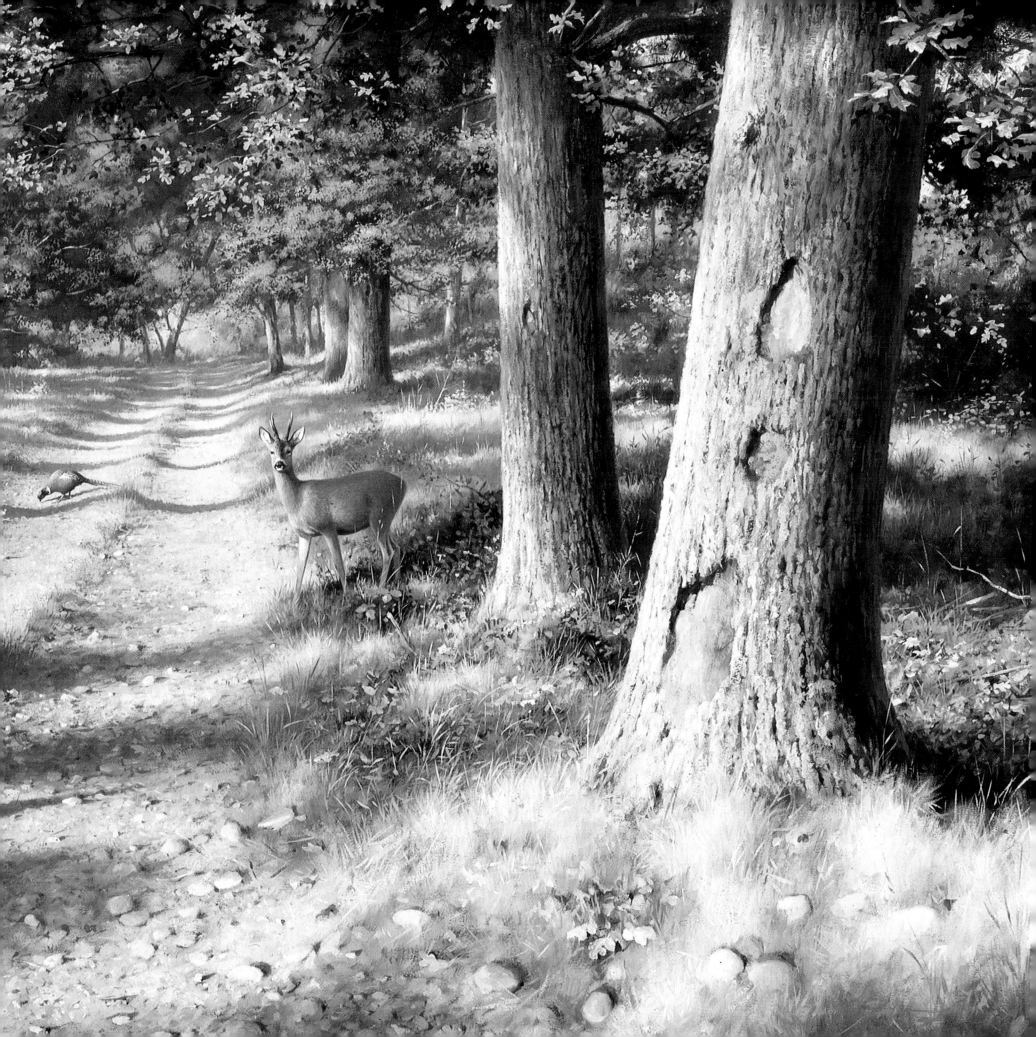

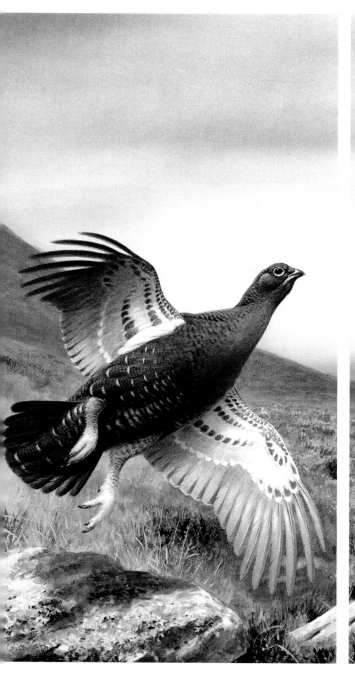

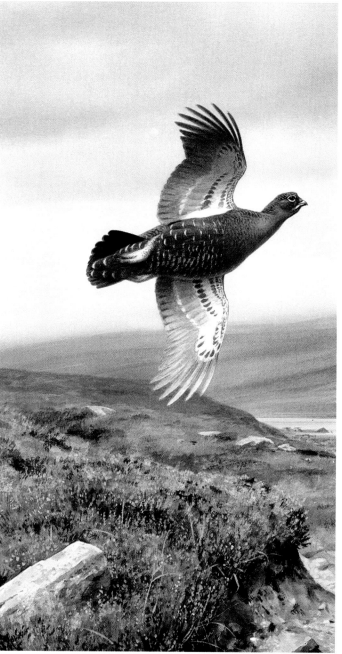

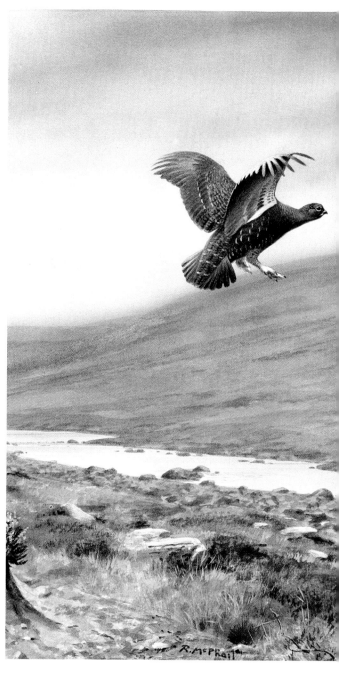

The advertisements that I did for "Famous Grouse" whisky ran in various forms for about 10 years.

I even did a cinema advertisement – a close-up of my paint-brush painting a grouse, cut in with shots of whisky pouring in slow motion. The one with four panels was made into a 40-foot poster! I was very proud of the lettering on the bottle.

These must have reached a wider public than any other work of mine.

RAISED IN THE HIGHLANDS.

THE
FAMOUS GROUSE
FINEST SCOTCH WHISKY
QUALITY IN AN AGE OF CHANGE

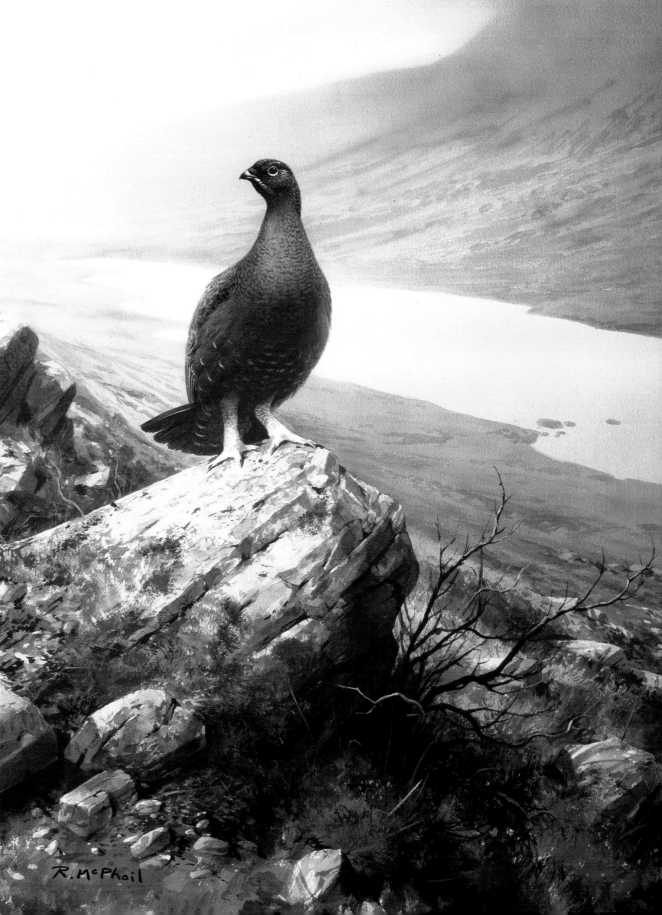

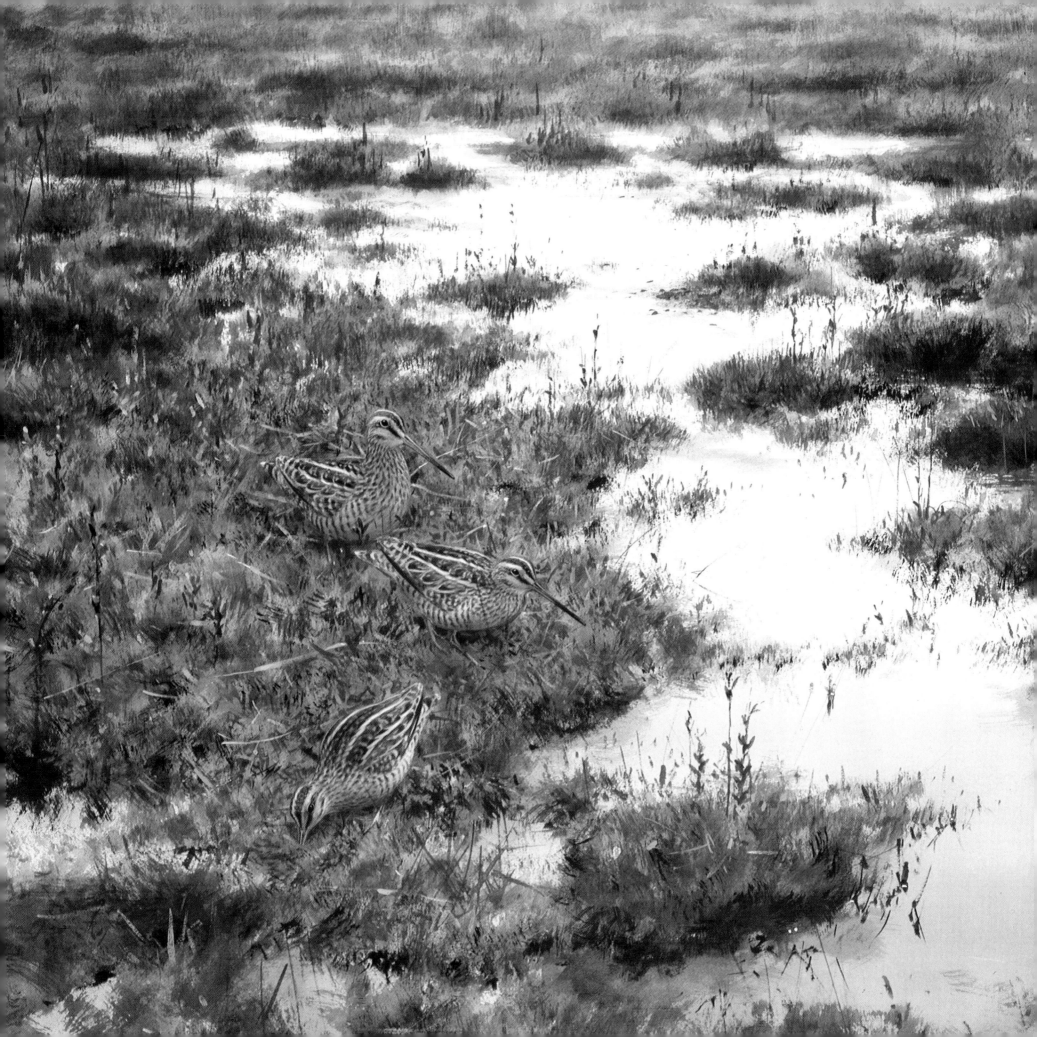

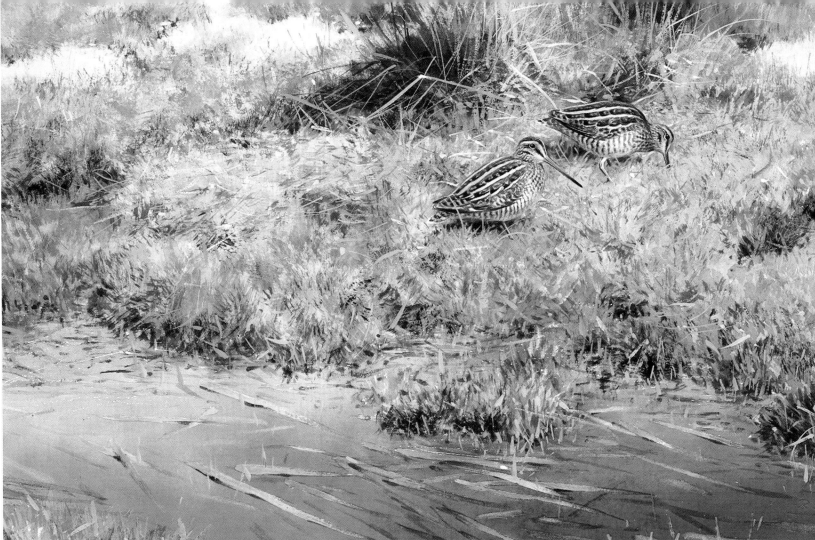

Above: Pair of Snipe 14″ x 18″ water-colour

Snipe are one of my favourite birds.
I never tire of painting them.

Opposite Page: Snipe 20″ x 26″ water-colour

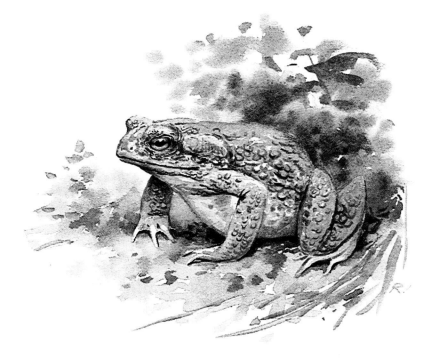

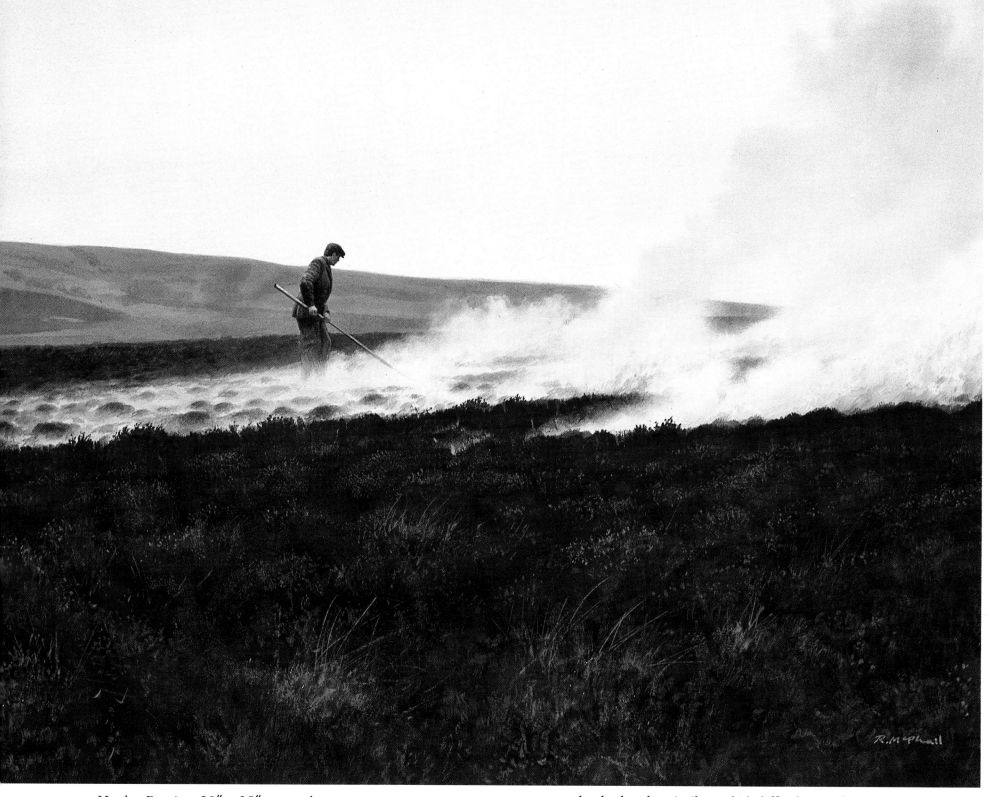

Heather Burning 20″ x 25″ water-colour

A good subject for a painting, if one that few grouse shooters ever see. It's hard, dirty work, but essential for the well-being of the moor.

Opposite: The Rock Butts 20″ x 24″ water-colour

The problem with painting driven grouse is that most grouse moors tend to look rather similar and it's difficult to make each one distinctive. No such difficulty with the famous "Rock Butts" drive at Eggleston – it could be nowhere else in Britain.

I painted this drive 20 years ago, for the McKinnons and shot my first grouse there.

Recently, I painted it again (right) for the new owner, Mr Michael Stone.

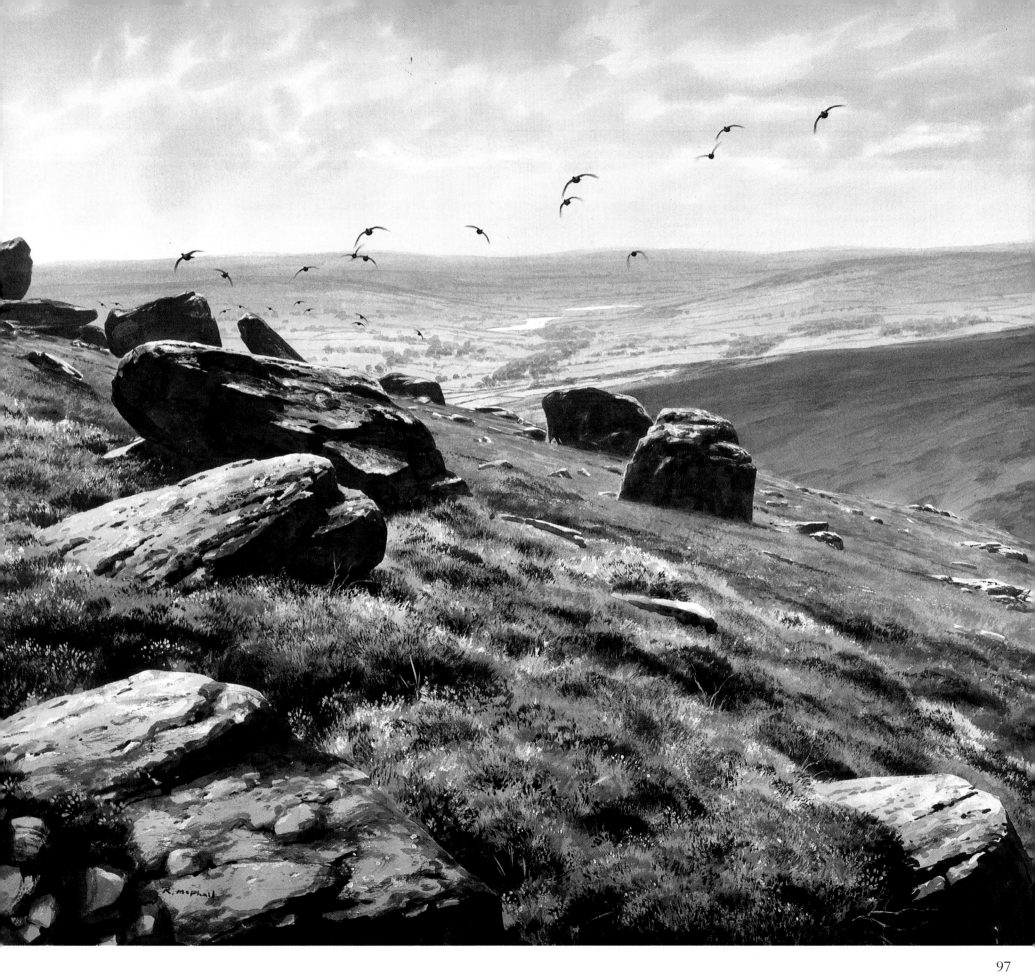

Right: Blackcock 15″ x 12″ water-colour

Opposite: Partridges in the Frost 17″ x 24″ water-colour

Below: Rabbit 20″ x 15″ oil

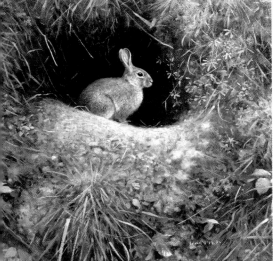

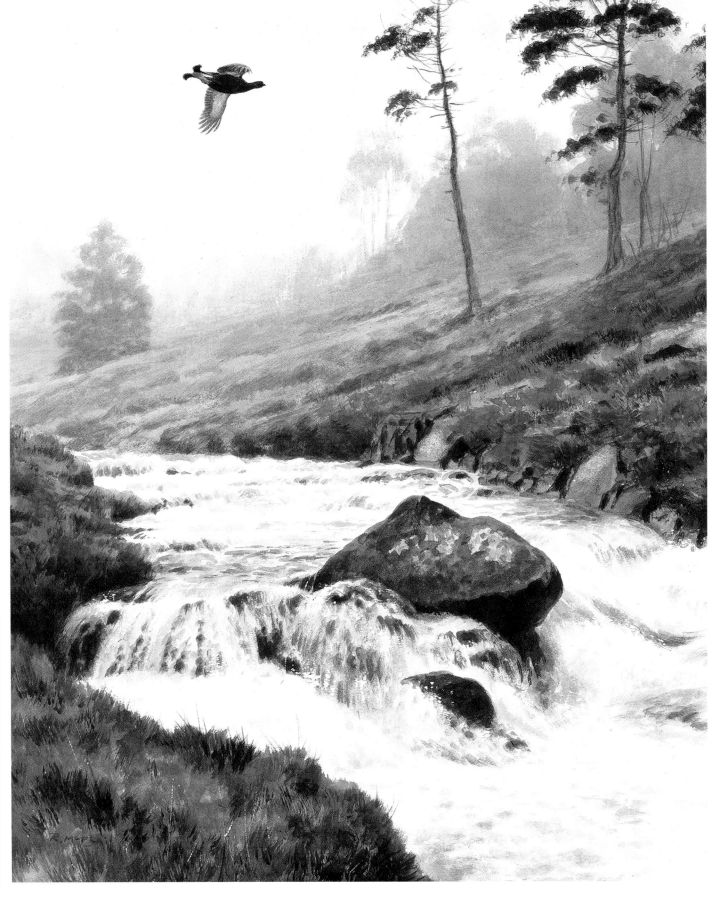

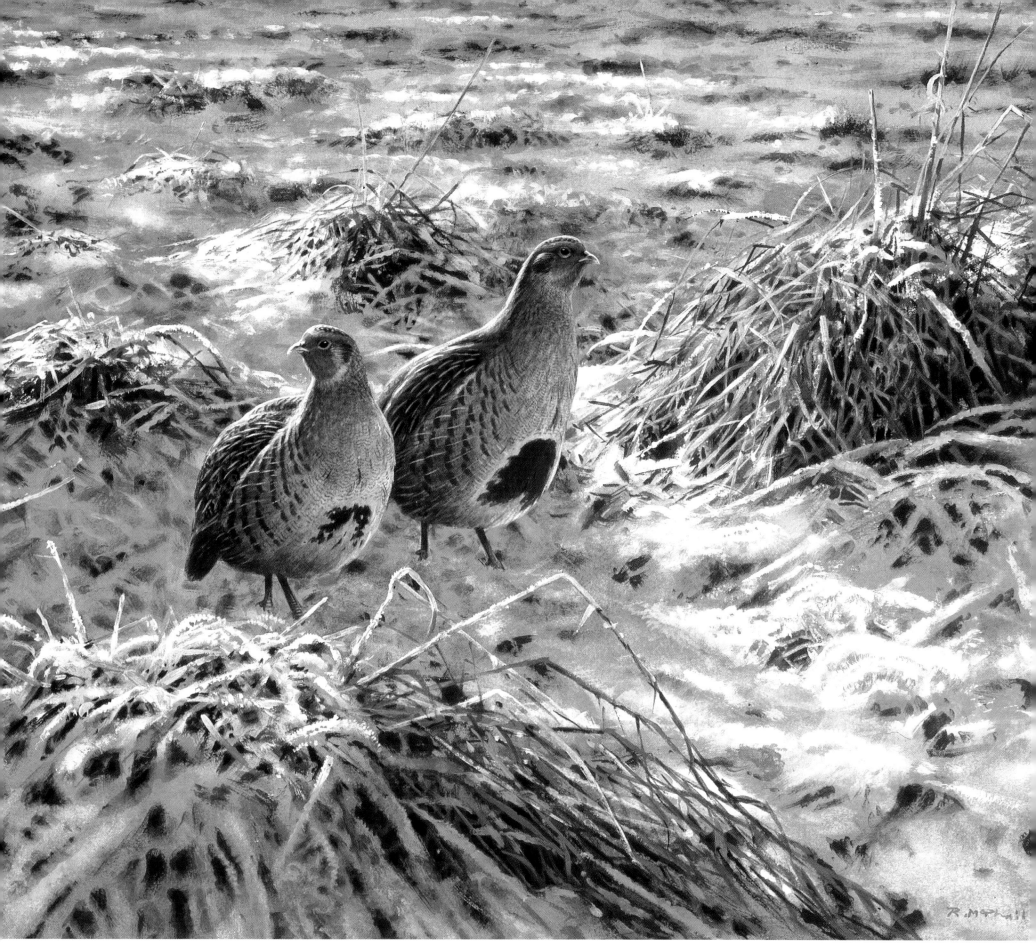

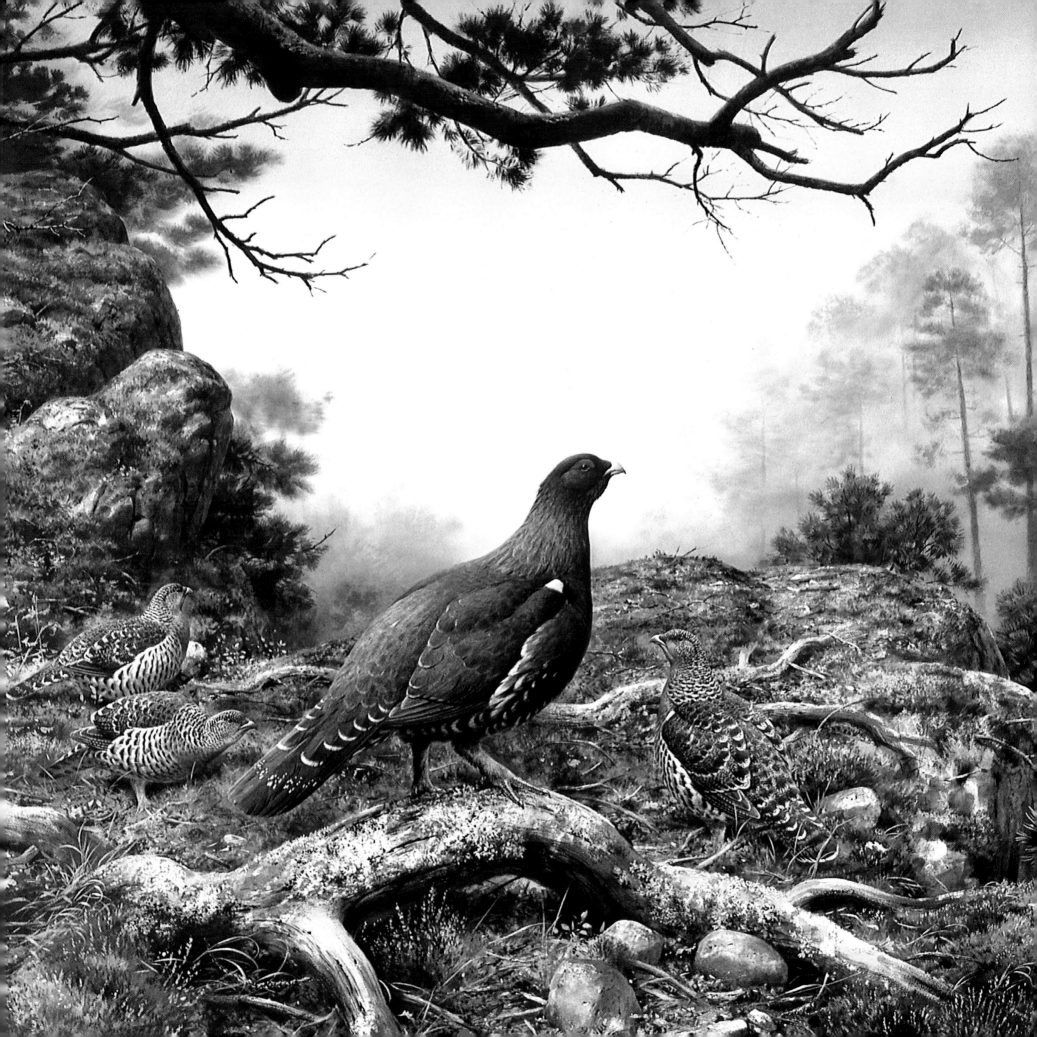

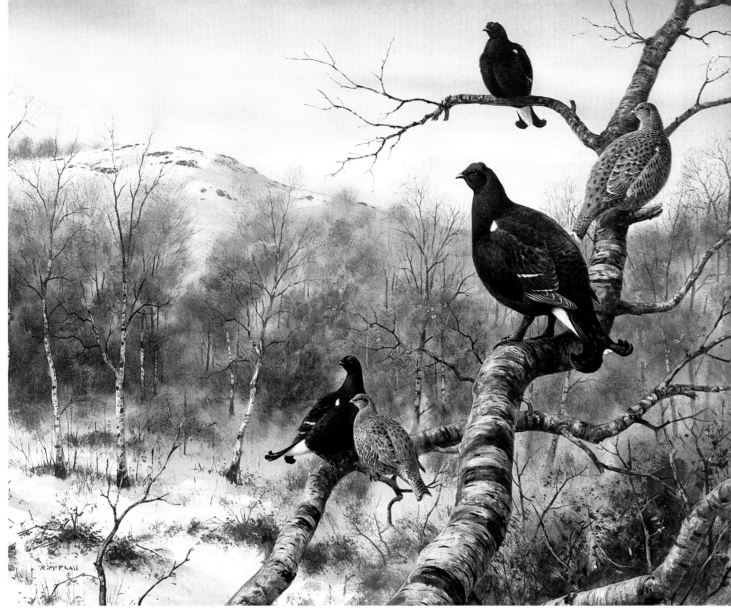

Above: Blackgame 19″ x 24″ water-colour

These are some of the pictures that decorate the House of Bruar near Blair Atholl.
The Capercaillie and the Grouse are the biggest watercolours I've done to date.

Left: Grouse 60″ x 42″ water-colour

Opposite Page: Capercaillie 42″ x 60″ water-colour

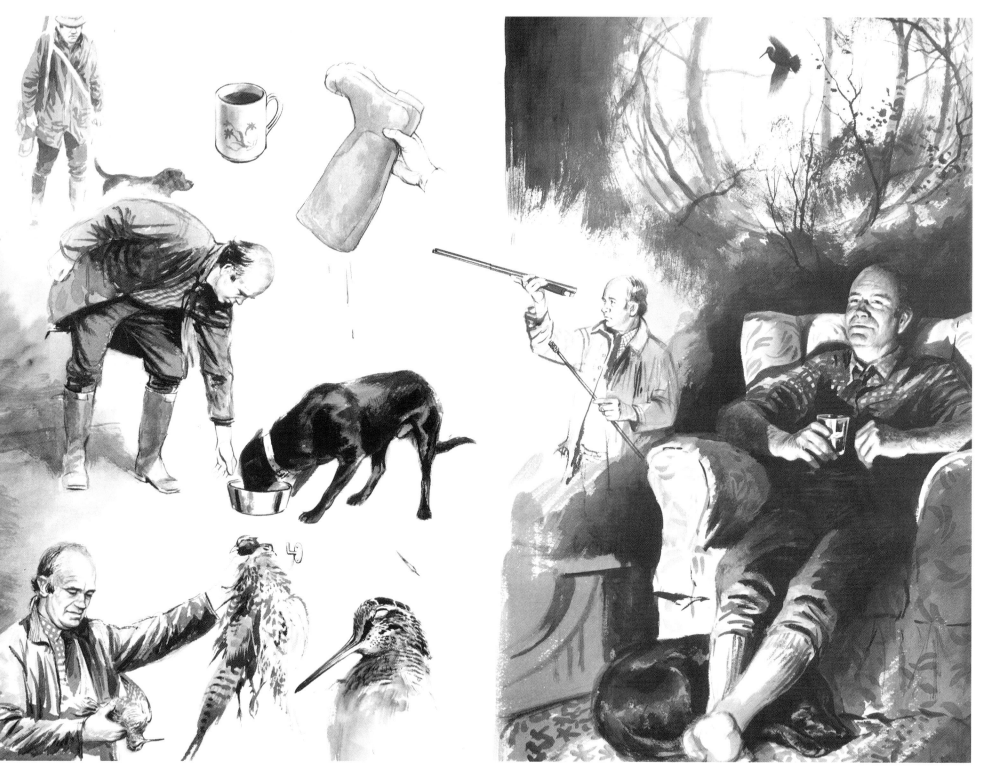

After the Shoot 18" x 24" sepia
(*From* Open Season)

Opposite:
The Walking Guns 22" x 28" water-colour

This was commissioned as a retirement present for John Herd, the Duke of Westminster's Keeper at Abbeystead.

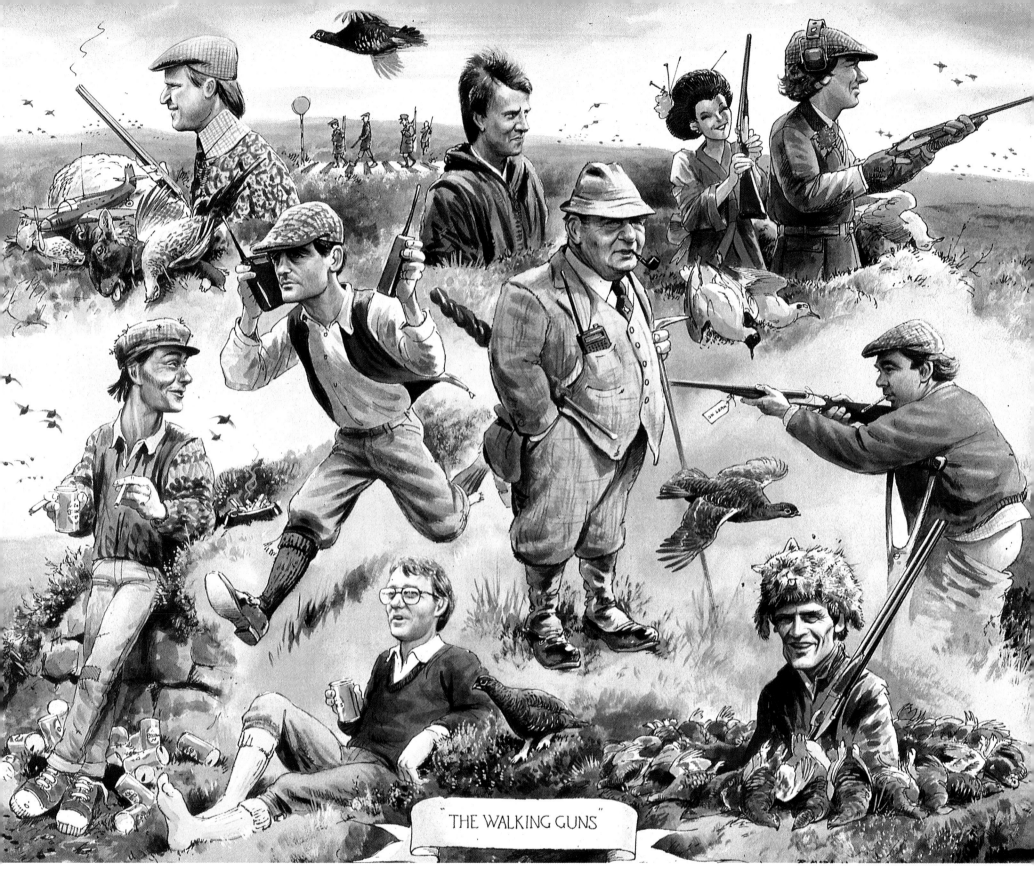

THE WALKING GUNS

Following Page:
"Cecilia Rowan" Cards
My wife's maiden name – Cecilia Rowan, seemed just right for these fluffy animal cards.
I've done lots of them over the years.
The one of voles blackberry picking has sold millions of copies.

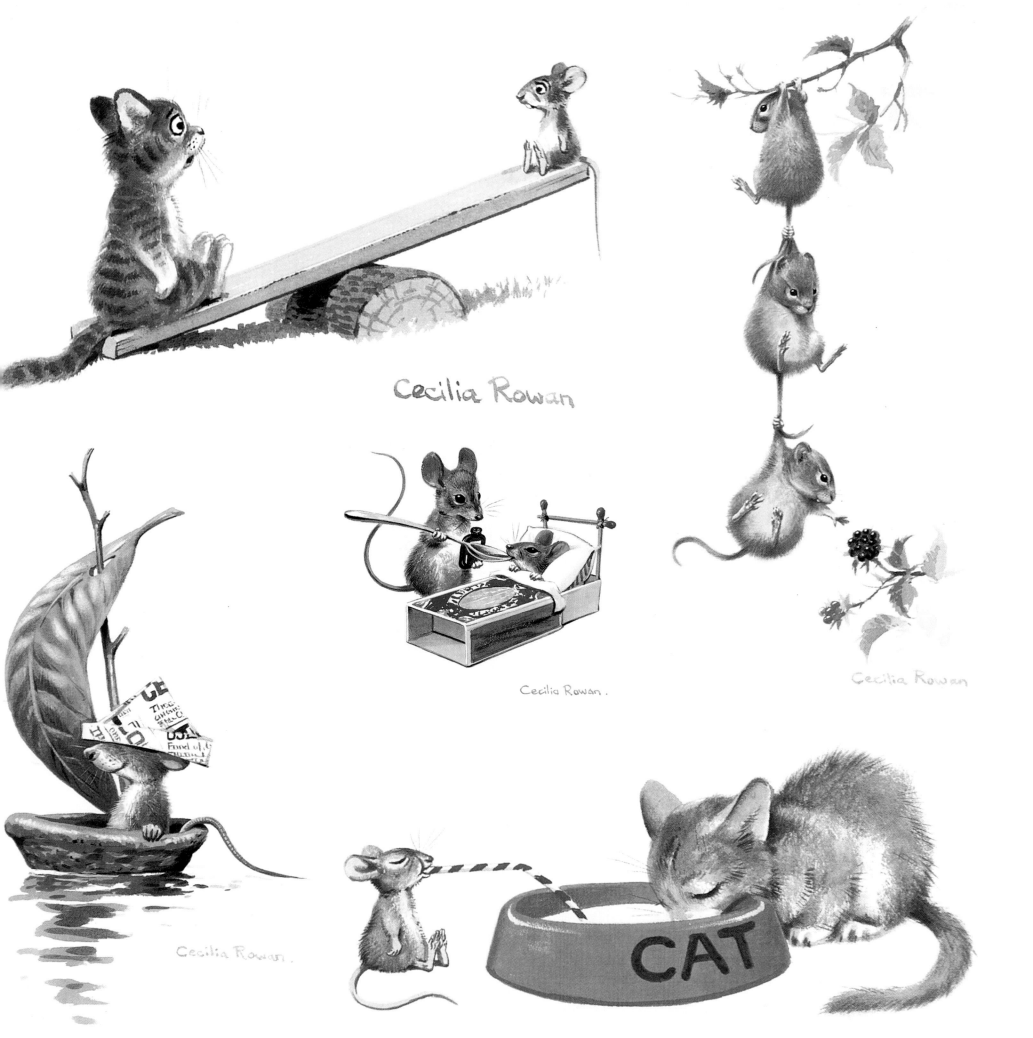

Cecilia Rowan

Cecilia Rowan.

Cecilia Rowan

Cecilia Rowan.

CAT

The Twitchers Guide.
These are some of the cartoons from The Twitchers
Guide, Birds Farm books 1989, with a foreword by
Robin Page.

Lady Amherst's Pheasant

Domestic Duck

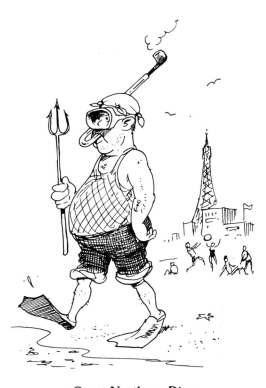

Great Northern Diver

Bean Goose

Rock Pipit

Crested tits

Arctic Skua

Godwit

Wood duck

Bullfinch

Sooty Tern

Little Bustard

Black-Headed Gull

Above: Dragon 16″ x 20″ water-colour

Opposite Page: Jailer 16″ x 20″ water-colour

These are illustrations from *Sir Agravaine* by P.G. Wodehouse.
I had just bought an airbrush, so the 20 or so pictures for this book
are full of airbrush work as I played with my new toy.
They are tricky to use, but good for suits of armour etc.

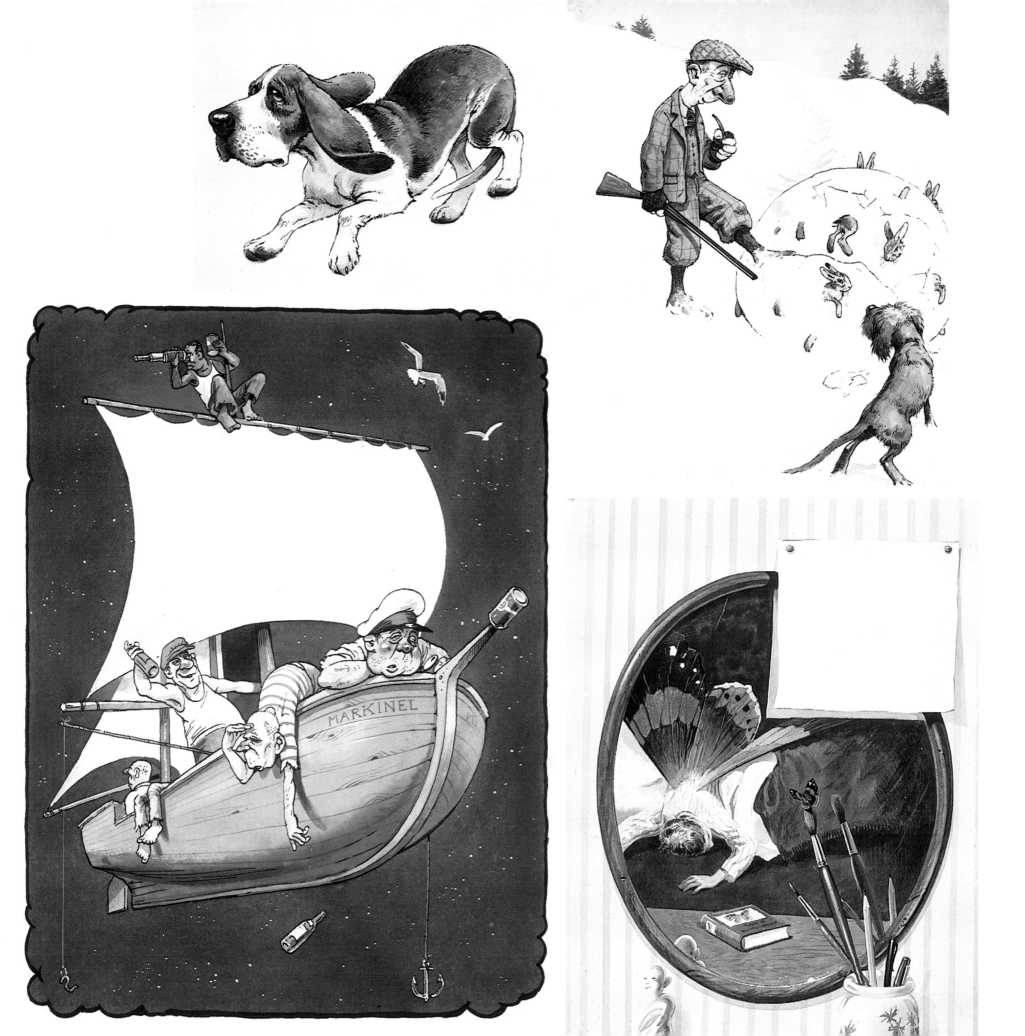

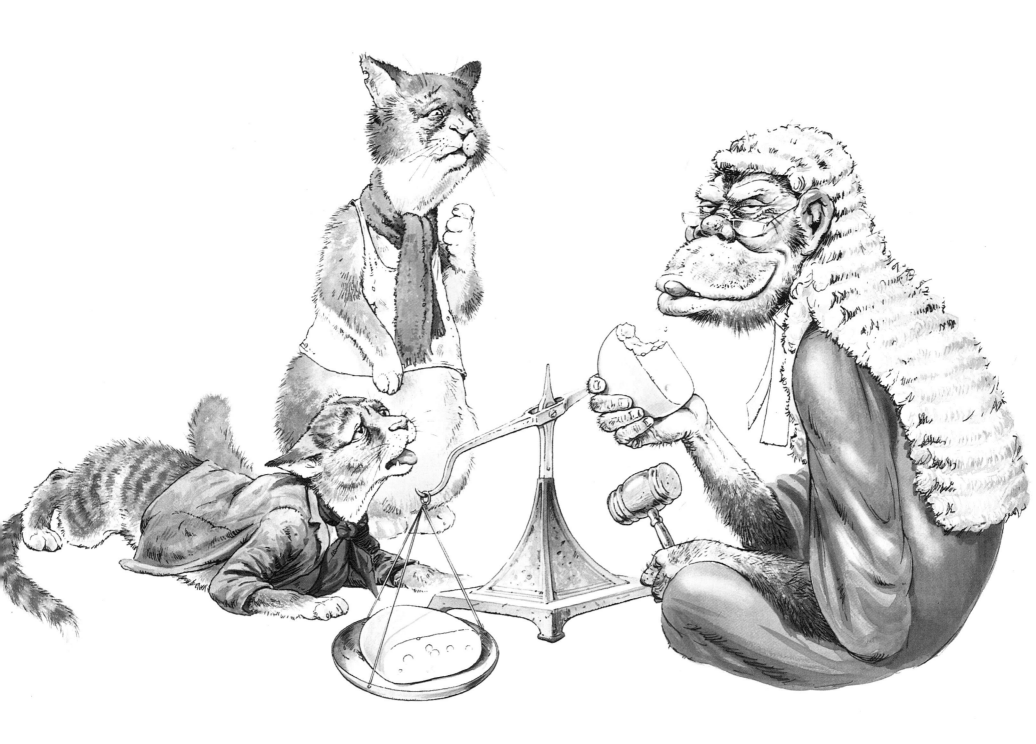

From The Oxford Book of Scottish Poetry
Oxford University Press 1983

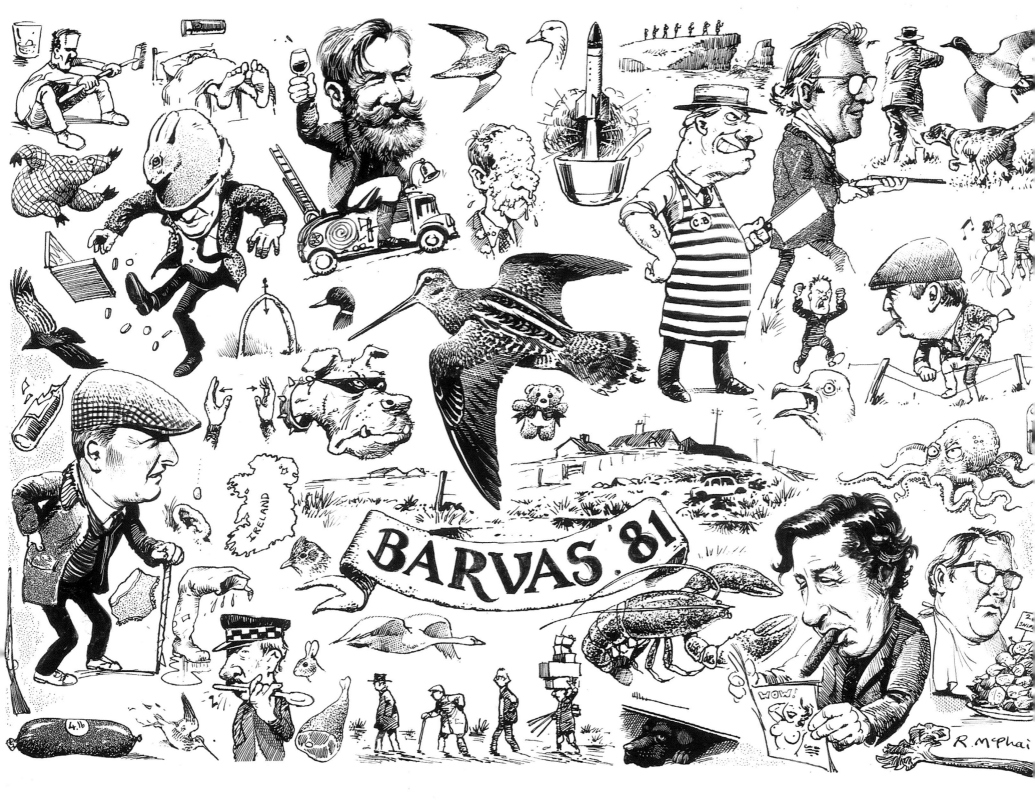

These scraper-board drawings were done as "Thank you" presents for
Peter Duckworth. "BARVAS" is his property on Lewis, where the
snipe shooting can be wonderful if the birds are in.
I had copies made to give to other members of the team as a
reminder of the great sport and wild parties!
I've done similar ones for fishing parties and Spanish Partridge
shooting.

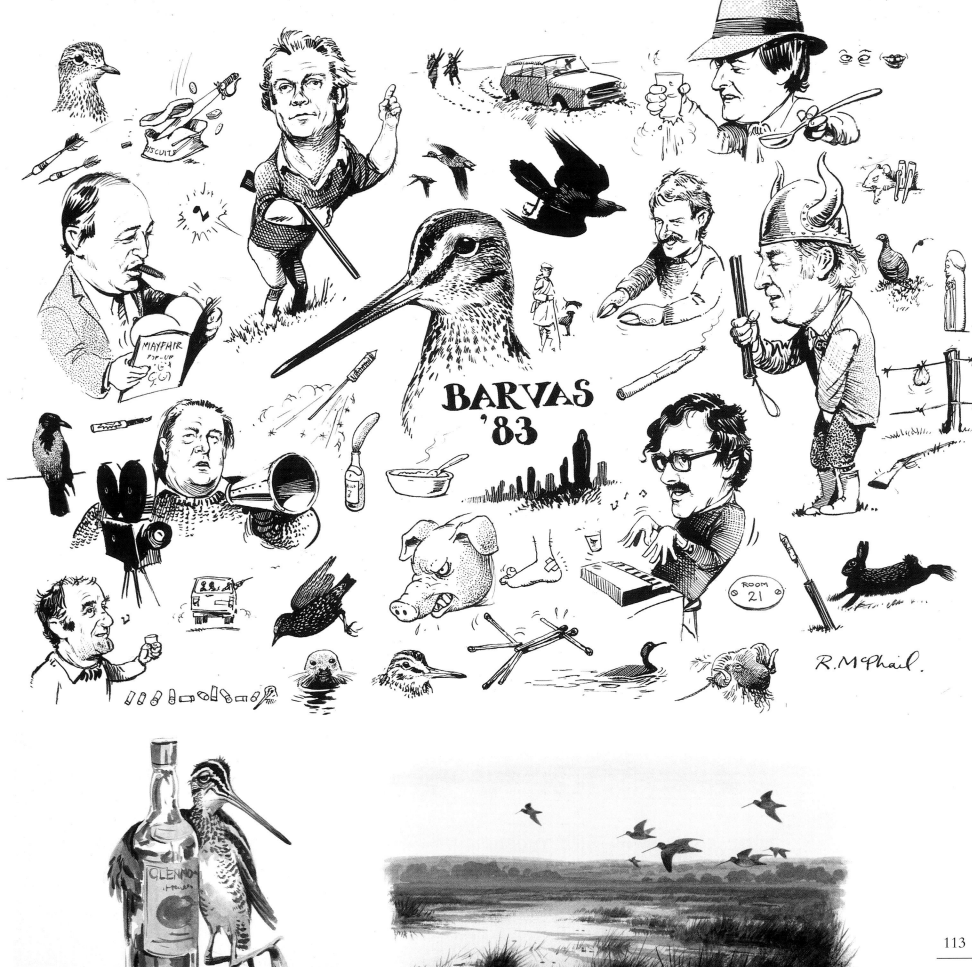

BARVAS '83

R.McPhail.

113

Greetings Cards published by Paper House

These are just a few of the designs for Paper House, I've done lots of them.

Some of the hand-made Christmas cards painted over the years for friends .

117

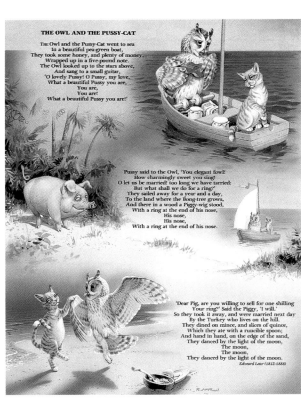

Left: The Mudwich (From Up the Boo–Aye.)

Far Left: The Owl and the Pussycat. 12″ x 18″ water-colour Abercrombie and Kent commissioned this.
They made a print out of it to give to honeymoon couples.

Below: Passing the Port 18″ x 24″ water-colour

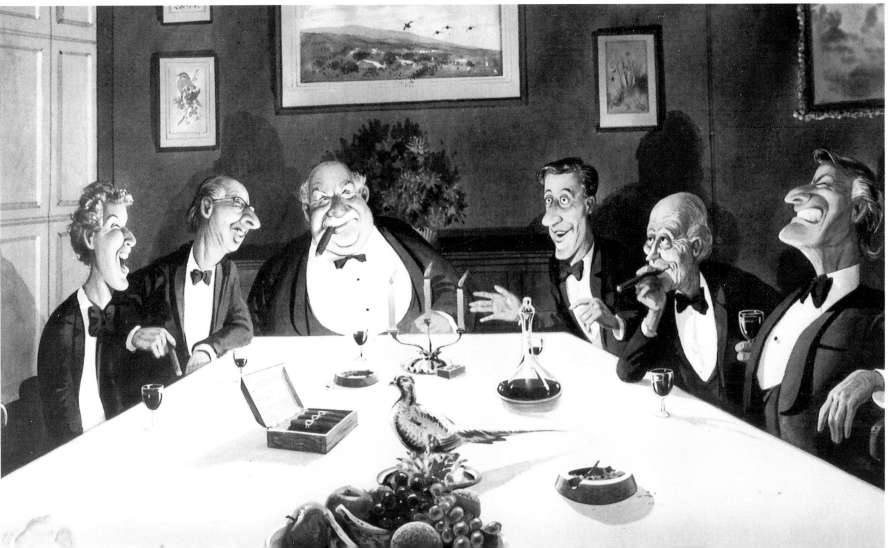

From Up the Boo-Aye Shooting Pookakies
by Mike Harding
Savoy Press 1980

These are some of the illustrations for a book of poems that
Mike Harding originally wrote for his children when they
were small.
The publishers went bust the week this book came out, so
it was a lot of work for nothing.

From Up the Boo-Aye

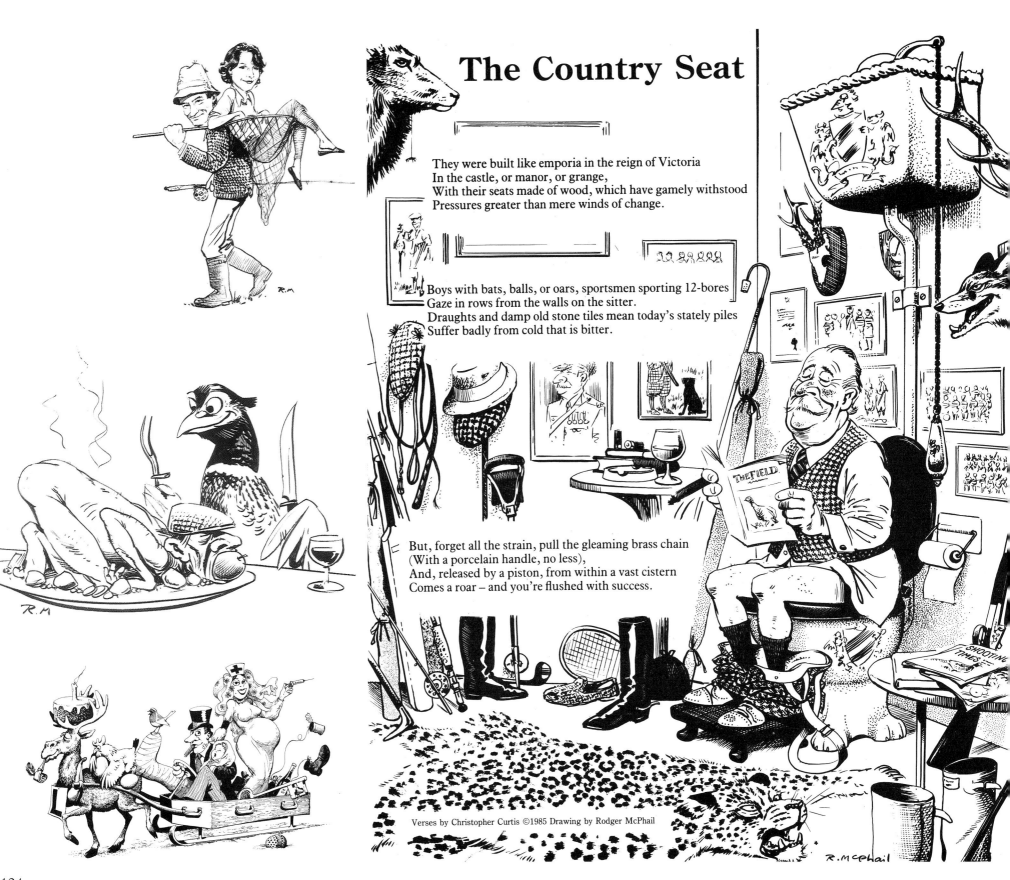

The Country Seat

They were built like emporia in the reign of Victoria
In the castle, or manor, or grange,
With their seats made of wood, which have gamely withstood
Pressures greater than mere winds of change.

Boys with bats, balls, or oars, sportsmen sporting 12-bores
Gaze in rows from the walls on the sitter.
Draughts and damp old stone tiles mean today's stately piles
Suffer badly from cold that is bitter.

But, forget all the strain, pull the gleaming brass chain
(With a porcelain handle, no less),
And, released by a piston, from within a vast cistern
Comes a roar – and you're flushed with success.

Verses by Christopher Curtis ©1985 Drawing by Rodger McPhail

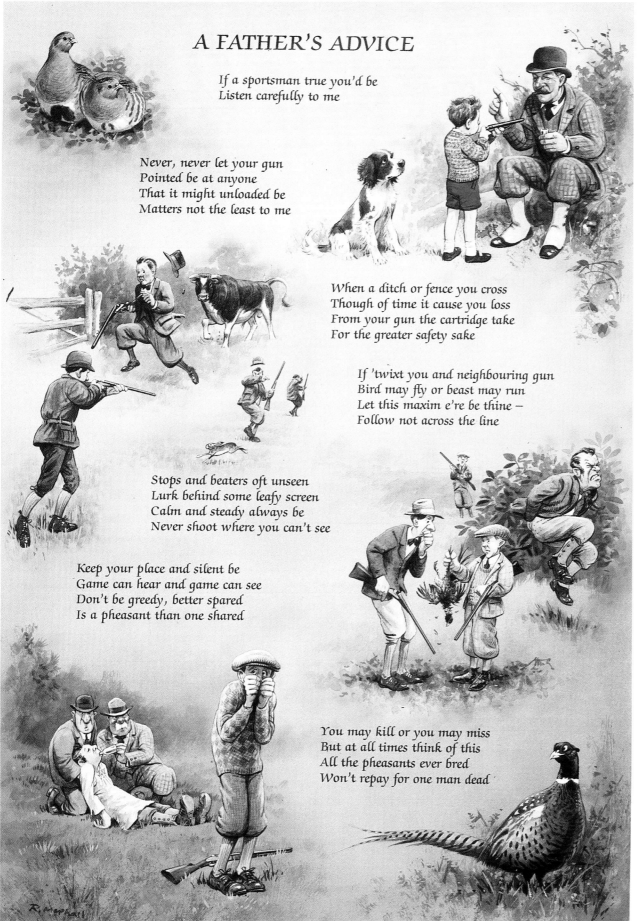

A FATHER'S ADVICE

If a sportsman true you'd be
Listen carefully to me

Never, never let your gun
Pointed be at anyone
That it might unloaded be
Matters not the least to me

When a ditch or fence you cross
Though of time it cause you loss
From your gun the cartridge take
For the greater safety sake

If 'twixt you and neighbouring gun
Bird may fly or beast may run
Let this maxim e're be thine –
Follow not across the line

Stops and beaters oft unseen
Lurk behind some leafy screen
Calm and steady always be
Never shoot where you can't see

Keep your place and silent be
Game can hear and game can see
Don't be greedy, better spared
Is a pheasant than one shared

You may kill or you may miss
But at all times think of this
All the pheasants ever bred
Won't repay for one man dead

Above: Frog and Bumblebees
15" x 12" water-colour

Left: A Father's Advice

This poem has been illustrated many times. This version was published by Pensthorpe Waterfowl Trust.

Opposite Page:
The Country Seat by Christopher Curtis.

Cartoons for a friend's wedding invitation and wedding menu.

An All-purpose Greetings card published by S. Hoyle.

Right: Ancestral Portrait (Norman Bullen) – detail

H.M.S. Pinafore

R.M. with Norman Bullen as Captain Corcoran & Dick Deadeye

Left: Ancestral Portrait (Chris O'Donnell) 84″ x 30″ oil

Opposite Page Bottom: Preliminary Stage Design for Act 2 of Ruddigore *10″ x 13″*

In 1994 the Hornby Occasionals, my Gilbert and Sullivan group produced *Ruddigore*. The second act is set in the picture gallery of Ruddigore castle. At one scene the lights go out for a few seconds, and when they come on again, the portraits have turned to life! To ghostly music, the spectres of the ancestors step out of their frames to haunt the Bad Baronet of Ruddigore (me). I had a false wall made and painted it to look like stone and picture frames. The life-sized portraits of the actors were painted on boards, that were removed when the lights went out. It worked very well. This portrait had to be jointed and hinged so that it could be hidden behind the false wall.

Utopia Ltd.

RM with Peter Silvester as Scapphio & Phantis

Ruddigore

RM with Django Sankey as Robin Oakapple & Rose Maybud

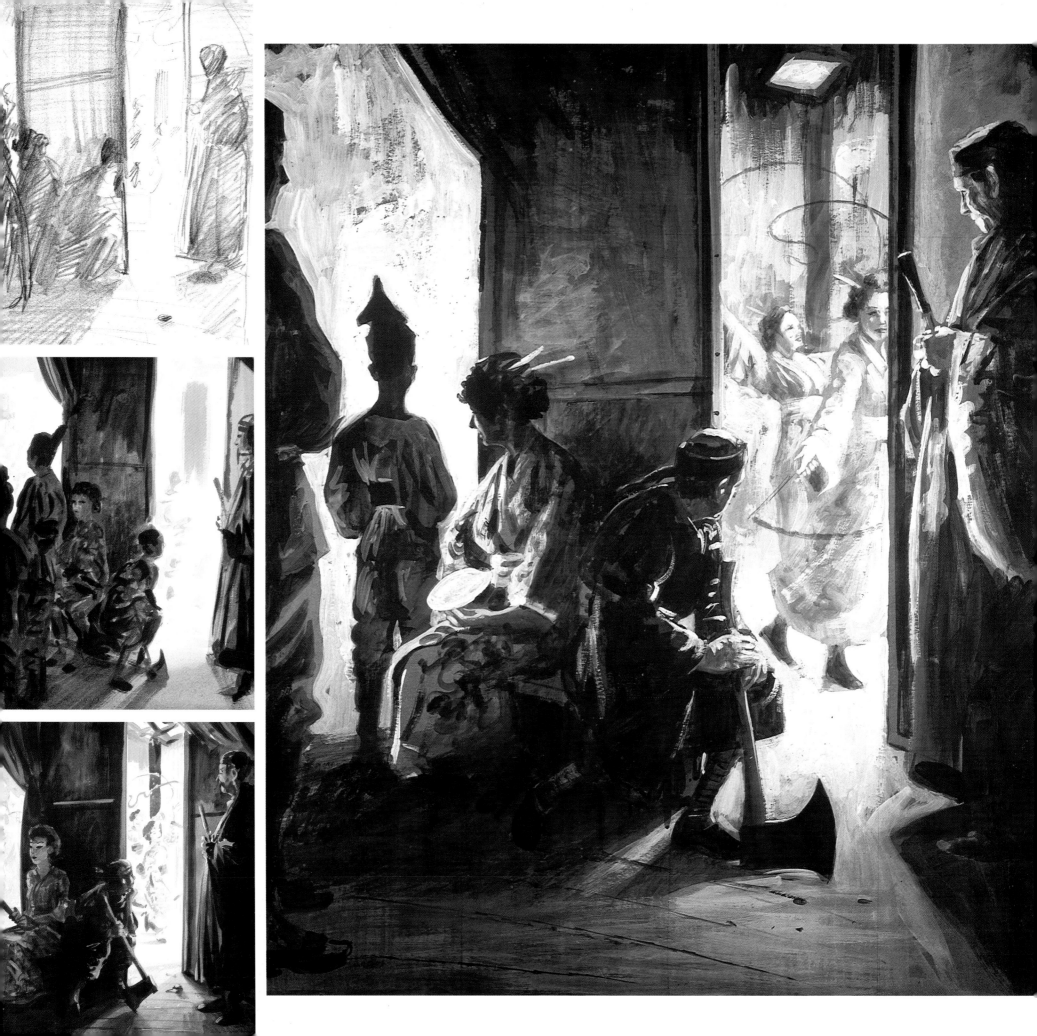

Opposite Page: Preliminary Work for Waiting in the Wings 20″ x 14″ water-colour

Right: Waiting in the Wings 36″ x 24″ oil

This is the 1997 Hornby Occasionals production of *The Mikado*. That's me with the axe as Ko-Ko the Lord High Executioner. Only those who have "trod the boards" can know the bowel-churning terror of waiting to go on stage!

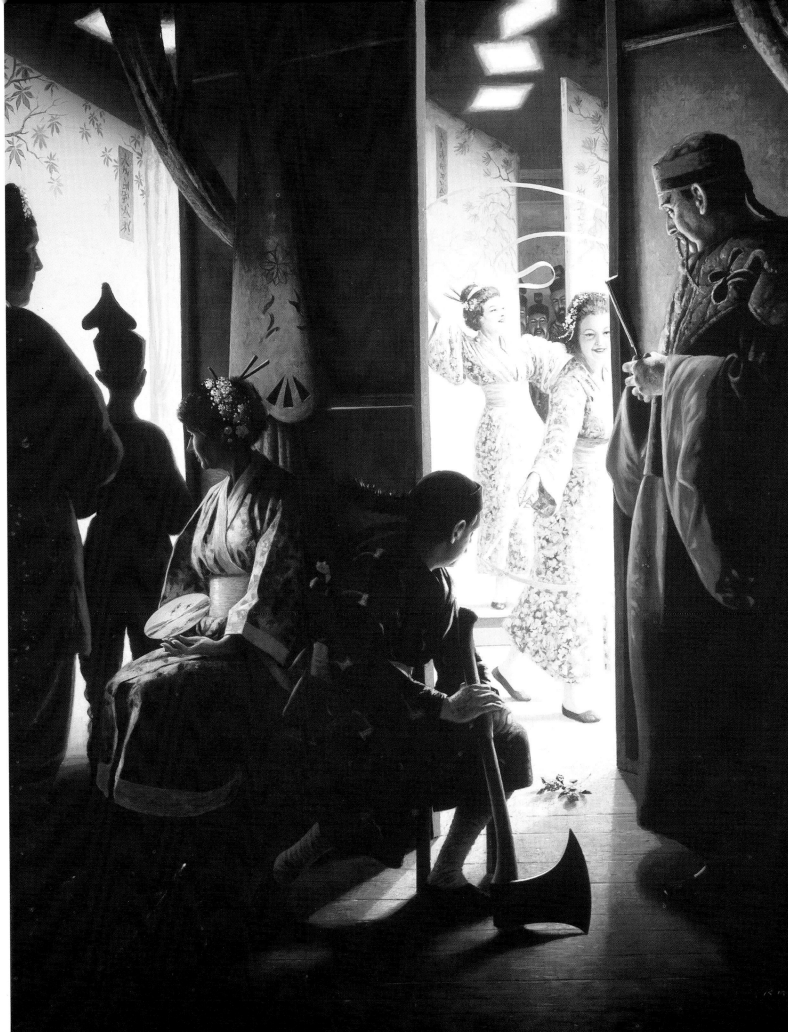

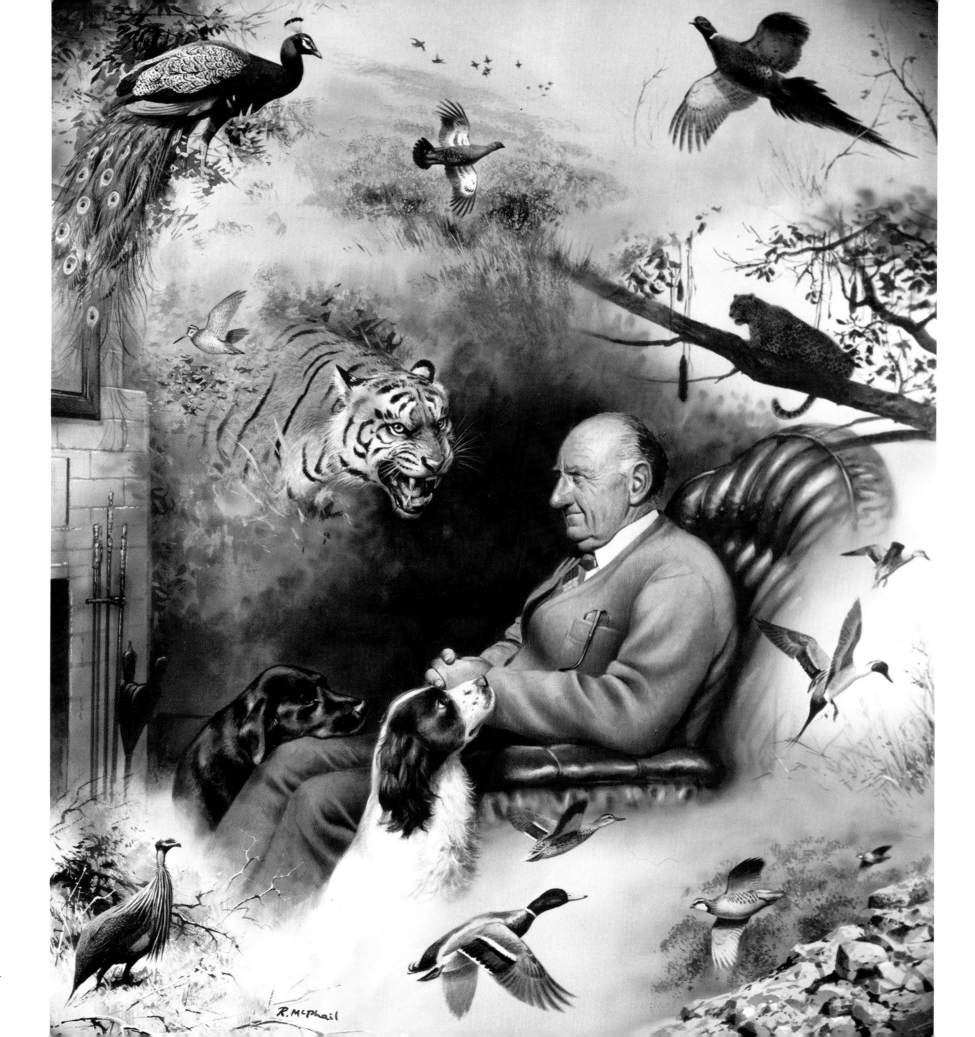

R. McPhail

Above: Golf at Newcastle 19″ x 26″ water-colour

I don't play golf .
This is my one and only golfing picture.
I was over in Ireland to paint a shooting portrait for the
Webb family, and they asked me to do a golf one too.
It's a pretty golf links between Belfast and Dublin with
the "Mountains of Mourne sweeping down to the sea"
in the background.

Left: In the Pub 9″ x 12″ water-colour

Left: Timothy Kimber, High Sheriff of Lancashire 18″ x 14″ water-colour

Tim's wife wanted a "Spy" cartoon-like picture, instead of a formal portrait.
The eyes are the most difficult part of a portrait, so Tim was easy – you can't see his for his long
flowing eyebrows!

Opposite Page: Bill Stremmel 30″ x 20″ water-colour

131

Right: Mrs Nadine Cantey 18″ x 14″
water-colour

Opposite Page: Mrs Judith Duckworth
60″ x 36″ oil

Mrs Duckworth was the first Lady High
Sheriff of Lancashire.

Below: Preliminary Sketch for a Portrait of
Shirley Hodgkiss pencil

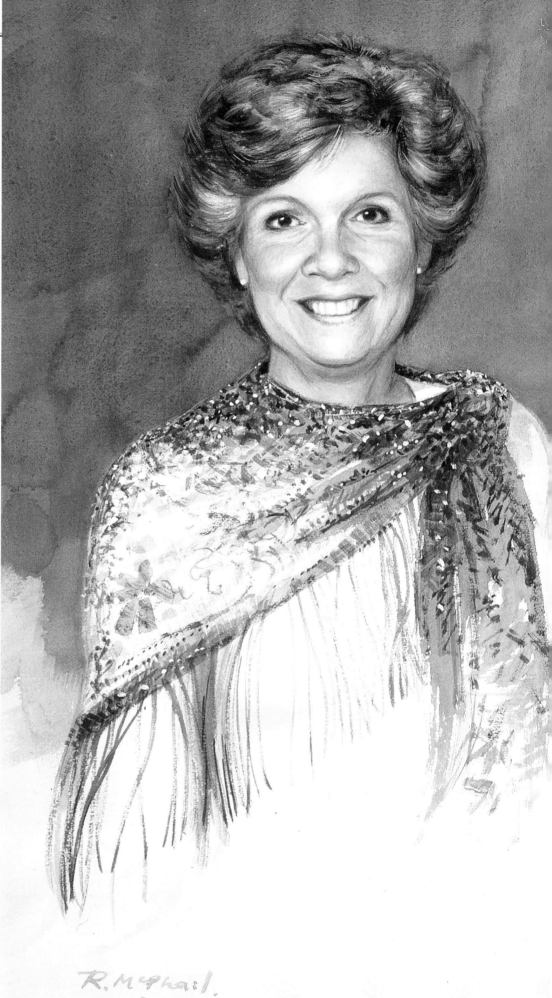

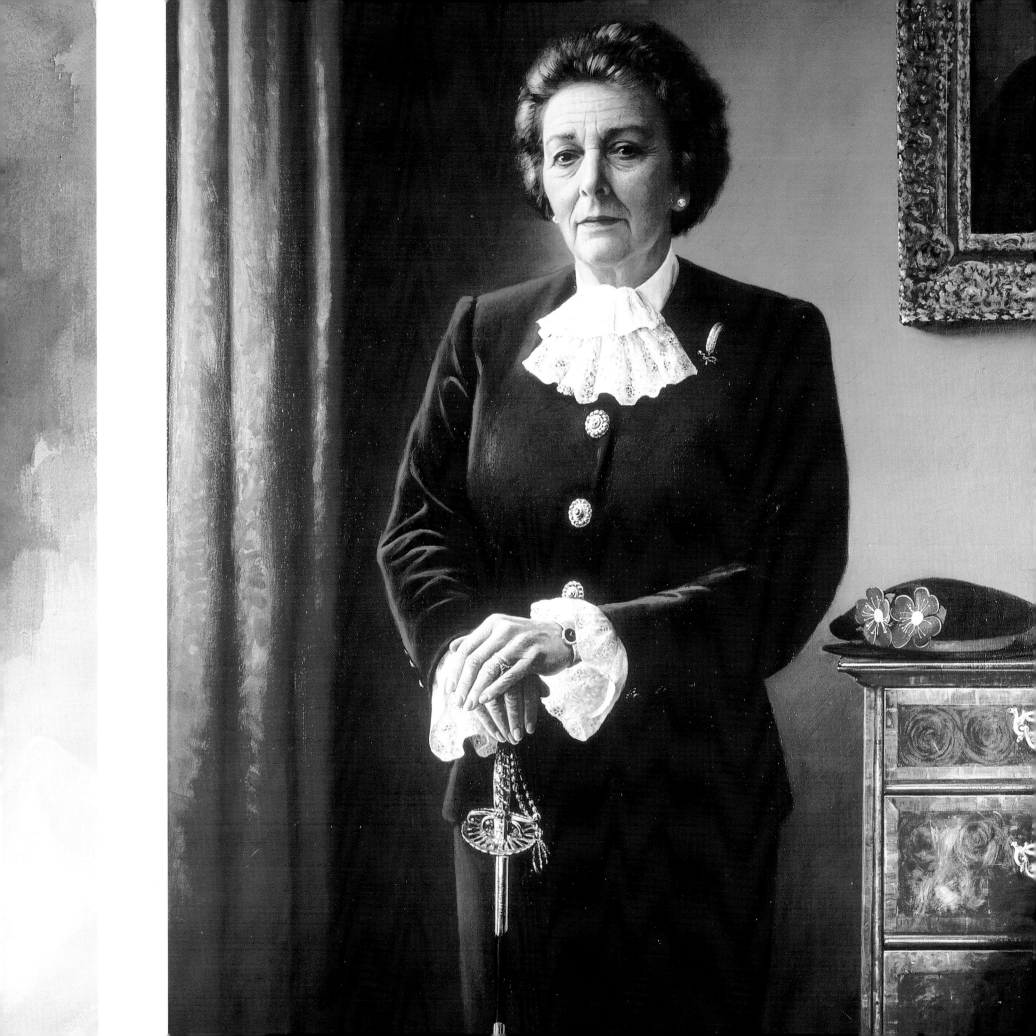

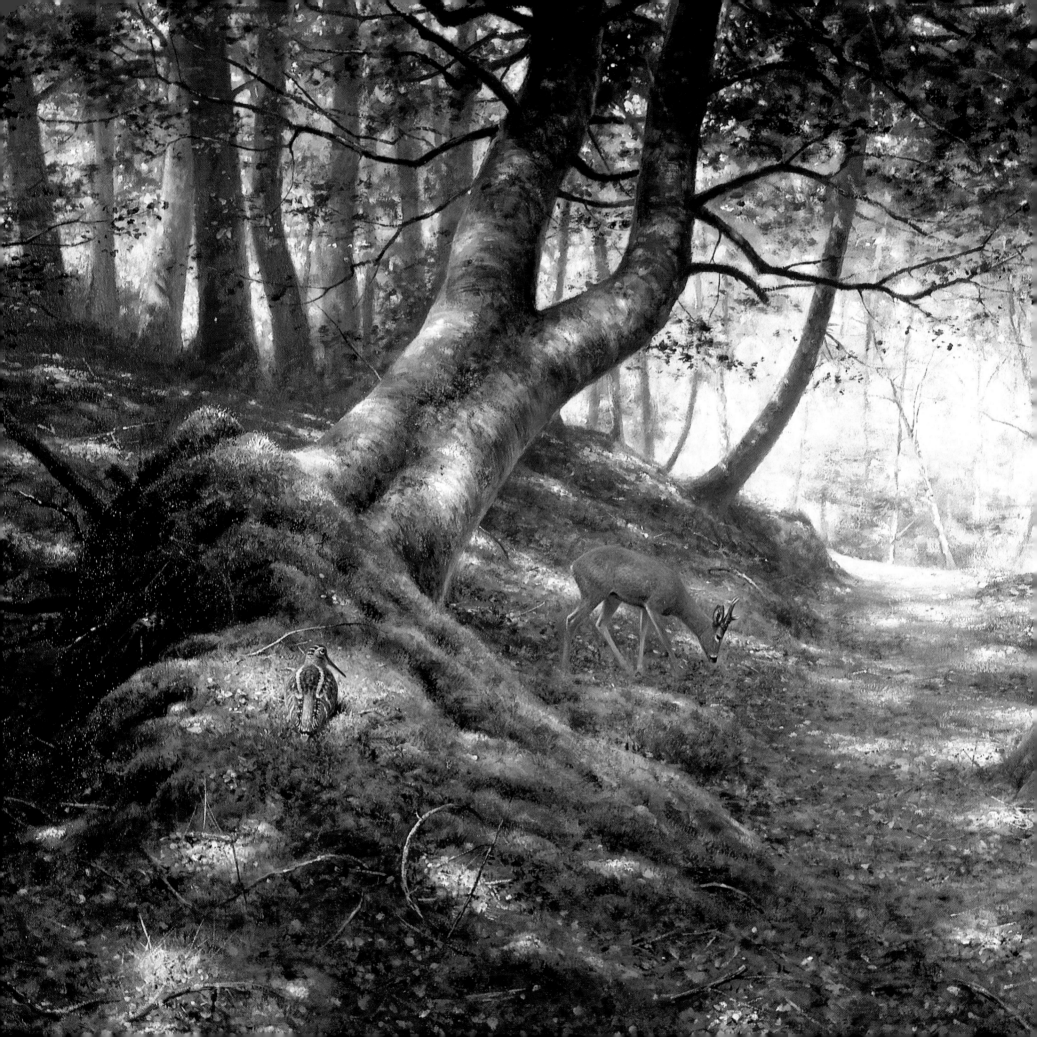

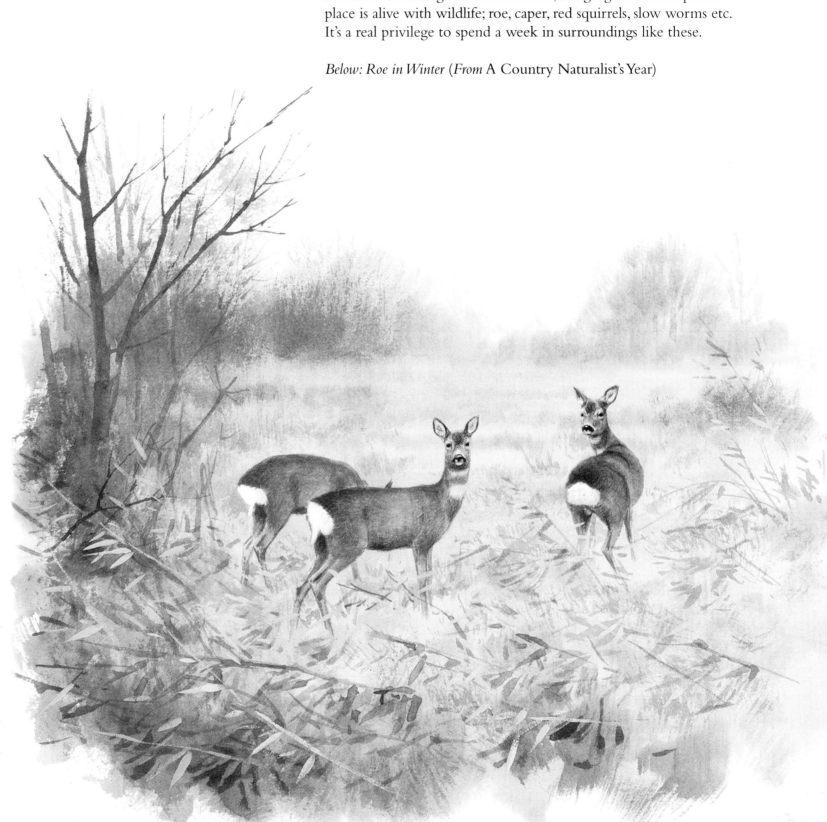

Opposite Page: Above the Findhorn 30″ x 35″ oil

This is a high path between the pools on the Findhorn – the most beautiful river in Scotland.
I've fished it for 20 years.
No road runs alongside the Findhorn, the gorge is too steep. The place is alive with wildlife; roe, caper, red squirrels, slow worms etc.
It's a real privilege to spend a week in surroundings like these.

Below: Roe in Winter (From A Country Naturalist's Year*)*

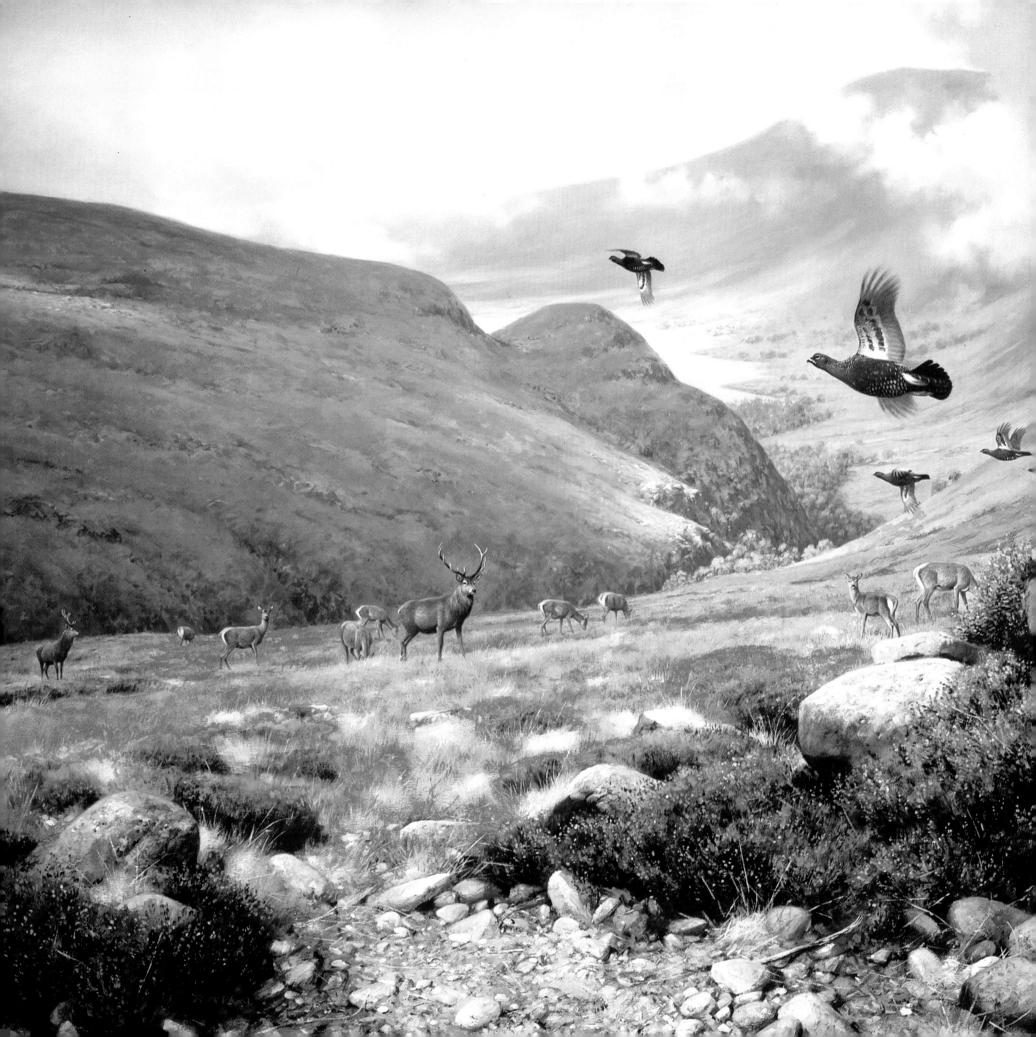

Above: Left Behind 14″ x 10″ oil

Anyone who has gone as a spectator with a stalking party in the Highlands will know this feeling.
The stalker and "rifle" will have gone forward to crawl in to the shot.
They may be five minutes, they may be two hours.
It can get very cold.

Left: Grouse & Red Deer 36″ x 48″ oil

Another imaginary background. "Glen Figment" as a friend called it.

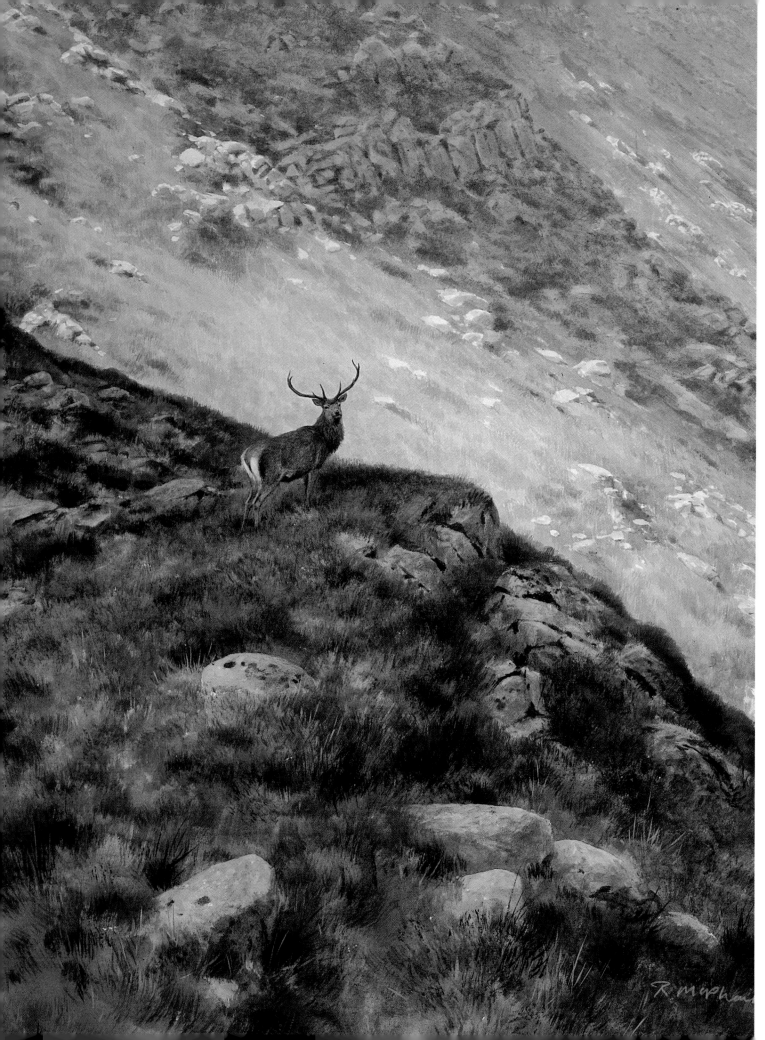

Left: Stag at Glen Etive 21″ x 16″
water-colour

For many years I have made an annual trip to Glen Etive to stalk deer with Peter Keyser and Andrew Lukas.
We were privileged to have, as our guide and mentor, Alastair Hunter – the finest stalker in the Highlands.
Alastair was, and still is, very selective about which beasts he chooses for culling.
Peter used to get frustrated as stag after stag was turned down for being "too good to shoot".

Opposite Below:
Roe and Garden Gnome. sepia
(From Roe Deer *by Richard Prior.)*

Opposite Above:
Stag and Hinds 24″ x 30″ oil

There is no doubt that the camera can be a valuable tool for an artist.
I saw these clouds against a dark hill in Scotland, stopped the car and took a photograph, changed the foreground and stuck the deer in.
Often, the most interesting effects of light and weather are fleeting. They would be gone by the time you've got your paints out. That's when the camera comes into its own.

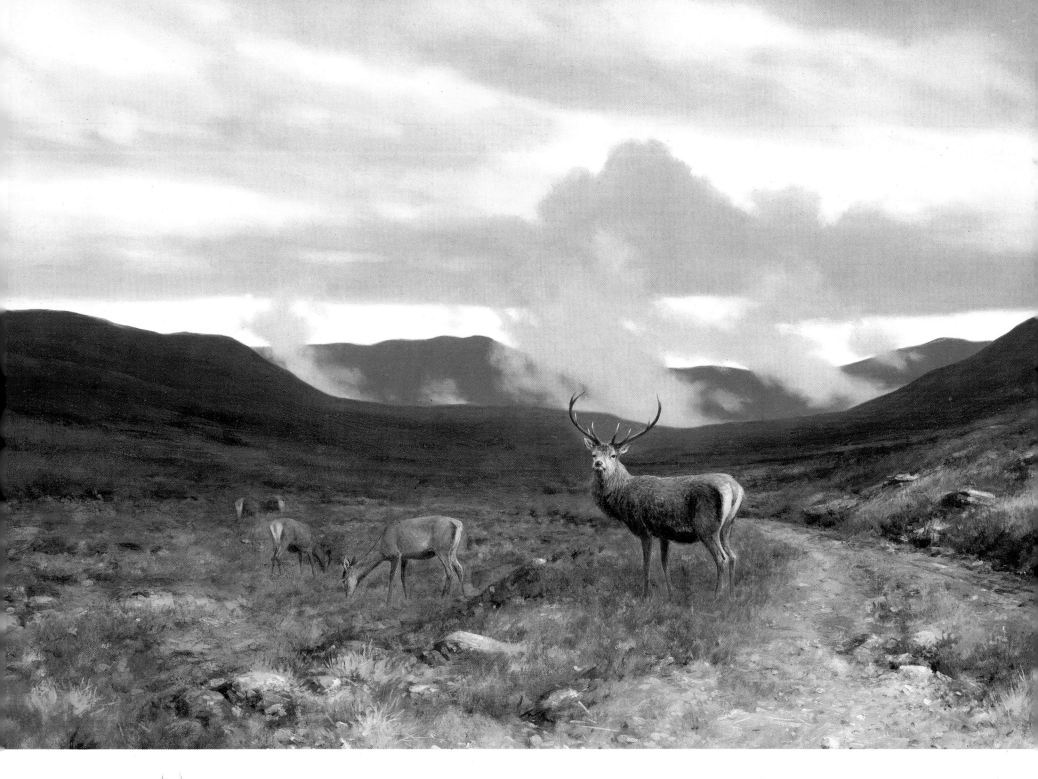

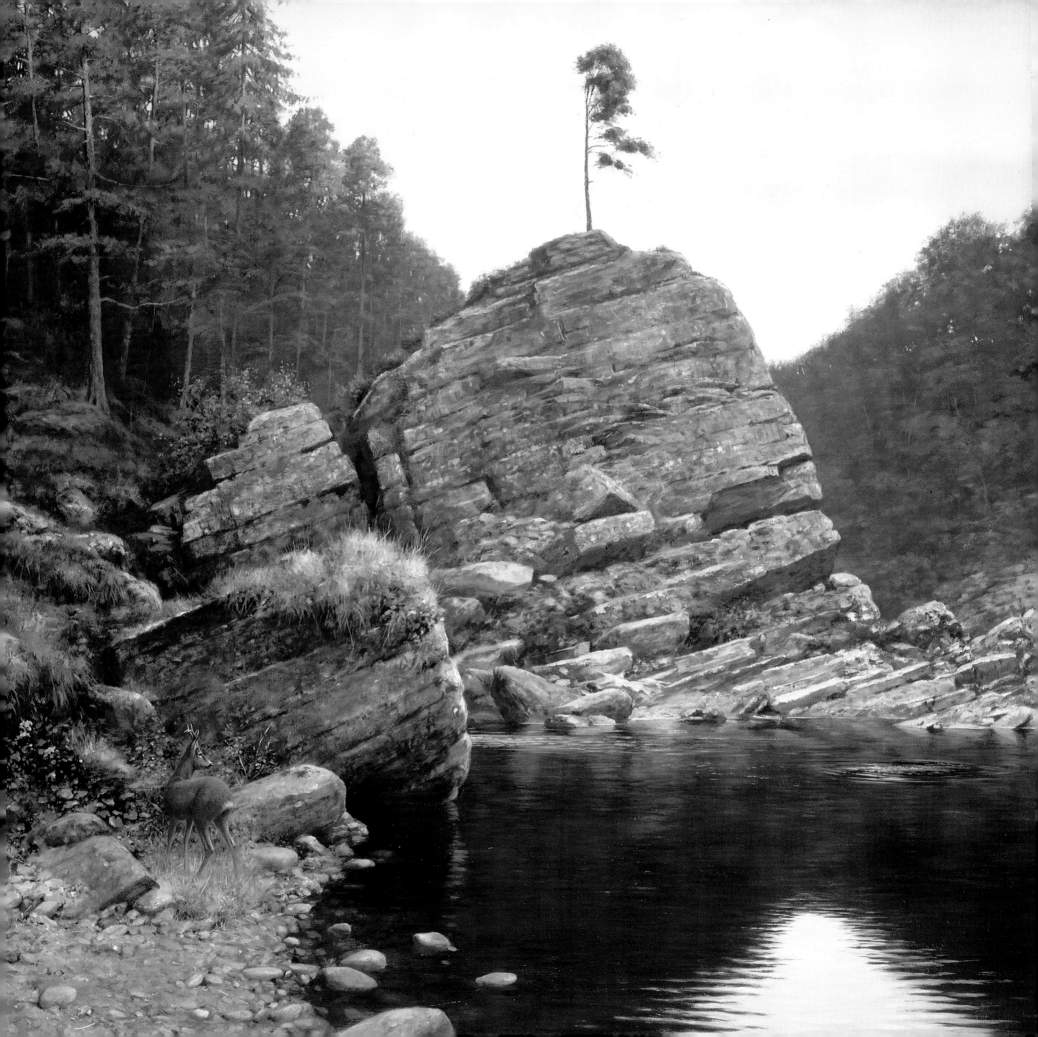

The Artist's Pool, River Findhorn 48″ x 60″ oil

I decided to do a huge oil of the Artist's Pool and went down to take reference photos just as the light was fading.

This is a famous beauty spot quite close to the road, and the weather was very hot. When I got there, the pool was full of tattooed youths swimming about. I didn't know how they tolerated the midges. They obligingly hid behind the rock while I took photos of the pool. I remember a McEwan can floating past.

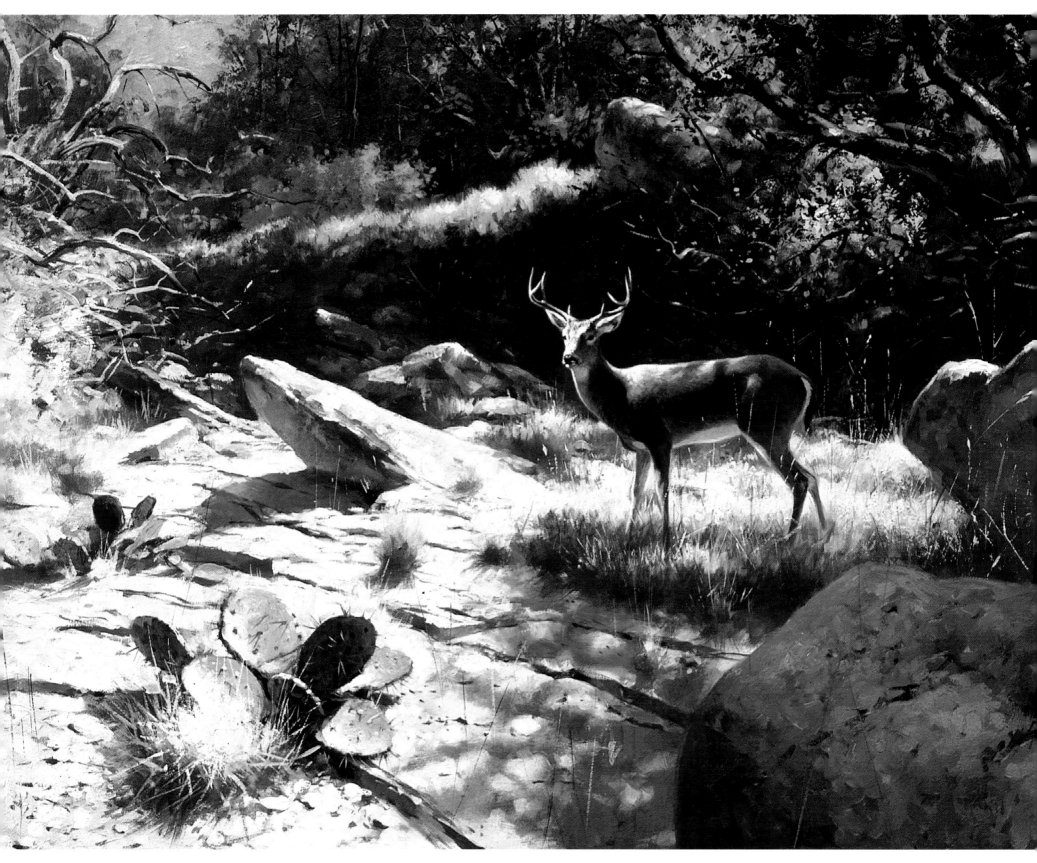

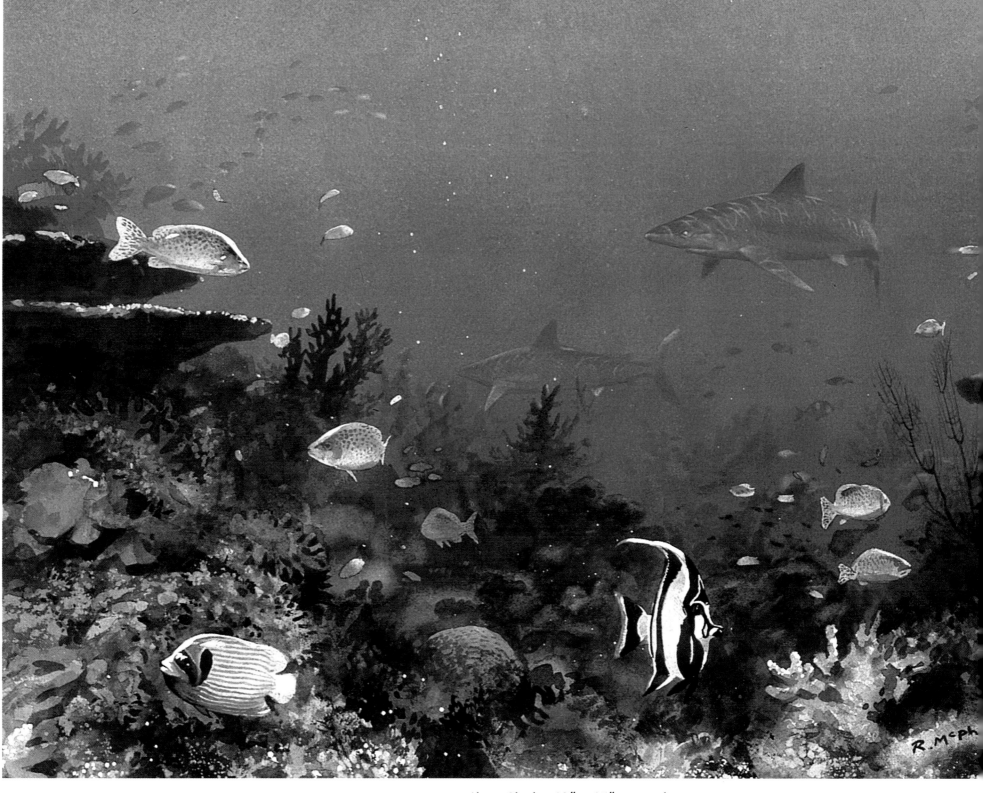

Above: Sharks 12″ x 15″ water-colour

I went to Mauritius to try to catch a Marlin.
Two days on heaving seas, breathing diesel fumes and feeling sick was enough for me.
I spent the rest of the trip Scuba diving. The reef was wonderful.
We saw sharks, manta rays etc, and on one occasion we fed a 6ft long moray eel!

Opposite Page: Whitetail Deer 18″ x 24″ oil

I had a craze on bow-hunting and went to Texas to try for a deer.
You have to get within 25 yards of your quarry and draw the bow without disturbing it. Very exciting!

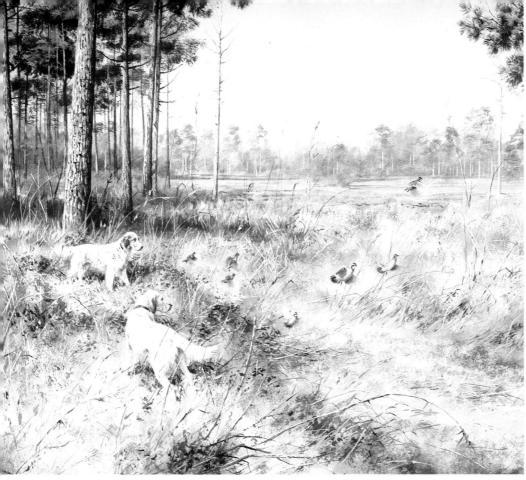

Above: Quail and Setters 15″ x 22″ water-colour

Right: Bobwhite Quail Shooting 42″ x 60″ oil

I've done a lot of quail shooting pictures for various clients. This is Mr and Mrs Jock Lawrence at their plantation in Florida. Mr Lawrence is a wonderful pianist, and we had some great sing-songs when I was there.

In the background is the traditional quail-wagon with matched mules.

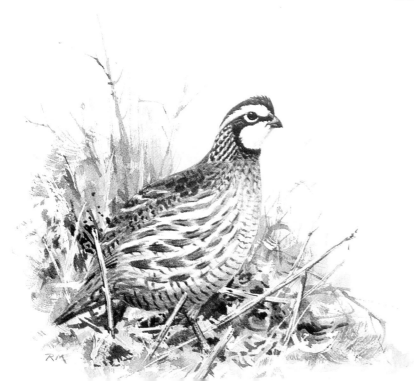

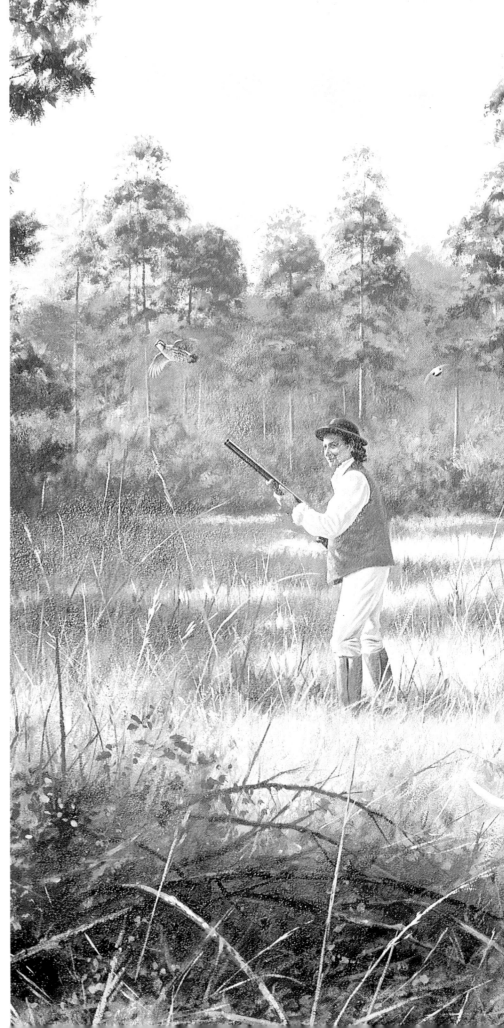

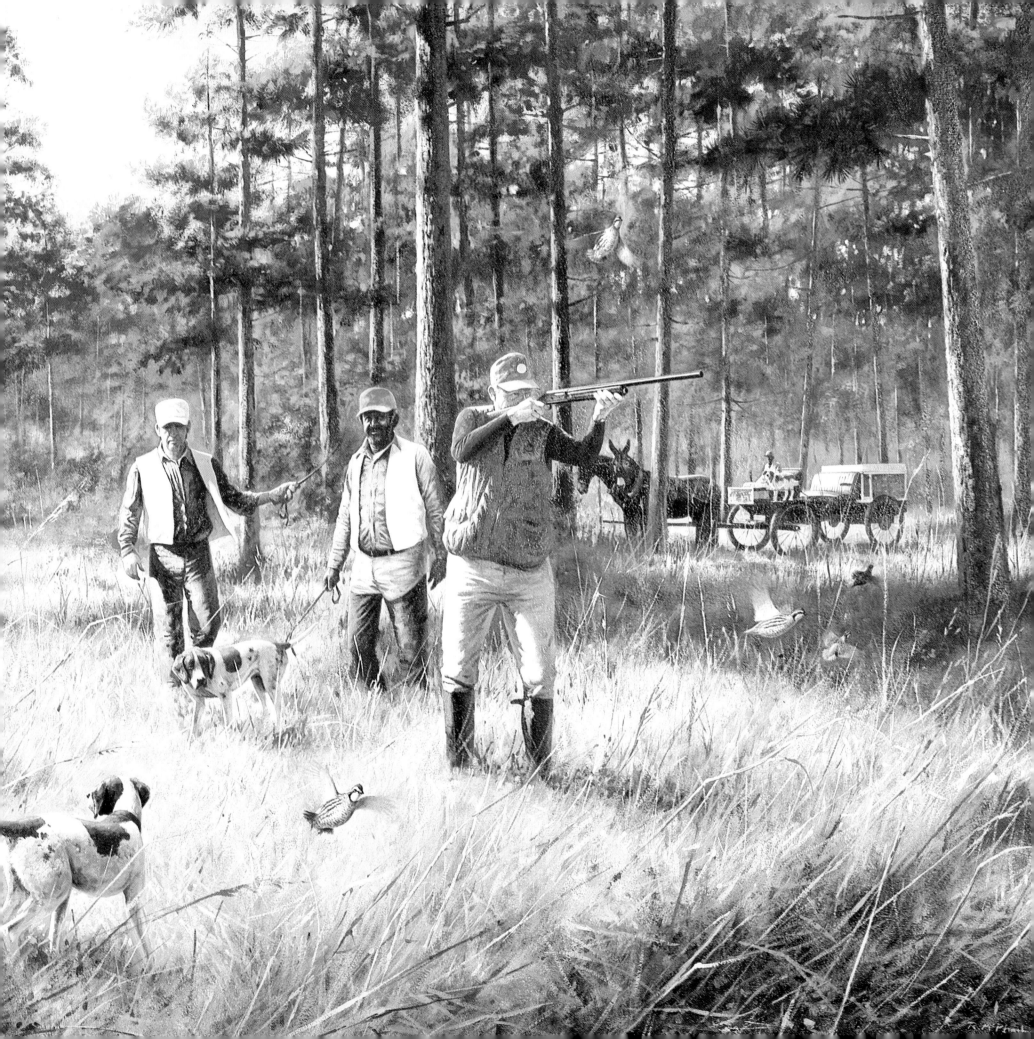

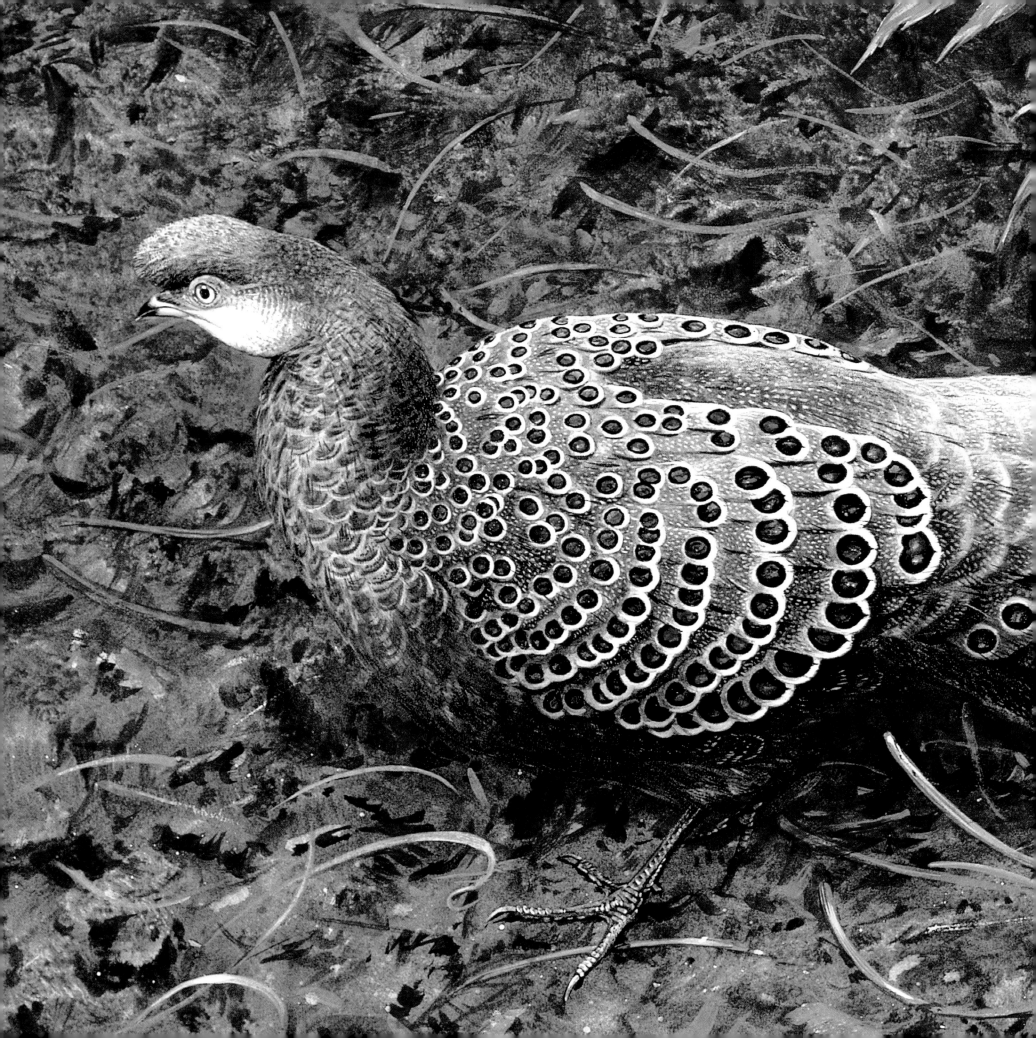

Grey Peacock Pheasant 14″ x 21″ water-colour

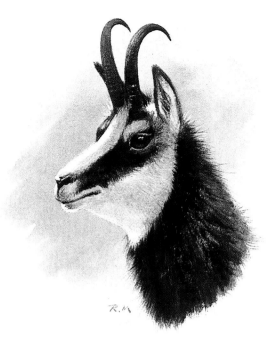
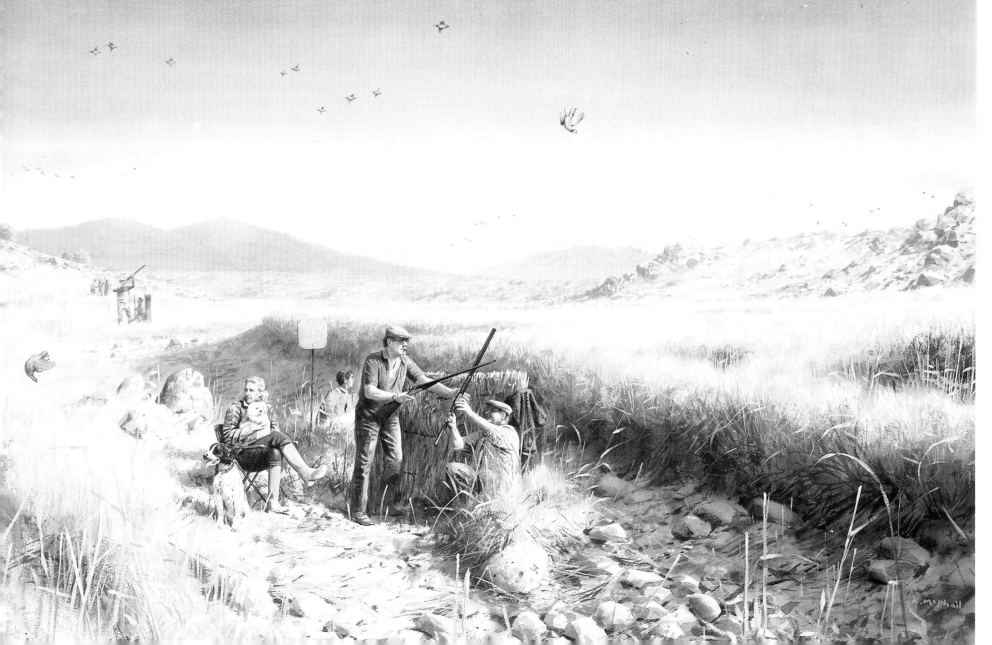

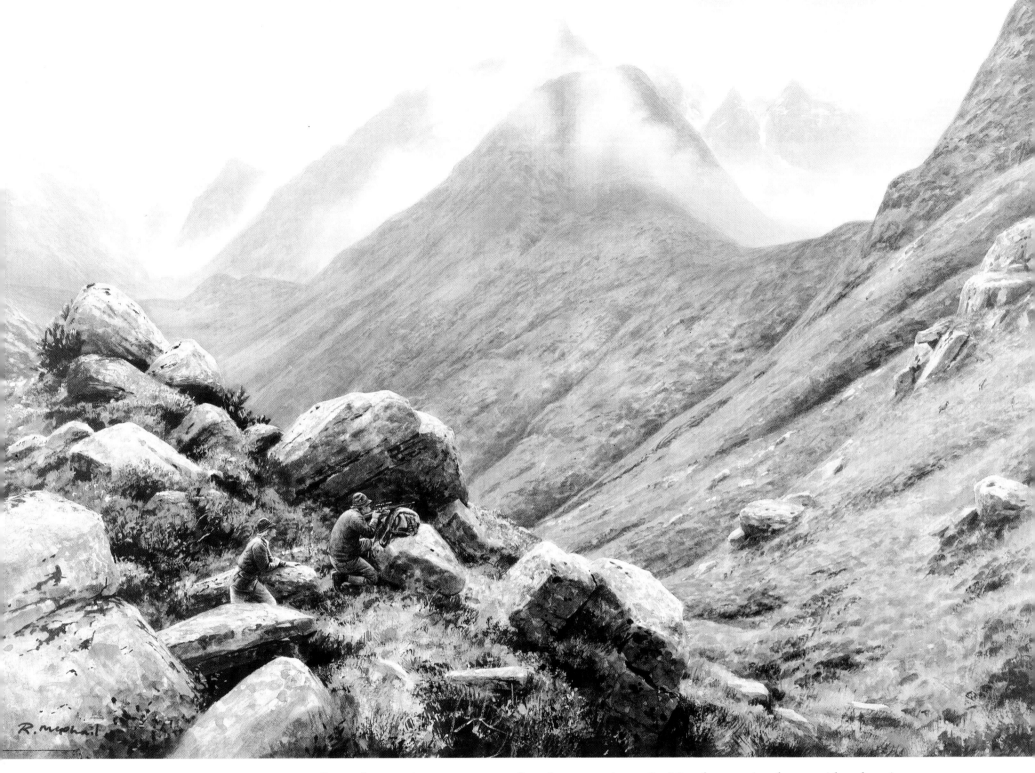

Above: Chamois Hunting in the Italian Alps 18″ x 25″ water-colour

This is Doctor Carlo-Alberto Pejrone and his wife Julietta.

Opposite Above: Chamois Hunter 18″ x 22″ water-colour

I've been lucky enough to hunt chamois on several occasions. What scenery!

Opposite Below: Spanish Partridge Shooting 18″ x 24″

I made many trips to La Mancha to paint the partridge shooting. Sometimes lucky enough to take a gun.
I loved the wild scenery and superb sport and great variety of wildlife. Some pretty wild behaviour from some of the shooting parties too!
I've done a lot of commissions of this sport for British, American, Spanish, French and Italian clients.
This is Mr and Mrs Alain Cheneviére from Geneva.

African Bird Shoot 20″ x 28″ water-colour

This was the result of a train trip down through the southern African countries. A wonderful experience.
I had prints made to give to the other members of the party.
The original went to Peter Johnson, the wildlife photographer who invited Cecilia and I on this, one of our best ever holidays.

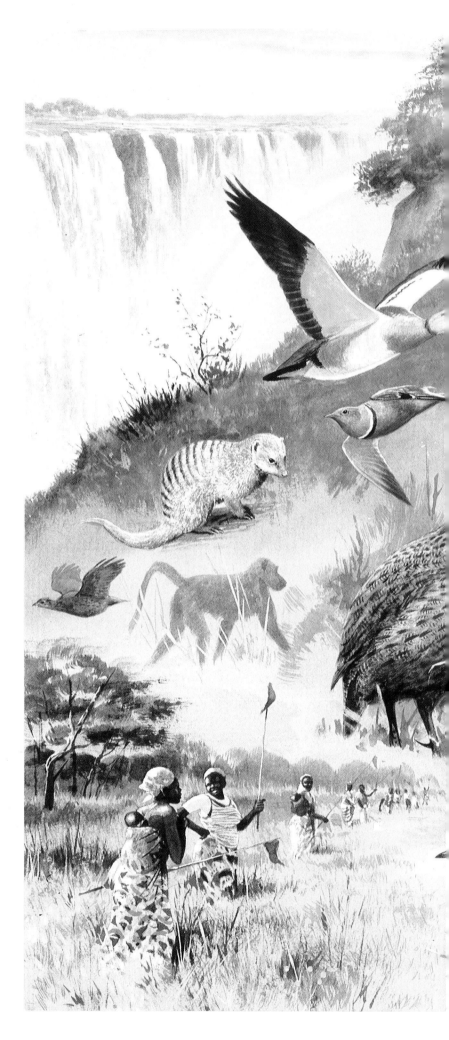

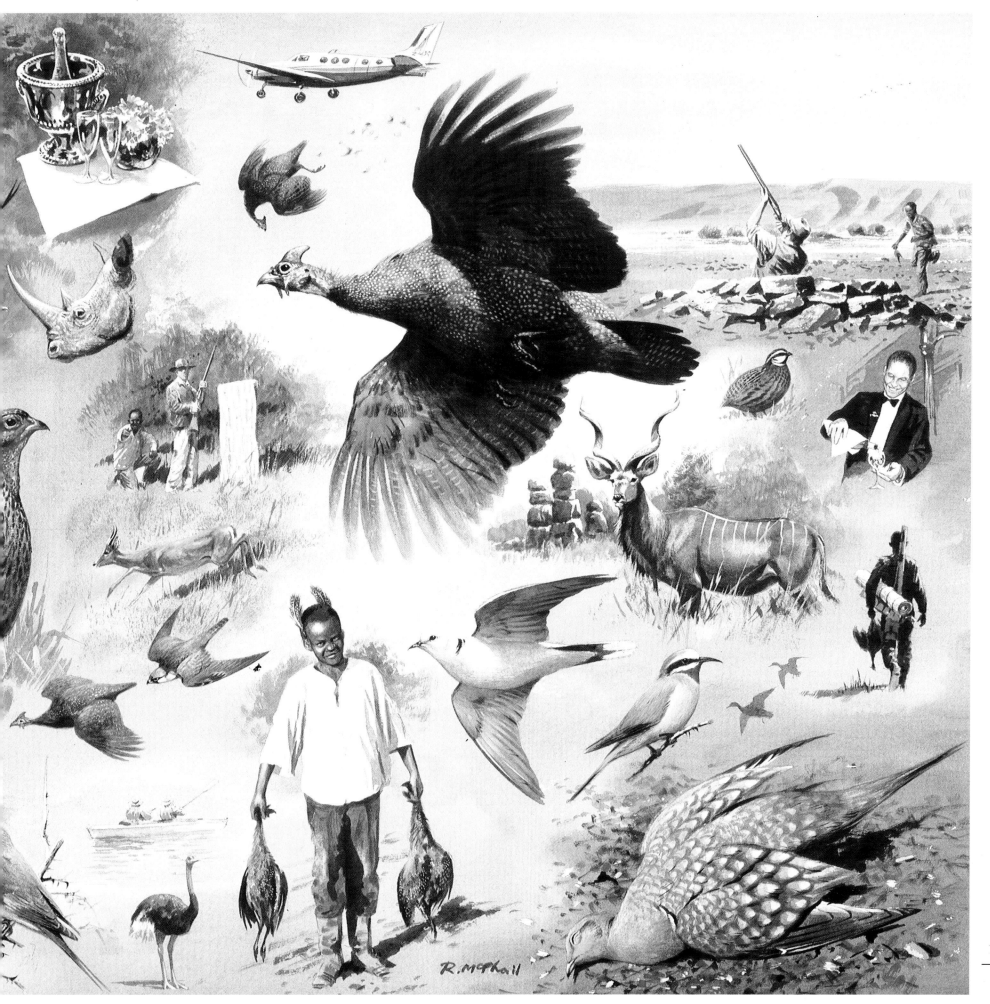

151

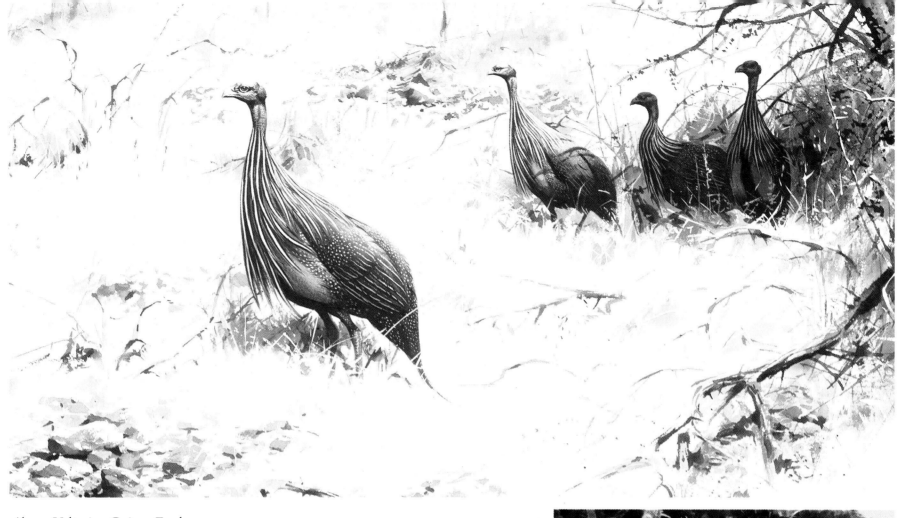

Above: Vulturine Guinea Fowl
15″ x 20″ water-colour

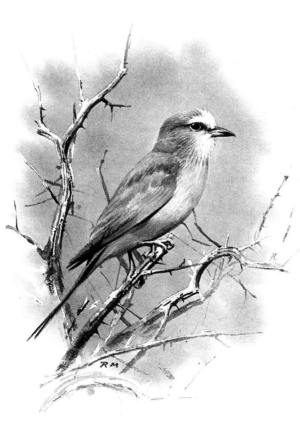

Right: Lilac-Breasted Roller
water-colour

Far Right: Marabou Storks
20 x 15″ water-colour

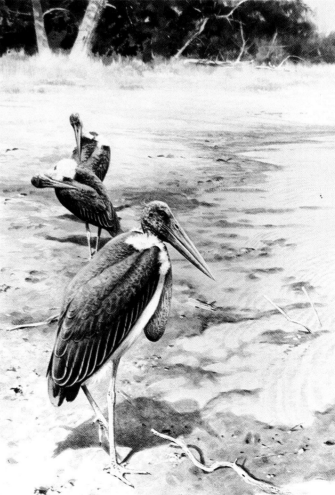

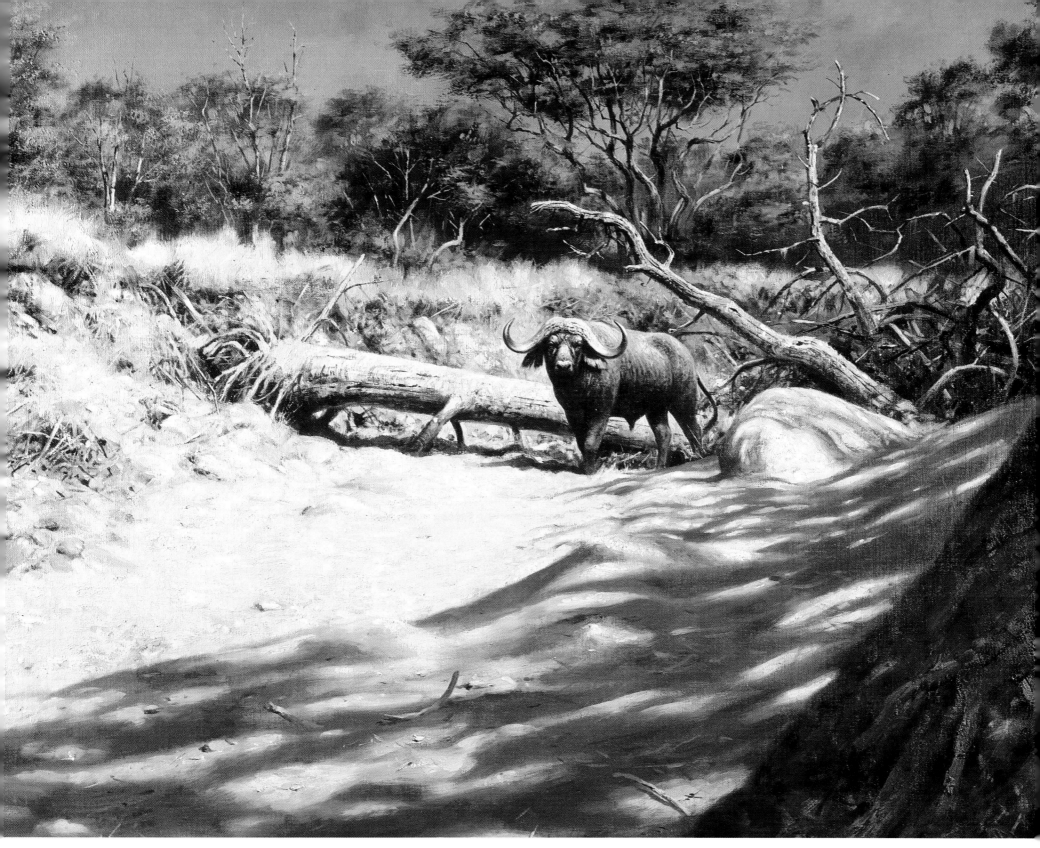

Cape Buffalo 15″ x 20″ oil

This would be a bad place to meet a buffalo – no escape!
A professional hunter put it well when he said that buffalo always
look at you as if you owe them money.

Peafowl Resting 15″ x 28″ oil

I've never been to India.
These are domestic peafowl painted in what, I hope, looks like an Asian background.

It took ages to paint all those eye feathers.
Peacocks are supposed to be bad luck, and these were for me – I couldn't sell the picture! It's hanging at home.

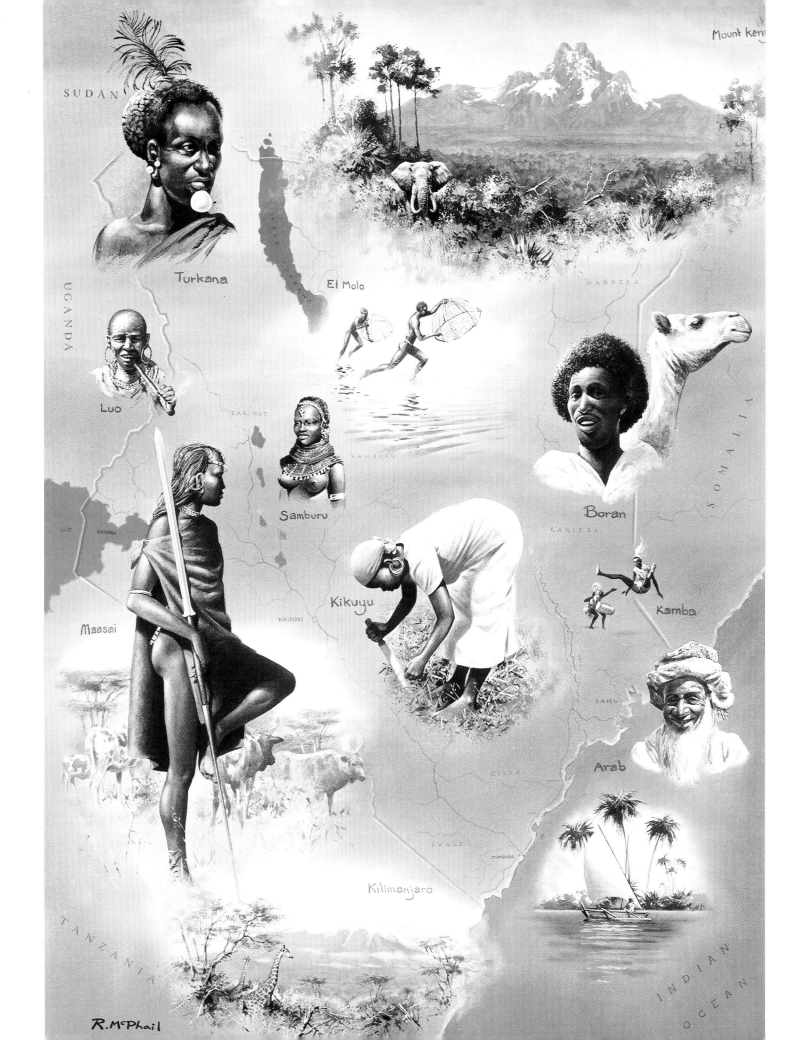

SUDAN

Mount Kenya

Turkana

El Molo

MANDERA

UGANDA

Luo

BARINGO

SAMBURU

Boran

SOMALIA

GARISSA

Samburu

VICTORIA

Kamba

Maasai

Kikuyu

NAIROBI

LAMU

Arab

KILIFI

KWALE

MOMBASA

Kilimanjaro

TANZANIA

INDIAN OCEAN

R. McPhail

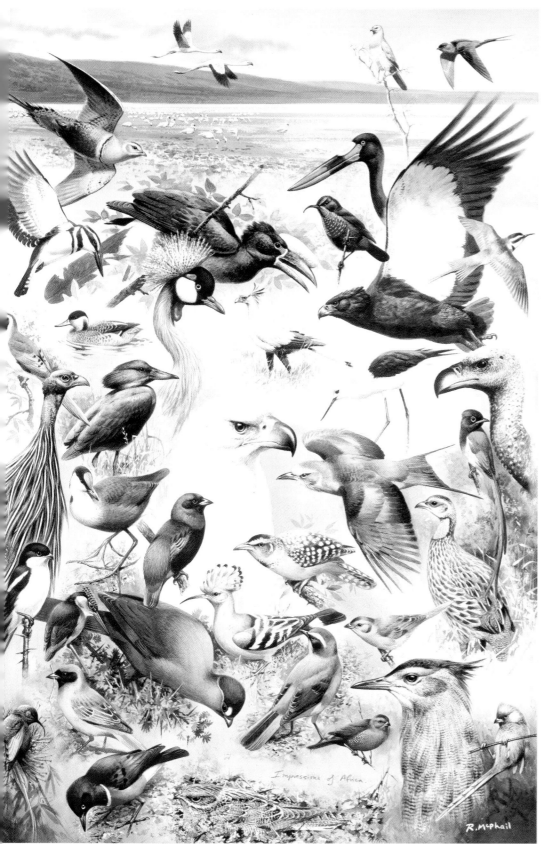

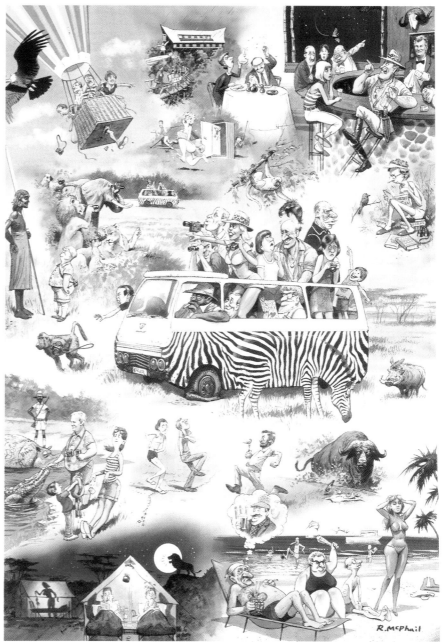

These are some of the posters for gift shops and game camps in Kenya.

I had a wonderful time doing the 'research'. We were shown round East Africa by professional hunters whose encyclopedia-like knowledge of wildlife, and tales of adventure made the trips an unforgettable experience.

Cecilia went out to arrange the printing etc. and as a result we got married.

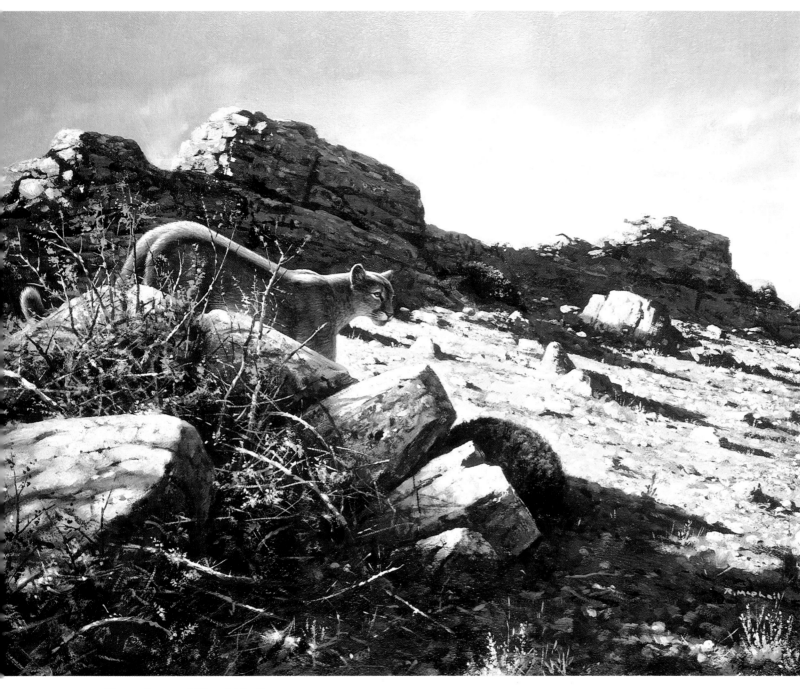

Above: Puma 10″ x 15″ oil

*Right: Llamas (Guanacos)
in the Andes 24″ x 130″ oil*

In 1995 I went to Chile with Hugh
Miles, who had been filming there for
two years. The Paine mountains in the
Southern Andes are indescribably
beautiful. Hugh's resulting film about
pumas won several awards.

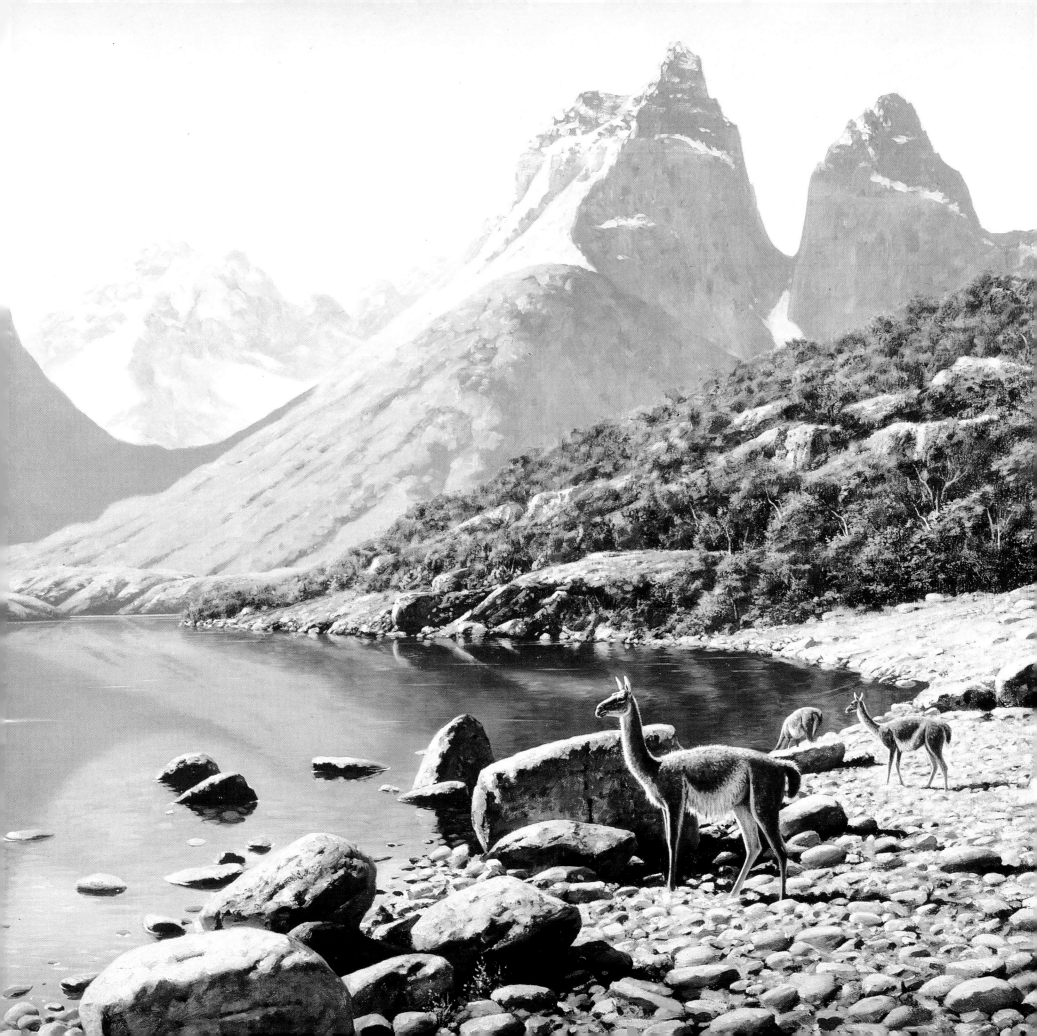